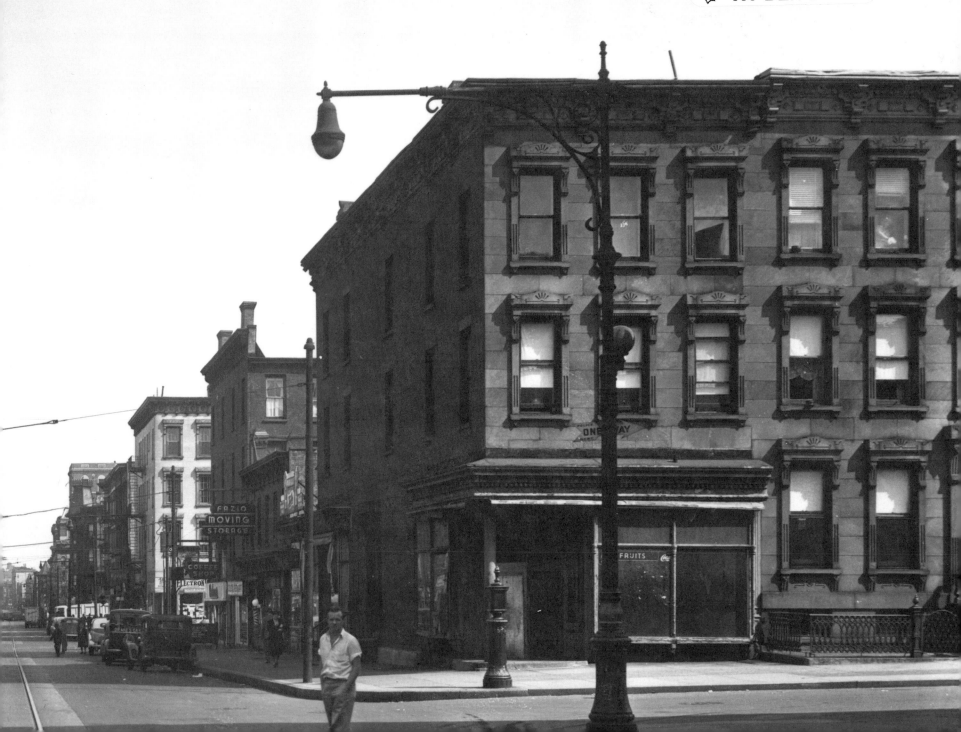

BROOKLYN'S
PARK SLOPE

a photographic retrospective

BRIAN MERLIS and LEE A. ROSENZWEIG

published by

The Sheepshead Bay Historical Society

in association with

Israelowitz Publishing

and

Brooklyn Editions

1999

second edition

2000

ACKNOWLEDGMENTS

The authors gratefully appreciate the assistance given to them by the following:
I. Stephen Miller, for underwriting this project; Robert L. Presbrey, for offering access to his archive; the helpful staff at the Brooklyn Public Library's Brooklyn Collection; Ronald Marzlock, for hand coloring the cover photograph; and Kristen Emanuelson for her editorial input and graphic advice. Site coordinator Lara Funderburk provided the inspiration necessary to get this project off the ground, and research assistant Mary Bosco facilitated the layout procedure. Timothy O'Hanlon's 1982 thesis on Park Slope was an invaluable source for us. Additional thanks to Robert and Helene Stonehill, Vincent F. Seyfried, Bob and Judi Pheiffer, and photographers Slade, Lundin, Staffman, Lloyd, Silleck, and Pullis. Current photographs were taken by the authors. The Park Slope maps from the 1929 E. Belcher Hyde Atlas of the Borough of Brooklyn are reproduced in this book.
We especially thank the people of Park Slope for their willingness to share their knowledge and memories of their neighborhood with us. The authors apologize for any factual or typographical errors which may have occurred during their endeavor.

BM & LAR

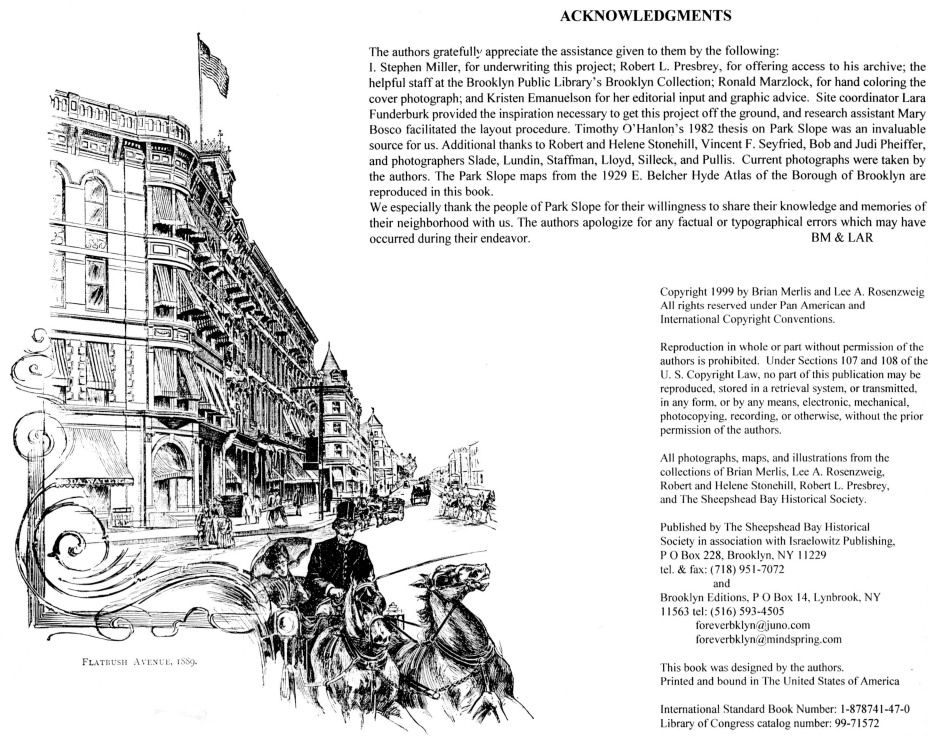

FLATBUSH AVENUE, 1889.

All photographs, maps, and illustrations from the collections of Brian Merlis, Lee A. Rosenzweig, Robert and Helene Stonehill, Robert L. Presbrey, and The Sheepshead Bay Historical Society.

Published by The Sheepshead Bay Historical Society in association with Israelowitz Publishing, P O Box 228, Brooklyn, NY 11229
tel. & fax: (718) 951-7072
 and
Brooklyn Editions, P O Box 14, Lynbrook, NY
11563 tel: (516) 593-4505
 foreverbklyn@juno.com
 foreverbklyn@mindspring.com

This book was designed by the authors.
Printed and bound in The United States of America

International Standard Book Number: 1-878741-47-0
Library of Congress catalog number: 99-71572

INTRODUCTION

PARK SLOPE—a name, a place, a community—each telling us of a special part of Brooklyn in one of the greatest cities of the world.

As a name, it is evocative of shady tree-lined streets whose rows and rows of brownstones slope up to broad avenues parallel with Olmstead and Vaux's other masterpiece—Prospect Park. As a place, it holds the historic site of the Old Stone House which was the central location of a clash between the mercenaries of the British Empire and the united rebels of the newly-declared republic of The United States of America. As a community, it evolved from the hunting grounds of Native American Lenni Lenape clans and the farms of Dutch colonial homesteaders to an elegant neighborhood of brownstones and community institutions becoming part of a great urban spread with its declines and its upswings in its popularity and its development.

Physically, PARK SLOPE is part of the Harbor Hill Terminal Moraine of the Wisconsin Glacial Ice Sheet that covered most of Canada and the northern United States. When the glaciers melted over 10,000 years ago, it left a mountain-like pile of rock debris that formed hills and created the outwash soil plain we call Long Island. The hills cross from northern New Jersey to Bay Ridge moving northeastward to create the rocky coastline of the North Shore along the Long Island Sound just across from Connecticut. As these hills became covered with leafy forests, the Native Americans found a rich hunting ground near an abundance of seafood off the Atlantic Ocean. Dutch and French trappers sent animal pelts home for use in the cold European winters. Farmers from the British Isles, the Netherlands, Germany, and the Scandinavian countries cut down the trees to plant their grain crops and raise their livestock.

Historically, PARK SLOPE is the home of one of the most important sites of the American Revolutionary War. It was at the Vechte-Cortelyou House of Gowanus that the Battle of Long Island (renamed the Battle of Brooklyn) reached its climax. At the Old Stone House, General George Washington's special troops known as the Maryland 400 under the leadership of William Alexander, the Lord Stirling, diverted British attention from the retreat of the American army across to Manhattan and up to the Hudson Valley. Most of the rebel troops escaped to regroup successfully to win other battles in New Jersey and the South. This battle site later became Washington Park where the Brooklyn Trolley Dodgers played early baseball games.

Communally, PARK SLOPE became urban in the 1880s. Edwin C. Litchfield, the developer of the Gowanus Canal, built an Italianate mansion in 1857 that held a commanding view of the fields and pastures, the Gowanus Canal, and New York Harbor. By 1871, most of Prospect Park had been completed. Magnificent private homes were built along the park, leading to the development of Brooklyn's urban "Gold Coast" from Plaza Street to Prospect Park West. In 1877, the world's largest clock factory, the Ansonia Clock Company, was built on Seventh Avenue, employing over 1,500 workers. Thus, at the end of the nineteenth century, two distinctive communities grew in PARK SLOPE—one of great wealth along the Gold Coast streets and one of the working class in simple houses and apartment buildings close to the factory. The extension of subway lines from Manhattan to PARK SLOPE further spurred the development of a third community bridging the two others as middle-class families moved into the spacious brownstones built on the side streets of PARK SLOPE.

The concentration of industrial wealth in the cities of the northeast after the Civil War was reflected in grand building projects throughout PARK SLOPE. Prospect Park, connected by Ocean and Eastern Parkways to the surrounding towns of Kings County, became the centerpiece of these building displays as the Brooklyn Museum, the Brooklyn Botanic Garden, and the Soldiers' and Sailors' Monument at Grand Army Plaza graced Brooklyn's landscape. Opulent Victorian structures were built for the wealthy to hob nob in the Montauk Club, the Cathedral Club (originally the Carlton Club), and the Brooklyn Ethical Culture School. The PARK SLOPE community was becoming a diverse cultural mix as Irish and Germans lived and worked near the mansions of Dutch, English, and Scandinavian industrialists. Every major religious group has built a magnificent structure for their congregations in PARK SLOPE. Today, the largest Irish-American Day Parade in Brooklyn is held on the streets of PARK SLOPE. After World War II, a large Latin settlement developed, followed by an influx of Asians in the 1960s, and more recently by Caribbean Islanders.

PARK SLOPE—once a remote ward of The City of Brooklyn, has at the end of twentieth century become a premier residential neighborhood in New York City's most populous borough.

BROOKLYN'S PARK SLOPE celebrates the oncoming of the twenty-first century with a rich ethnic cultural diversity amongst splendid public landmarks and significant historic sites.

Join the authors in celebrating the next hundred years of PARK SLOPE by surveying the history of New York City's showplace neighborhood.

I. Stephen Miller, President, *The Sheepshead Bay Historical Society*

4

This 1840s steel engraving by W.H. Bartlett shows New York Bay from Gowanus Heights. The view is from near Fourth Avenue and Eighteenth Street.

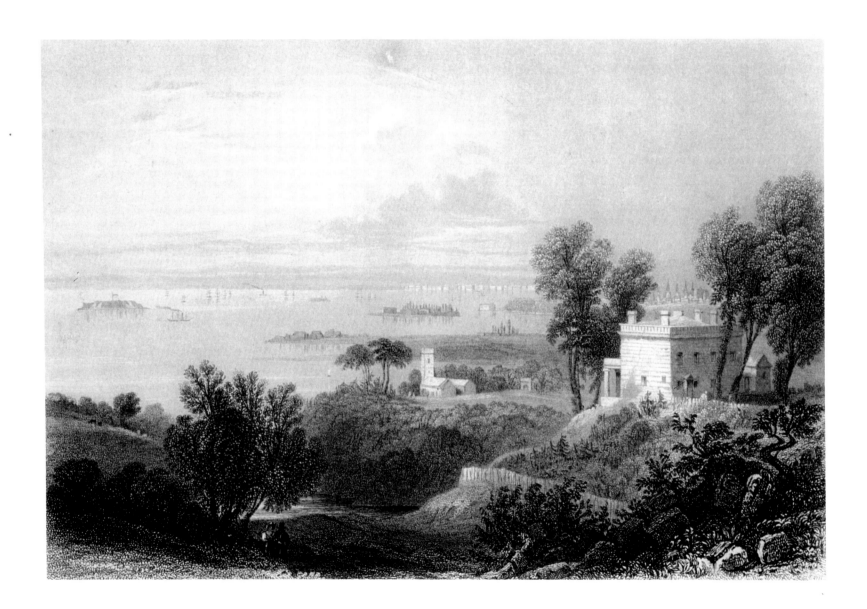

Park Slope was named for its proximity to Prospect Park and its location on land which gradually elevates from the low-lying meadows of the Gowanus to the highlands of the park. Original land holdings were divided into long rectangular parcels extending from within today's Prospect Park to about Second Avenue.

At the onset of the Battle of Brooklyn, on August 27, 1776, the outnumbered American soldiers encountered 4,000 British troops at Battle Pass, which is now located within the boundaries of Prospect Park. The Port Road, possibly of aboriginal beginnings, branched off the Flatbush Road, near Valley Grove, in today's Prospect Park. The Port Road proceeded along the approximate path of today's First Street, passed the Shore Road (between today's Fourth and Fifth Avenues), and led to the Gowanus Creek. The Port Road crossed over the Gowanus Creek by a pre-Revolutionary bridge known as Freeke's tidal-mill dam. The Port Road was known as the "Shunpike" because it was used by farmers who wanted to avoid paying tolls on the Flatbush Road, which was a turnpike.

When the Revolutionary fighting ended at Battle Pass, Hessian legions, comprised mainly of *Jaegers,* chased the remaining American soldiers down the Port Road, firing at them when they had good visibility through the thick foliage. The Hessians, with other British reinforcement, took control of the fortress-like Vechte-Cortelyou house. Cannons were carried into the brick-and-fieldstone house. In the valiant charge by the Americans, 256 Maryland soldiers died in the shadow of the Old Stone House. This sacrifice enabled the Continental Army to restructure in Brooklyn Heights, and escape under cover of fog, to Manhattan.

By 1850, about a dozen families owned the land which was to become Park Slope. Among them were the Bensons, van Brunts, Polhemuses, and the Cortelyous—families whose Brooklyn origins can be traced back to the 1600s.

Beginning in 1852, Edwin C. Litchfield began purchasing land in the area. He was the son of a former New York State Assembly Speaker. A partner in the New York City law firm of Litchfield & Tracy, he was once president of a midwest railroad. Litchfield purchased the Cortelyou family holdings for $150,000. The property, between today's First and Fifth Streets, extended from Prospect Park to the Gowanus Canal.

In 1857, Litchfield built a Tuscan Manor house first known as "Ridgewood" and later "Grace Hill," which still stands, near Fourth Street within Prospect Park. It was designed by Alexander Jackson Davis. He continued to acquire land, and by the 1860s extended his property to Ninth Street. By the outbreak of the Civil War, Litchfield was Park Slope's foremost landholder—controlling about one-third of the district. Litchfield realized that as the Industrial Revolution progressed that his property could only increase in value. Litchfield saw the potential of his waterfront properties below Fourth Avenue by the Gowanus Canal, built in 1848-9. By draining swamp lands, he constructed canal extensions leading to his lumber warehouses.

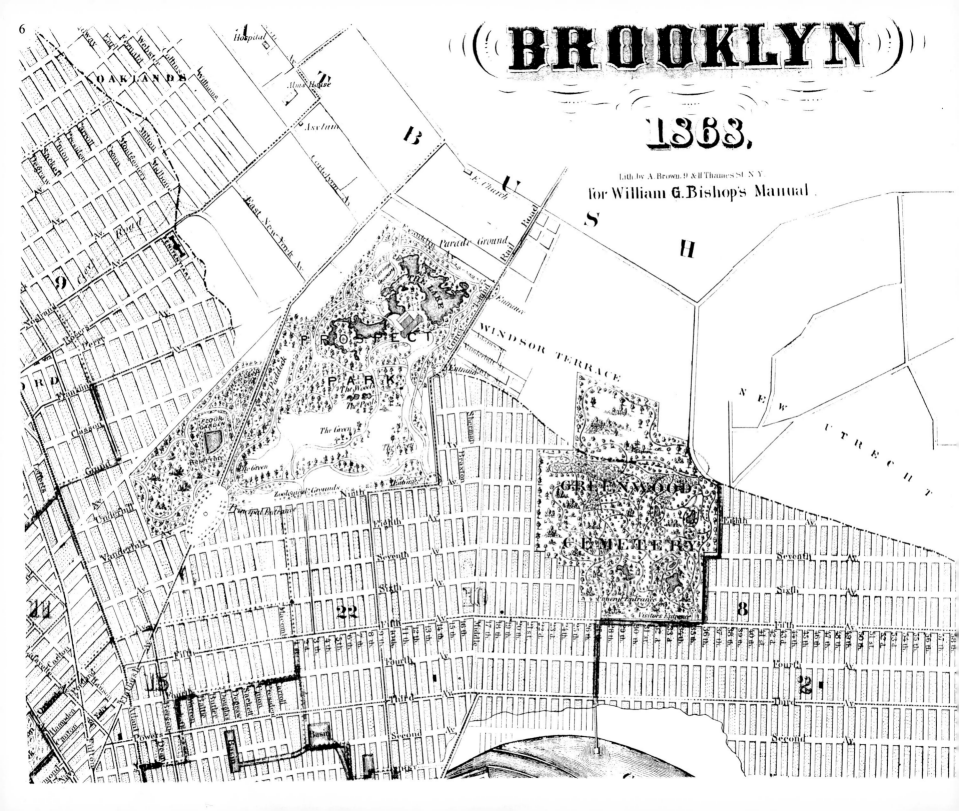

Litchfield foresaw the development of an "industrial park" between Fourth Avenue and New York Bay. To finance this venture, he secured a $250,000 loan from the City of Brooklyn. Litchfield invested nearly a million dollars in laying out many of the streets and avenues situated on his property.

With the 1860 approval by the State Legislature to develop Prospect Park, Litchfield's property immediately appreciated in value. Litchfield was instrumental in the movement to create a park, and use his influence to have James S.T. Stranahan named as President (1861) of the Brooklyn Park Commission. Its role was to plan the park and issue bonds which would later be paid back by property taxes. Although General Egbert L. Viele first suggested plans for the park in 1858 which were approved in 1861 by the commission, the Civil War delayed groundbreaking.

After the war, Frederick Law Olmsted and Calvert Vaux were hired to draw up revised plans. They envisioned a grander park extending to Ninth Avenue instead of Tenth Avenue and reaching Fifteenth instead of Ninth Street. This plan reflected the architects' objection to the bisection of the park by Flatbush Avenue. Litchfield was enraged as his country villa and nearly fifteen acres were located within the revised plans. Despite his objections, the plans were approved by the State Legislature and in 1869 Litchfield received $552,000 as compensation.

Brooklyn's city fathers realized that the park's construction would accelerate the residential development of the district. As a result, tax revenues for the city would increase. It was hoped that upper-class families from Manhattan would be attracted to the area by Prospect Park.

Although a number of streets in the vicinity of Seventh Avenue and Degraw Street (renamed Lincoln Place in 1873) had been opened in the late 1850s, only a few houses had been erected in Park Slope prior to 1865. Completed in 1857, the William B. Cronyn house, located at No. 271 Ninth Street, is a New York City landmark. It was later home to the Charles M. Higgins india ink company. St. John's Episcopal Church was constructed on Douglass Street (renamed St. John's Place in 1870) in 1869. It was designed by Edward T. Potter in the Victorian Gothic style, popular at the time. Speculators began purchasing lots, sometimes at auction, and would erect a row of houses in the style of the period. Since the houses were nearly identical, the use of standard construction materials kept the price of each house affordable to prospective middle-class buyers.

Robert S. Bussing built the first houses on Seventh Avenue, at Nos. 50 and 52, in 1870. He, in partnership with Philip Cootey in 1872, constructed eleven French Second Empire-style houses on Seventh Avenue. Additional rows were built along Park Place and the streets close to Flatbush Avenue during the early 1870s. This was actually an extension of the upper-class section which bordered the retail areas along Fulton Street and Flatbush Avenue.

A national depression, beginning in 1873, nearly brought construction in the area to a halt. By 1880, when the nation recovered from the Panic of 1873, development resumed. The area's first school, P.S. 39, on Sixth Avenue and Eighth Street, was built in 1877. It has been designated a city landmark.

The area southwest of Ninth Street was settled by working-class families. Laborers could easily reach the industrial section near the Gowanus Canal or the docks by a horsecar which ran along Ninth Street, crossed the Canal, and turned onto Smith Street, terminating downtown. This transportation line, and the one along Fifth Avenue, had been in operation since the 1860s. Workers lived in smaller houses, some of which were wood-frame. Development in the Lower Slope shows an irregularity in lot size as well as building design. Commercial structures were built adjacent to houses. This pattern was rarely found northeast of Ninth Street, in the Upper Slope. By the 1880s the center of Park Slope, including the park blocks, remained undeveloped. Hundreds of domestic animals grazed in open fields which would soon be transformed into one of Brooklyn's finest residential districts.

8

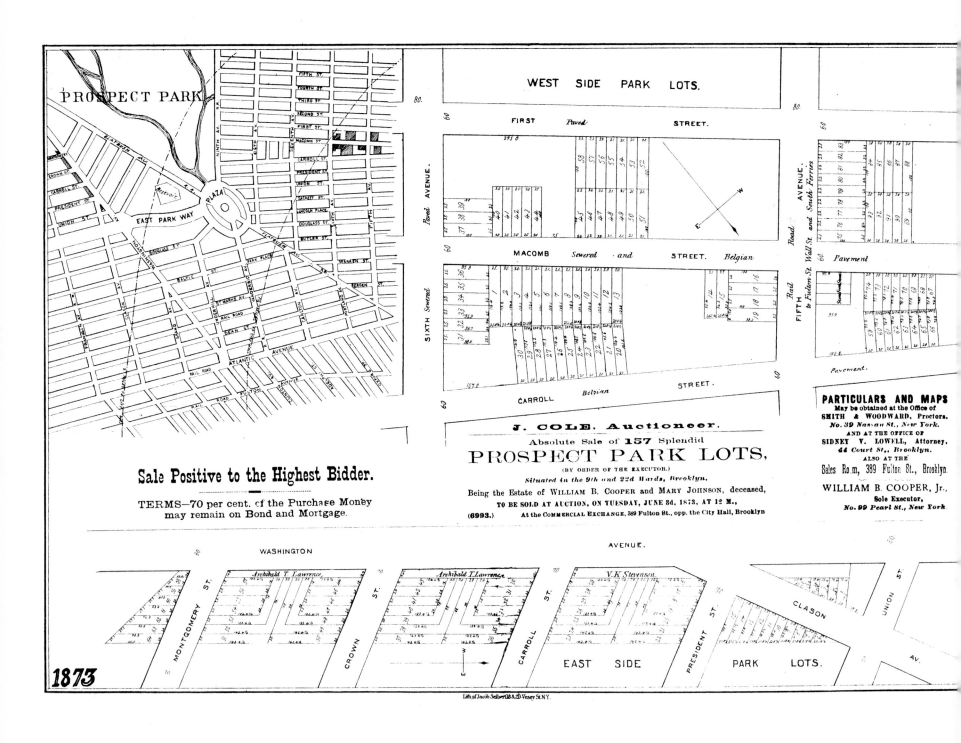

PROSPECT PARK

WEST SIDE PARK LOTS.

FIRST *Paved* STREET.

MACOMB *Sewered and* STREET. *Belgian*

CARROLL *Belgian* STREET.

Sale Positive to the Highest Bidder.

TERMS—70 per cent. of the Purchase Money
may remain on Bond and Mortgage.

J. COLE, Auctioneer.

Absolute Sale of **157** Splendid
PROSPECT PARK LOTS,
(BY ORDER OF THE EXECUTOR.)
Situated in the 9th and 22d Wards, Brooklyn.

Being the Estate of WILLIAM B. COOPER and MARY JOHNSON, deceased,
TO BE SOLD AT AUCTION, ON TUESDAY, JUNE 3d, 1873, AT 12 M.,
(6993.) At the COMMERCIAL EXCHANGE, 389 Fulton St., opp. the City Hall, Brooklyn

PARTICULARS AND MAPS
May be obtained at the Office of
SMITH & WOODWARD, Proctors,
No. 39 Nassau St., New York.
AND AT THE OFFICE OF
SIDNEY V. LOWELL, Attorney,
44 Court St., Brooklyn.
ALSO AT THE
Sales Room, 389 Fulton St., Brooklyn

WILLIAM B. COOPER, Jr.,
Sole Executor,
No. 99 Pearl St., New York.

1873

WASHINGTON AVENUE.

Archibald T. Lawrence. *Archibald T. Lawrence.* *V. K. Stevenson.*

EAST SIDE PARK LOTS.

JOHN MCCORMICK.

A LEADING and eminently popular dry-goods emporium in Brooklyn is that of Mr. John McCormick, which is located at the corner of Ninth street and Fifth avenue. His establishment is without exception the largest and finest in that part of the city, and its reputation is known all over Brooklyn. The stock is most complete in every respect, and special pains are taken to have every department stocked with a full assortment of all the latest novelties of foreign importation or domestic invention. The quality and desirability of the stock is ably maintained and inducements in prices are quoted that only obtain with a house so thoroughly prepared for efficient service.

No mercantile pursuit of the present day is so exacting in its demands as the dry-goods trade. In none are the requirements of customers more critical and the successful dry-goods merchant needs to be not only a man of tact and sound business ability, but a thorough judge of human nature and especially familiar with the demands of fashion. The

McCormick Building.

ladies, of course, make up the majority of customers in a dry-goods store and the ladies of Brooklyn have a national reputation for possessing the most critical taste in the country. To cater successfully to the demands of this class of trade requires an exceptional amount of business tact and a thorough knowledge of the many details which the modern dry-goods business embraces. That all these requirements are possessed, in an exceptional degree, by Mr. McCormick, the success of his business, the extent of his trade and the wide and excellent reputation enjoyed by his store afford abundant evidence. He has been exceptionally fortunate in the selection of his assistants and here again his own thorough business training and knowledge of human nature has been clearly displayed. Every department is in charge of employees who are experts in their line and the buyers for the house possess a thorough knowledge of the needs of trade which enables them to select a stock for their respective departments that in style, quality and price cannot be excelled.

Mr. McCormick is a native of Brooklyn. He has always taken pride in the growth and development of his native city and has ever been prominently identified with every public spirited movement to increase the prosperity of the city or the welfare of its citizens. This feeling is reciprocated by his fellow-citizens who recognize in his business success the well-earned reward of industry, application and business ability. He is well known and honored as an able and successful merchant and one of Brooklyn's representative and substantial business men. He is a director in the Fifth Avenue Bank, where his experience and judgment have proved valuable in the development of the bank business.

-1892-

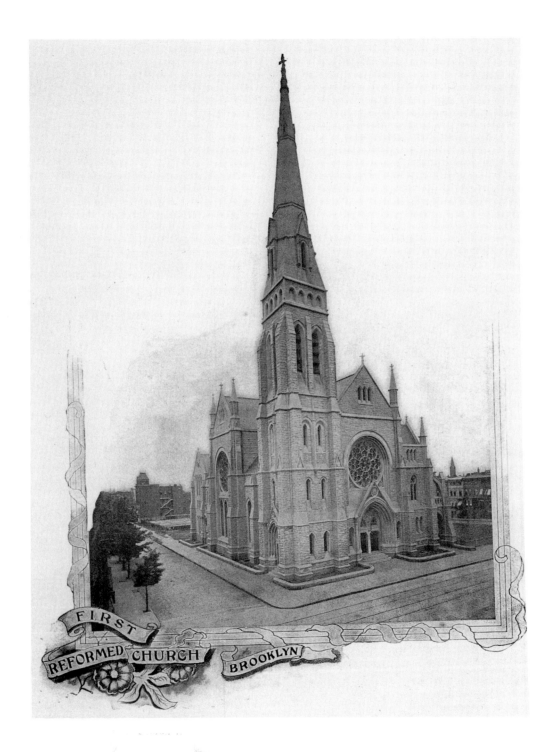

✠

Laying of the Corner Stone

OF THE NEW EDIFICE OF THE

First Reformed (Dutch) Church

Seventh Avenue. Corner of Carroll Street.

BROOKLYN

✠

On Saturday Afternoon, November 9th, 1889,

AT TWO O'CLOCK.

✠

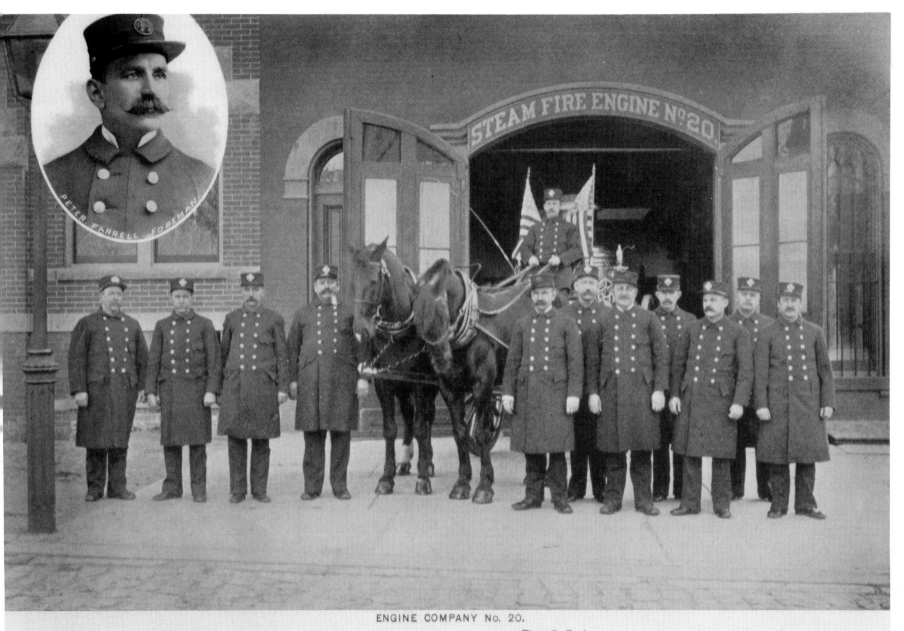

ENGINE COMPANY No. 20.

Thos. F. Ennis.

Jeremiah J. Delaney. Jas. T. Donohue. Geo. H. Fletcher.

David Roche. Jas. Fitzpatrick. Rich. S. Heard. John W. Dunn. Peter Farrell, Marcus Fitzgerald, Alex. J. Reekie. James T. Shannon.
 Foreman. Asst. Foreman.

Engine Company No. 20 was established by the Brooklyn Fire Department in 1882. The Firehouse at No. 532 Eleventh Street, between Seventh and Eighth Avenues, was completed that same year. The photograph above was taken in 1892. Now used to house Ladder Co. No. 122, NYFD, the building is pictured toward the back of the book.

HEAD OF DEPARTMENT.

MARY MOLOW.

TEACHERS.

LUCILLA E. SMITH,	JENNIE MACKAY,	MARIA PENDLETON,
SARAH E. SCOTT,	ROSINA M. TAYLOR,	JENNIE M. NICHOLSON,
EMMA L. JOHNSTON,	SOPHIE FITTS,	RACHEL HARNED,
MARY TOBIN,	CHARLOTTE E. BOLDNAN,	MARY L. FLYNN,
KATHARINE J. KING.		

JOHN GALLAGHER,

PRINCIPAL.

HEADS OF DEPARTMENTS.

SARAH A. SCOTT,
CAROLINE A. COX,

TEACHERS.

WILLIAM M. DACKERMAN,	CORA B. GOESMAN,	MARY EVANS,
SUSAN V. N. ROUGET,	FLORENCE A. GAMGEE,	AGNES F. McCORMICK,
ELIZABETH L. SAVAGE,	ANNIE W. MEYER,	ELIZA J. WALKER,
MARTHA W. WARD,	MATTHEW A. GEVLIN,	ESTHER E. MEISTER,
JOHN O. JUDGE,	JANE C. VAN PATTEN,	JENNIE E. MILLS,
JANE DAVIDSON,	JENNY BROWN,	JOSEPHINE M. CURRIER,
MARY EAGAN,	JOHANNA L. RIS,	ROSE B. GRANGER,
JOSEPHINE E. BLYDENBURGH,	ROSE A. MOAN,	EDMERE DALGLEISH,
ANNA M. TREACY,	MARY T. HOGAN,	HENRIETTA S. TOMPKINS,
ALICE L. CARPENTER,	HELENA D. GUNTHER,	MARY L. DeMAI,
LENA G. COLLINS,	MARY A. YEATON,	FANNIE MILLER,
SARAH B. VanBRUNT,	CARRIE M. RICE,	MARY K. VOORHIES,
KATE SHEPPARD	IRENE FARRELL,	FRANCIS H. NICHOLS,
ALMA T. NORBERG,	NELLIE L. McDONALD,	CAROLINE E. ALCOCK,
M. ANNIE SPENCE,	JULIA C. GEISBUSCH,	ALICE M. MELLICH,
SARAH H. CARTER,	JULIA McNULTY,	

JOHN H. HAAREN,

PRINCIPAL.

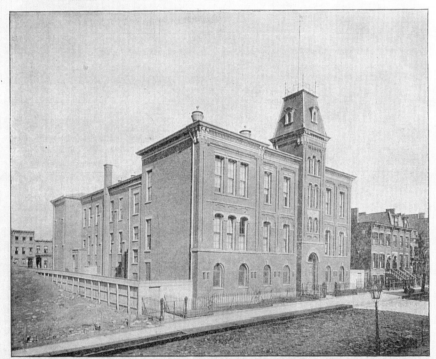

TRAINING SCHOOL

BERKELEY PLACE, NEAR FIFTH AVENUE.

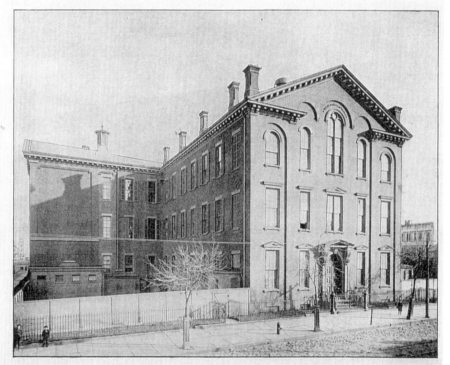

PUBLIC SCHOOL NUMBER 10

SEVENTH AVENUE, CORNER SEVENTEENTH STREET,

1892

CHANNING STEBBINS,
PRINCIPAL.

HEADS OF DEPARTMENTS.

CORA A. SLOAN,
FANNIE S. COMINGS.

TEACHERS.

JOSEPHINE E. BARKER,	IDA I. GILBERT,	MARY H. NASE,
HARRIET H. ILSLEY,	ADA CALLAGHAN,	EVELYN A. MEYENBORG,
AGNES DOUGALL,	MARGARET E. DOWNS,	MARY DUNN,
EMMA H. PAYNE,	MATILDA F. WALSH,	LOUISE A. KEMBLE,
ELIZABETH A. BUTTS,	MARIETTA WOLCOTT,	MARGARET L. FALION,
HATTIE T. SWEENEY,	JENNIE E. SHANNON,	ANNA M. WHITE,
SARAH W. ROBB,	EMMA L. LEONARD,	KATE F. LYSTER,
BELLE J. DEUELL,	MARGARET A. QUILL,	CLARA MILLINGTON,
ANNAH BENNERS,	MINNIE C. JOHNSON.	MARY A. ABRAHAMS.

MARY E. SLOAN,
BRANCH PRINCIPAL.

HEAD OF DEPARTMENT,

EMMA A. DUNN.

TEACHERS.

NELLIE L. AITKEN,	MARGARET R. SMITH,	EMMA L. WALTON,
AMY L. D. PONTON,	KATE S. EDWARDS,	MARY A. O'BRIEN,
ELIZABETH A. BYRNE,	J. MAY DeWART,	CORNELIA J. NOONAN,
ALTHEA LOUGHLIN,	ELIZABETH F. SULLIVAN,	ANNA M. SHANAHAN,
EMILY F. HOLT,	ANNA G. KASSENBROCK,	JUANITA I. O'HARA,
ISABEL M. McELHINNEY,	ANNIE E. BUSBY,	ANNA L. McGOVERN,
MARY E. KEARNEY,	ANNA M. CUNNINGHAM,	KATIE E. OPP,
ELLEN J. BELLAMY,	LIZZIE A. McGRONEN,	GERTRUDE ROSE.

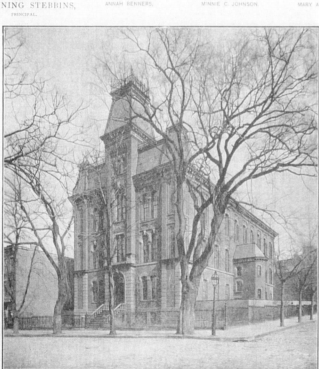

PUBLIC SCHOOL NUMBER 39.
SIXTH AVENUE, CORNER EIGHTH ST.

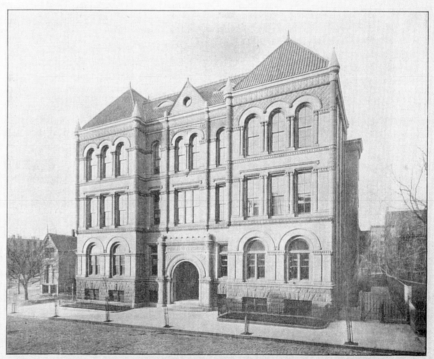

PUBLIC SCHOOL NUMBER 77 (Branch of No. 39).
SECOND STREET, NEAR SIXTH AVENUE.

1905

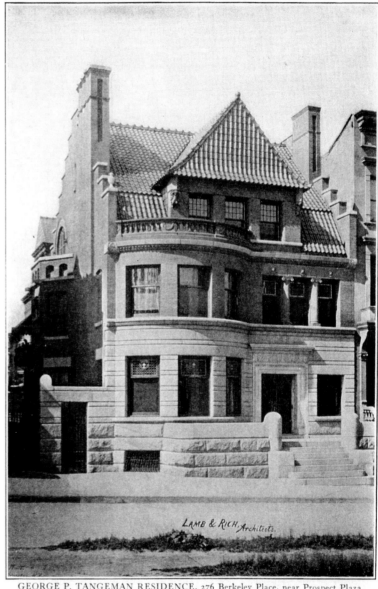

DESMOND DUNNE RESIDENCE, 25 Prospect Park West.
The spacious and tasteful home of the President of the Desmond Dunne Co., originators and controllers of extensive advertising projects; Director Brooklyn Bank, Long Island Safe Deposit Co., etc.

GEORGE P. TANGEMAN RESIDENCE, 276 Berkeley Place, near Prospect Plaza.
Granite and brick. The home of a Brooklyn capitalist, whose fortune was largely made through Royal and Cleveland Baking Powder Companies. Trustee of Peoples Trust Co., Hoagland Laboratory, etc.

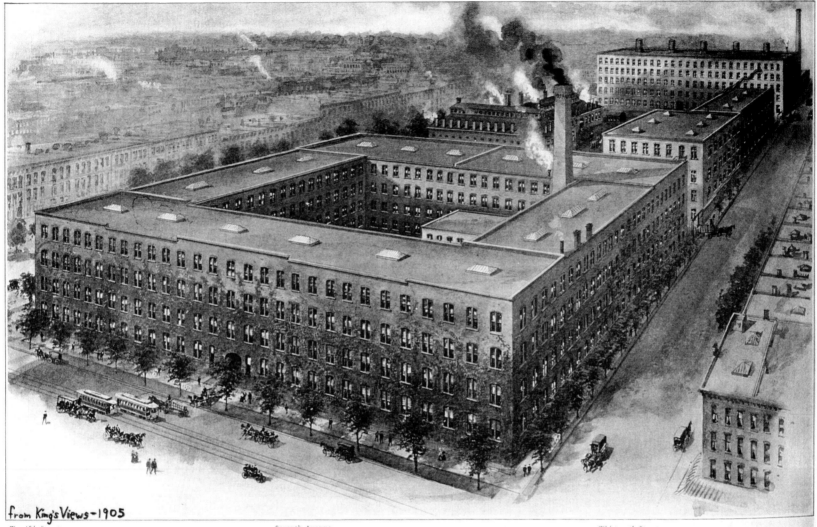

from King's Views—1905

ANSONIA CLOCK COMPANY, Phelps, Dodge & Co., Seventh and Eighth Avenues, Twelfth and Thirteenth Streets. Main offices and salesrooms, Cliff and John Streets, New York.

The Ansonia Clock Company

Anson Phelps developed a brass foundry on the banks of Connecticut's Naugatuck River in the early 1800s. He named the town that grew up around it "Ansonia." and began producing clock parts for the fledgling American clock industry. The company was incorporated in the 1870s and moved to Brooklyn.

By the 1880s, Ansonia had become one of the largest clock manufacturers in America, employing 1,500 workers and capable of producing 10,000 timepieces a day in their 300,000-square-foot complex. The company was best known for its decorative novelty clocks and inexpensive watches.

Just before World War I, Ansonia's best selling items, the novelty clock and the dollar watch, became subject to fierce competition. Rather than maintaining competitive prices, they attempted to cut their losses by selling clocks near the cost of production. This tactic failed, and Ansonia began a downward spiral in the clock industry, that resulted in heavy losses. By 1929 the majority of the timekeeping machinery, and some tools and dies, were sold to the Russian government, and exported. This purchase enabled Moscow to establish itself in the European clock market.

Following Ansonia's demise, the complex housed sweatshops until the 1970s. Since 1982, the factory buildings have undergone conversion to cooperative apartments known as *Ansonia Court*.

The Old Stone House At Gowanus

On Third Street between Fourth and Fifth Avenues, lies J.J. Byrne Park. Within its confines is a structure that played a major role in the Battle of Brooklyn, enabling the United States to achieve victory in the Revolutionary War. The building is the Vechte-Cortelyou House, better known as The Old Stone House at Gowanus, built in 1699 by Nicholas Vechte. The property was bought by the Cortelyou Family in 1790.

During the Battle of Brooklyn (the first battle of the war) which began on August 27, 1776, the British occupied the house and installed a cannon on the second floor. An elite group of Americans, known as the Maryland 400, led by General William Alexander (Lord Stirling), charged the house six times, twice clearing the house of British troops. It was due to these charges that the American troops, led by General George Washington, were able to regroup in Brooklyn Heights and Red Hook and retreat to Manhattan. When General Alexander finally surrendered (to the Hessians as to not have to submit to the British), 256 of the Maryland 400 had been killed leading General Washington to say "What brave fellows I must this day lose." A monument to their memory and bravery stands in Prospect Park.

In the latter part of the nineteenth century, the area was known as Washington Park and in 1884, The Old Stone House became the clubhouse for the Brooklyn Baseball Club, later known as The Dodgers. The original structure was torn down and buried in 1893 during the development of Park Slope.

The Brooklyn Parks Department purchased the property in 1926, and the original stones of the house were unearthed in 1930. The house was reconstructed during the years 1933-1934, using the original stones, and was used as a storage shed and a public toilet.

During the 1980s, the First Battle Revival Alliance took up the cause to preserve this unique piece of American history. After extensive renovation, the Old Stone House Interpretive Center celebrated its grand opening to the public on May 3, 1997.

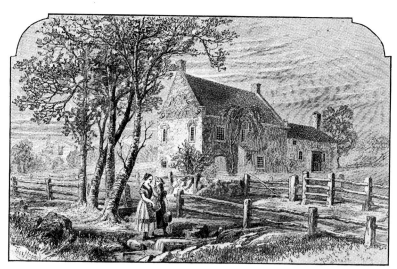

BROOKLYN EAGLE POST CARD, SERIES 64, No. 380.
THE VECHTE-CORTELYOU HOUSE AT GOWANUS IN 1699.

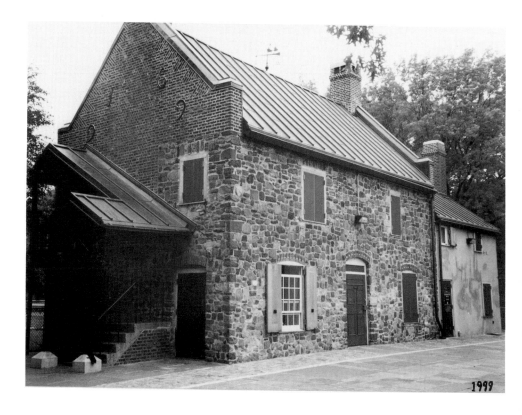

1999

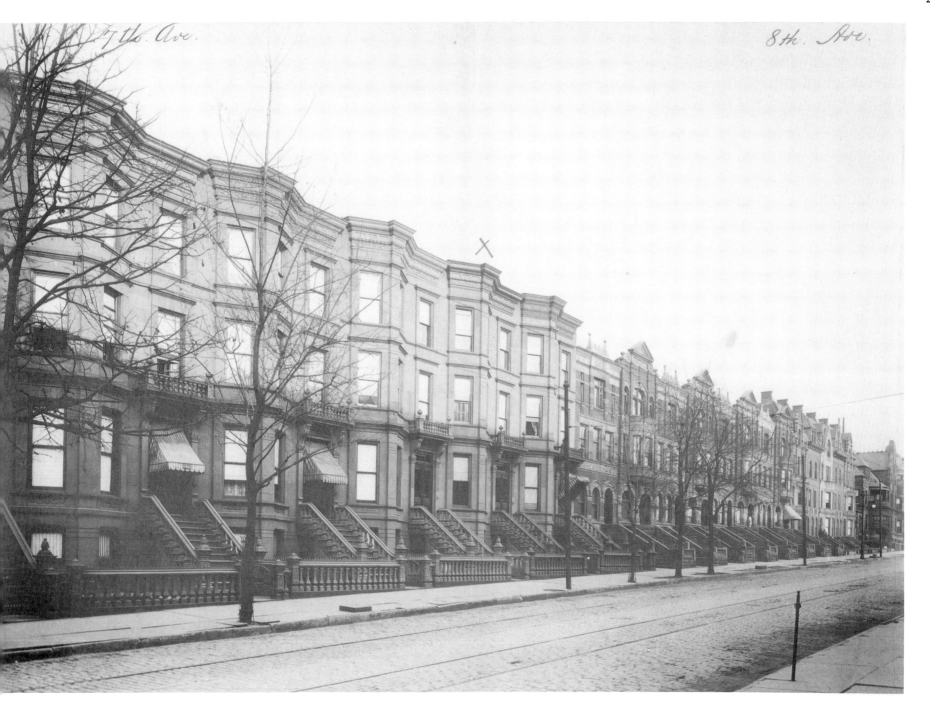

7th. Ave.

8th. Ave.

Odd Numbered Side of Union Street, between Seventh and Eighth Avenues - ca. 1905

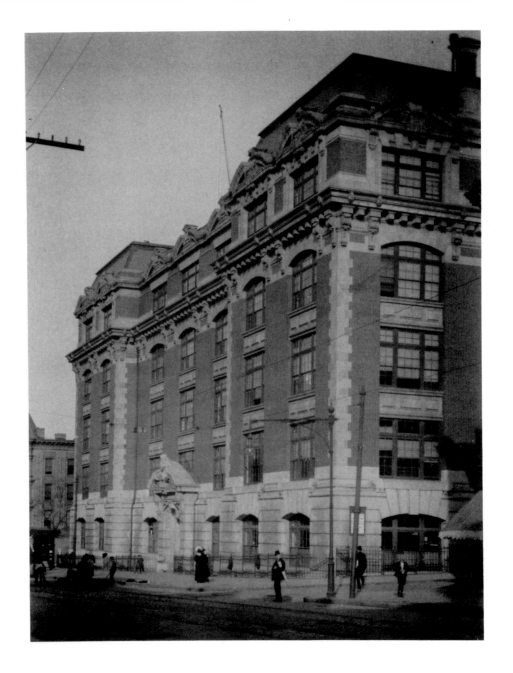

Manual Training High School - Seventh Avenue from Fourth to Fifth Streets - 1908

Designed by C.B.J. Snyder in the Modern French Renaissance Style, this school was completed in 1905 at a cost of $500,000. It could accommodate 2,500 pupils, and contained chemical and physical laboratories, forge and machine shops, printing and bookbinding rooms, a sewing room, and a bicycle room. The first principal here was Charles D. Larkins. The building is now John Jay High School.

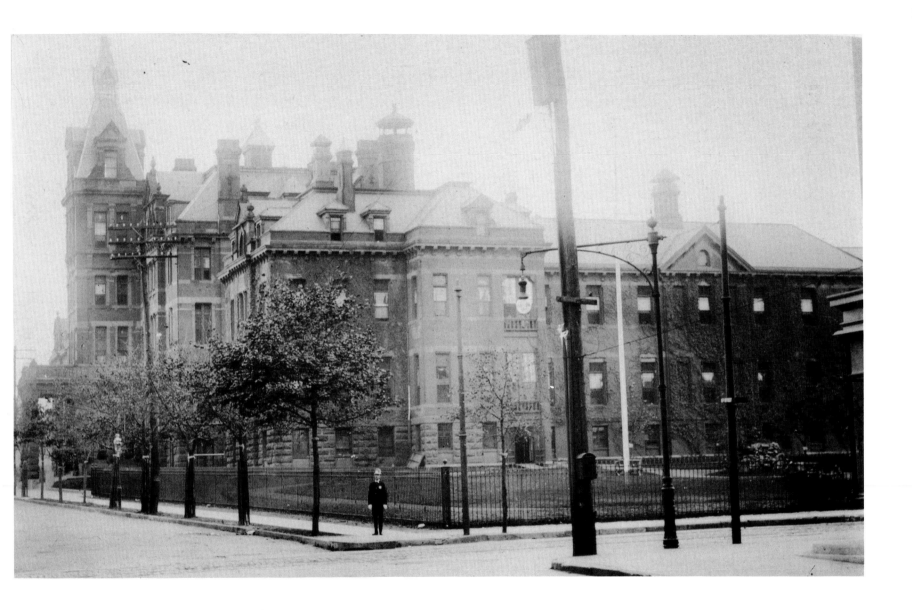

Methodist Episcopal Hospital - Looking south from Sixth Street, across Seventh Avenue - 1908

In 1881, George Ingraham Seney, an officer of the Metropolitan Bank, donated $200,000 to establish this hospital. In September, the cornerstone for the main building was laid. By 1883, Seney had contributed an additional $200,000 to the hospital, which would soon bear his name. When the hospital opened in December 1887, nearly two-thirds of all its cases were surgical. The hospital built its own electric plant in 1900. The original Romanesque-style building was demolished in the 1930s. In 1994, the hospital became the New York Methodist Hospital and continues to serve the community today. Joshua Merlis, son of the author, was born there in 1987.

26

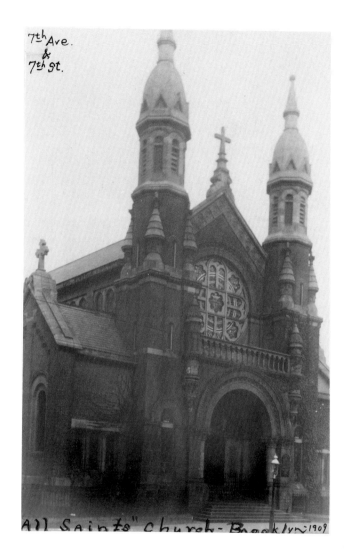

7th Ave.
&
7th St.

All Saints" Church - Brooklyn 1909

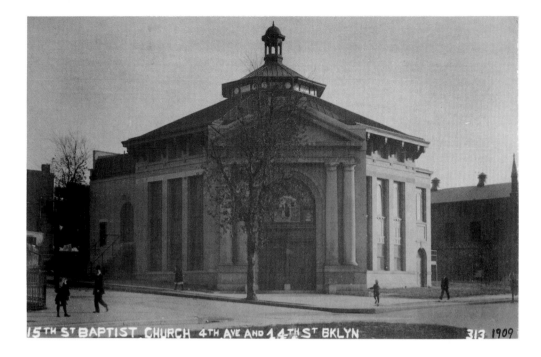

15th St Baptist Church 4th Ave and 14th St Bklyn 313 1909

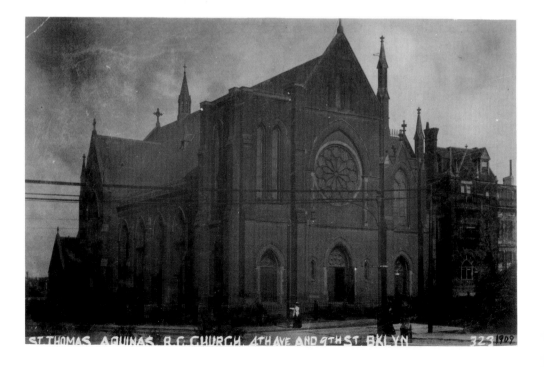

St Thomas Aquinas R C Church 4th Ave and 9th St Bklyn 323 1909

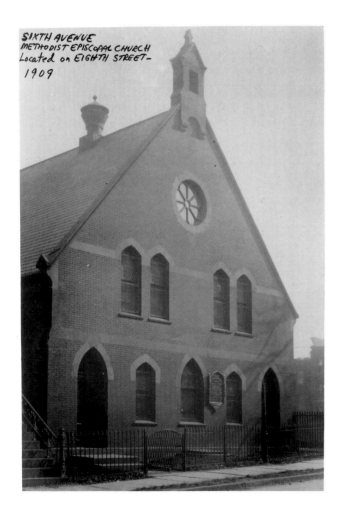

SIXTH AVENUE
METHODIST EPISCOPAL CHURCH
Located on EIGHTH STREET—
1909

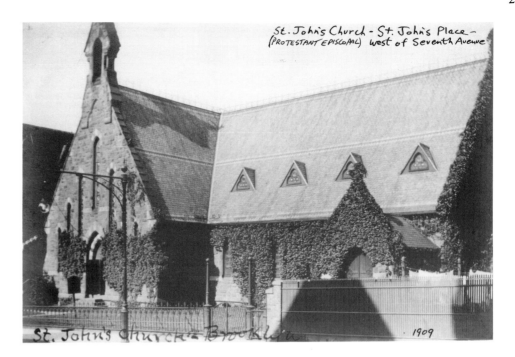

St. John's Church - St. John's Place -
(PROTESTANT EPISCOPAL) West of Seventh Avenue

St. John's Church - Brooklyn 1909

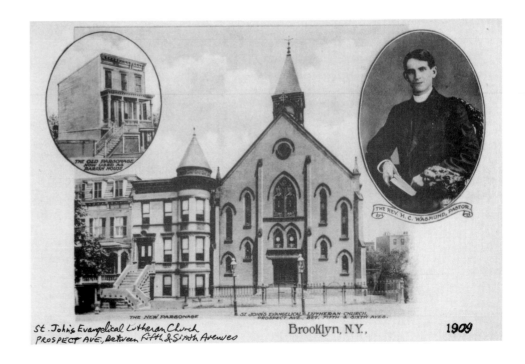

THE OLD PARSONAGE
NOW USED AS
PARISH HOUSE

THE REV. H. C. WASMUND, PASTOR.

THE NEW PARSONAGE

ST. JOHN'S EVANGELICAL LUTHERAN CHURCH
PROSPECT AVE., BET. FIFTH & SIXTH AVES.

St. John's Evangelical Lutheran Church
PROSPECT AVE., Between Fifth & Sixth Avenues Brooklyn, N.Y. 1909

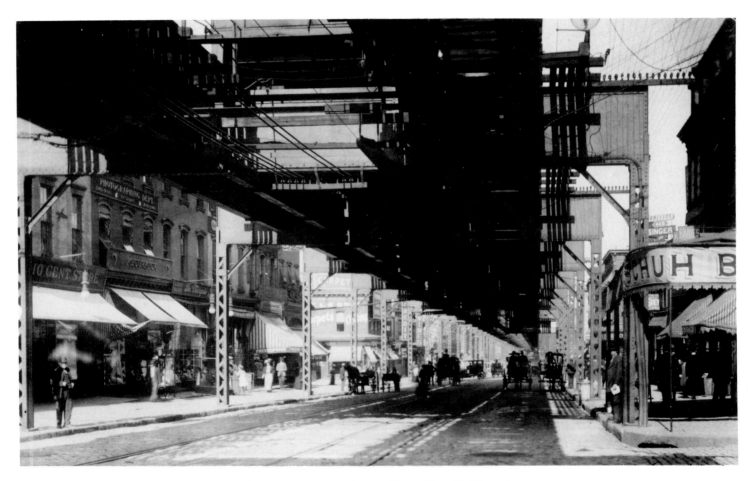

Fifth Avenue, northeast from Tenth Street
1909
Schuh Bros. grocery at the far right (No. 459) and McCormick's store on the left (No. 458).

"Hosch's Corner" - Fifth Avenue & Twentieth Street - 1909

Founded in 1884, M. Hosch was the area's leading gents' furnisher. To the right, a cigar store displays post cards for sale and a cigar-store Indian.

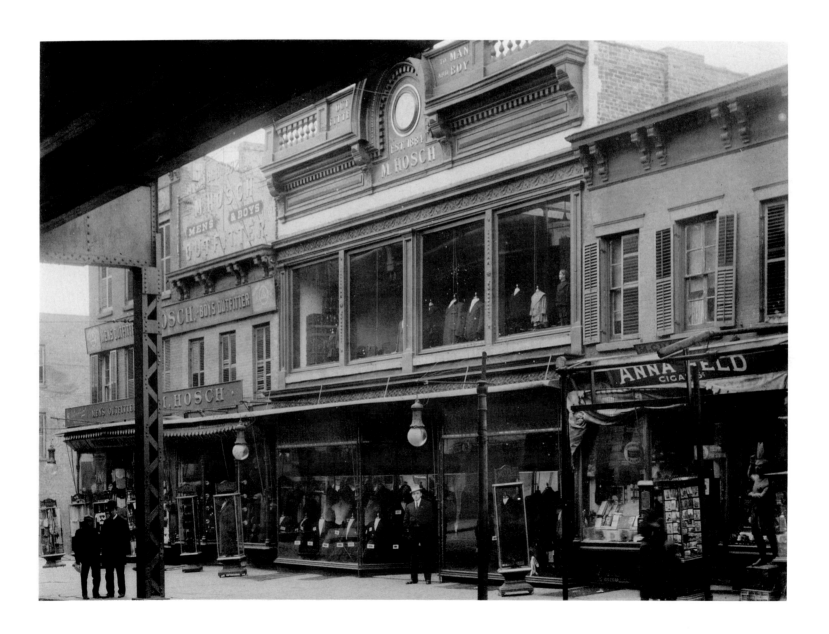

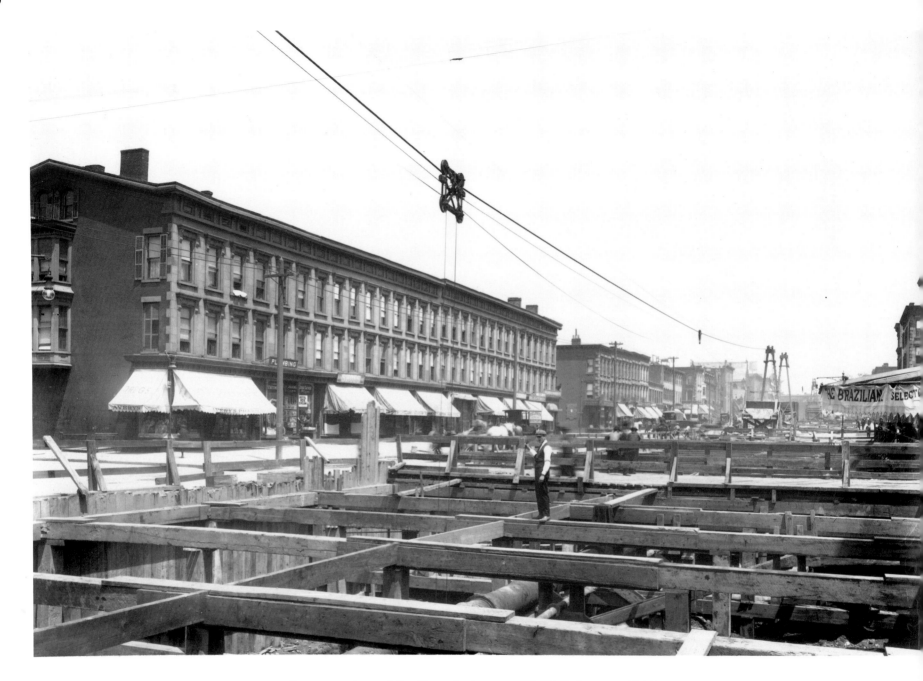

Construction of the Fourth Avenue BMT Subway - 1910

View looking southwest at St. Marks Place. The subway from Bay Ridge to Sixth Avenue, Manhattan caused land values along the Fourth Avenue corridor to increase.

M. K. Povlsen's Apothecary, No. 541 Ninth St. - 1910

This *Deutsche apotheke* (German pharmacy) was located at Seventh Avenue. Italian asphalt workers are taking their lunch break. A pizzeria currently occupies this store, which during the 1940s housed Hanscom's Bakery.

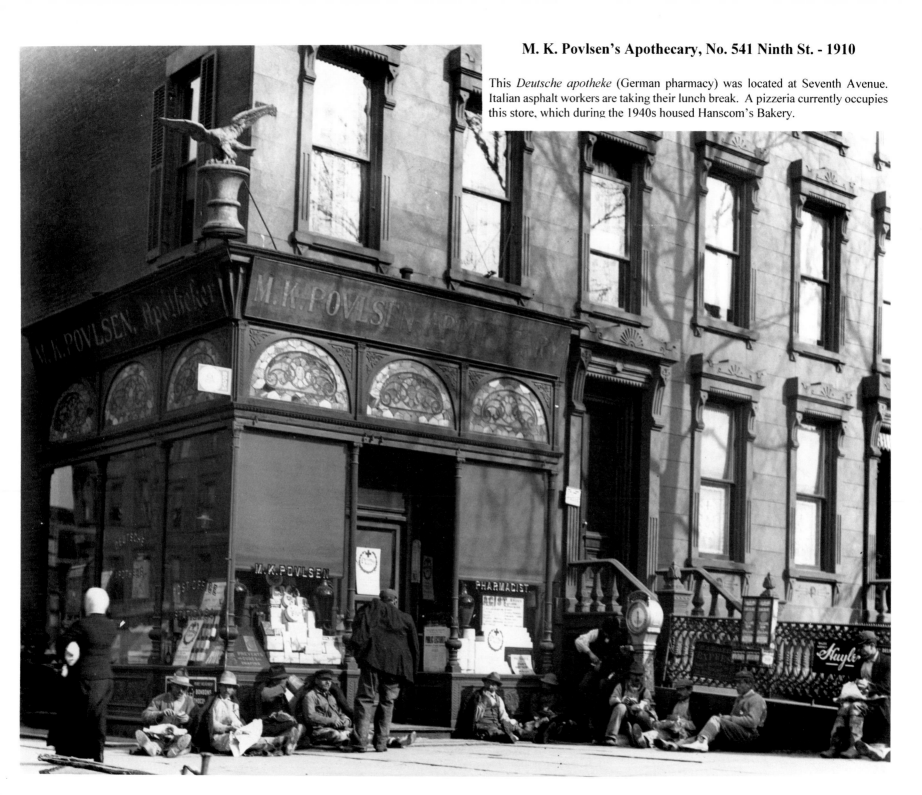

Fourth Avenue, northeast at Tenth Street - 1910

The row of wood-frame houses were built about 1875. Most of them were demolished in 1929 when construction of the Sixth Avenue BMT line began.

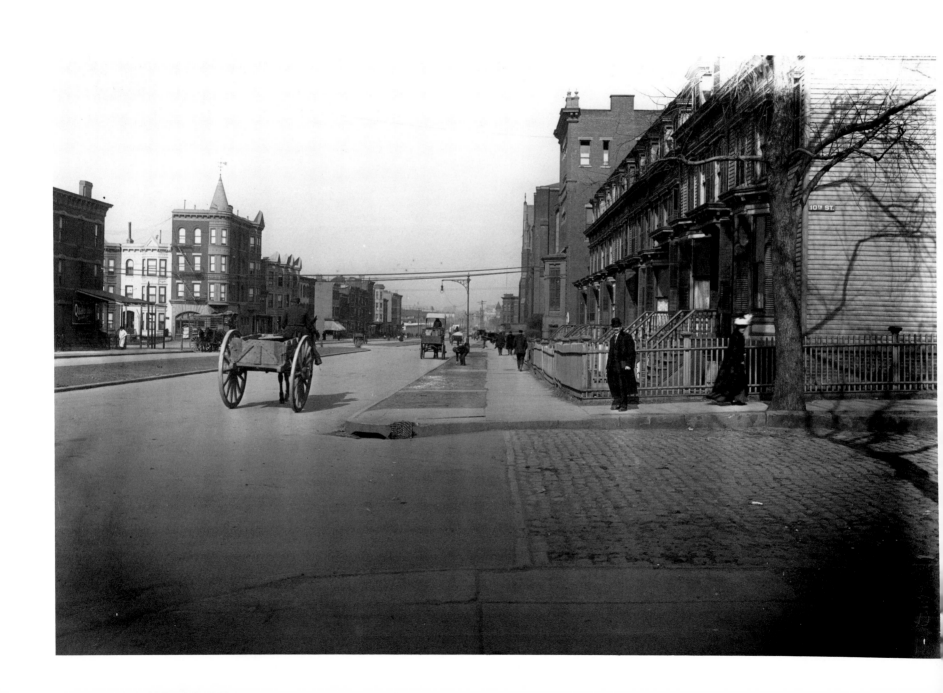

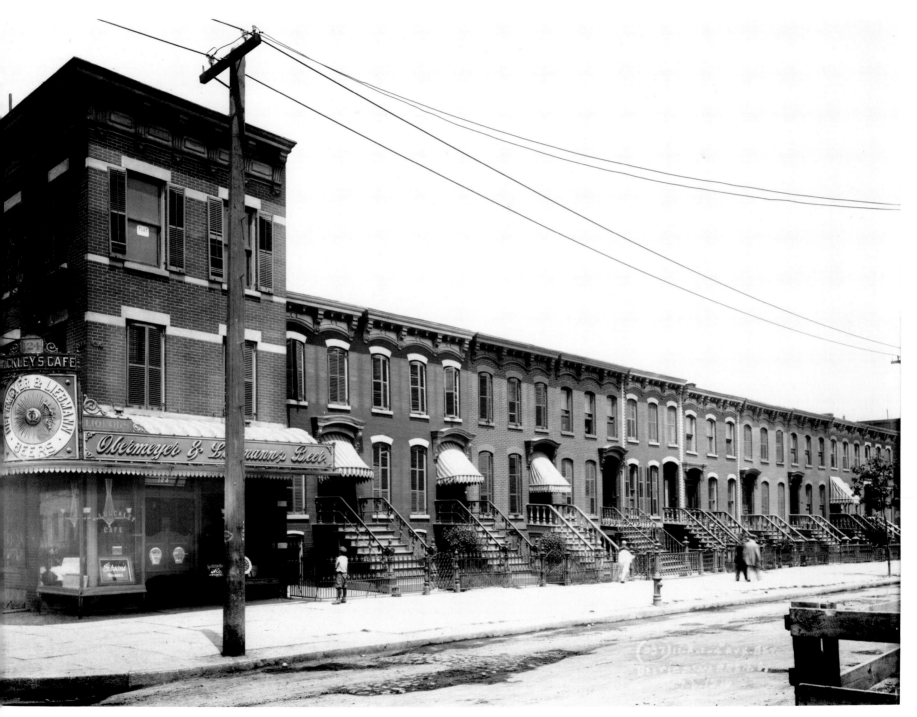

Buckley's Café - No. 124 Fourth Avenue, corner Baltic Street - 1910

The row of attached brick houses, which extended to Warren Street, was constructed during the 1870s.

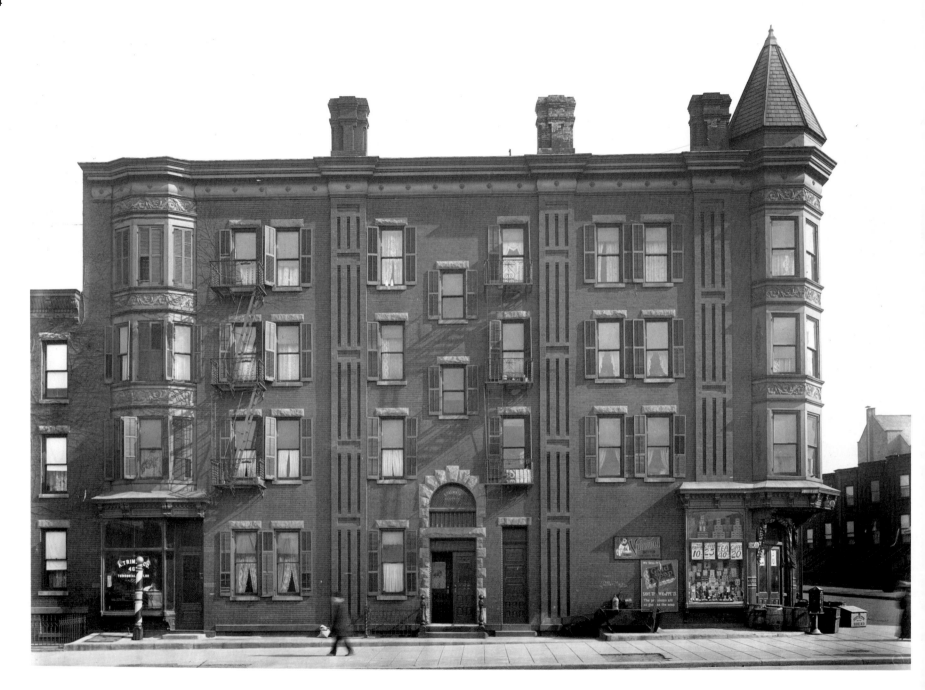

Columbia Apartments; No. 463 Fourth Avenue, northeast corner of Eleventh Street - 1910

This late-nineteenth-century shuttered building housed a corner grocery and a barber shop.

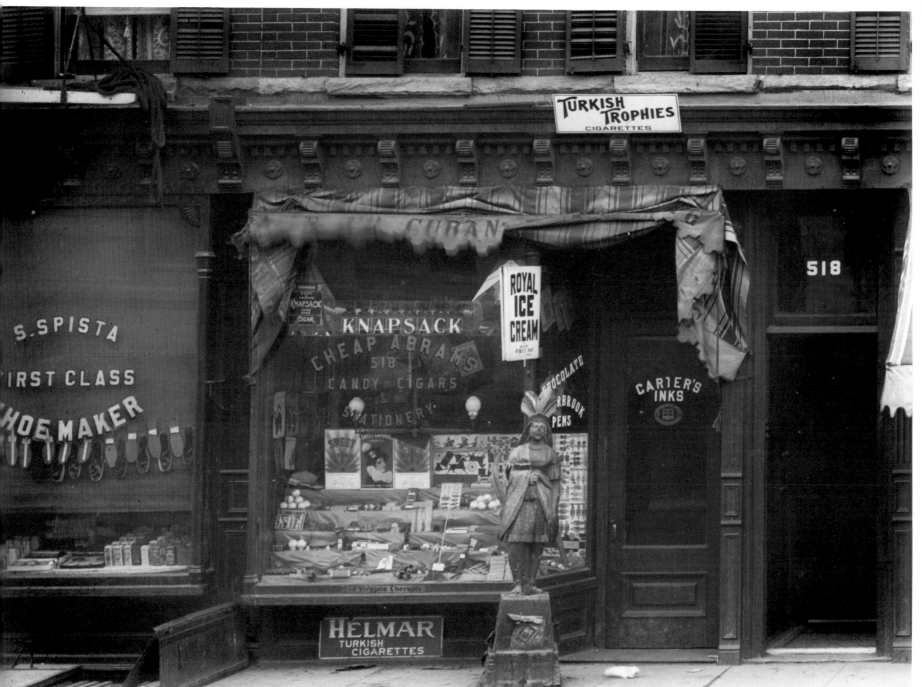

Cheap Abrams Candy & Cigar Store at No. 518 Fourth Avenue - 1910

A cigar-store Indian greets patrons on the sidewalk. Abrams also sold stationery, including Carter's inks and Estabrook pens. Another branch of *Cheap Abrams* may be seen on p. 125 of *Brooklyn The Centennial Edition.*

Prospect Hall, No. 263 Prospect Avenue - 1910

This structure was built in the 1890s. It was once used as a German opera house, and featured an outdoor beer garden. After 1900, a silent-movie theatre was established in the building. During Prohibition, several socials and dances were held here every week. Having undergone extensive restoration, Grand Prospect Hall has become one of Brooklyn's finest catering establishments, with a ballroom that can accommodate up to 2,000 guests.

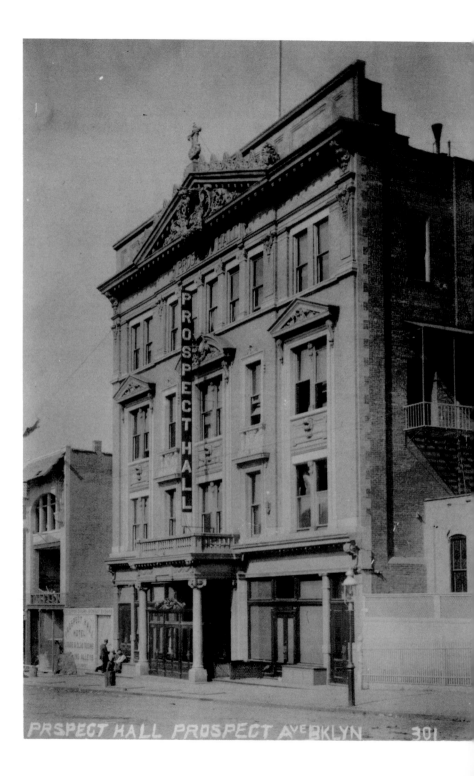

ENRIQUE

DURAN

AND HIS

S A N T O

D O M I N G O

SERENADERS

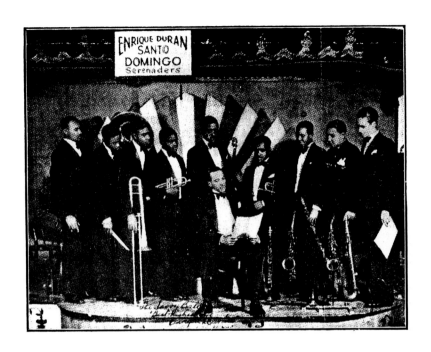

SAVOY

B A L L R O O M

C O T T O N

C L U B

W M C A

W R N Y

PROSPECT "MAIN" HALL

Prospect & Fifth Avenues, Brooklyn, N. Y.

SAT. EVE'G. OCT. 17, 1931

Two Sensational Orchestras

-: *Continuous Dancing* :-

Subscription

GENTLEMEN ONE DOLLAR

LADIES 50 CENTS

Shore Road Press — 9104 - Fourth Avenue, Brooklyn, N. Y.

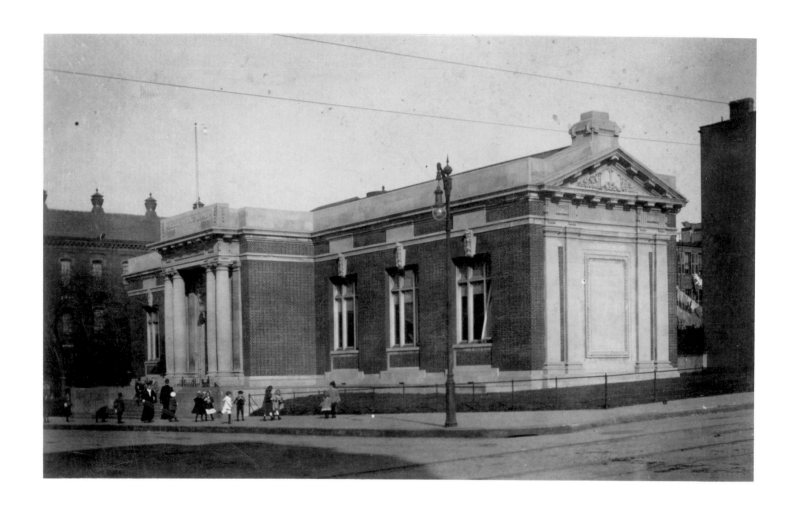

Park Slope Branch - Brooklyn Public Library - No. 431 Sixth Avenue, corner Ninth Street - 1910

Designed by Raymond Almirall, this Carnegie-funded building opened in 1906. (It replaced the storefront library located at No. 372 Ninth Street, then known as the "Prospect Branch.") Two tiled fireplaces and a vaulted stained glass ceiling accentuate this building's interior.

Fourth Avenue, northeast to Thirteenth Street - 1910

Students from P.S. 124, across Fourth Avenue, pose for the photographer.

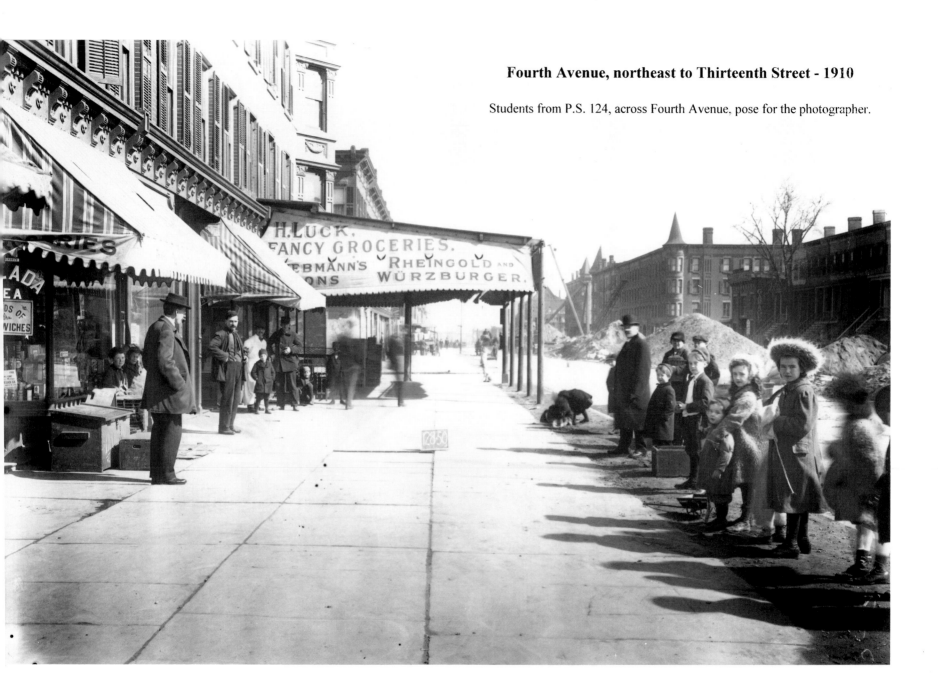

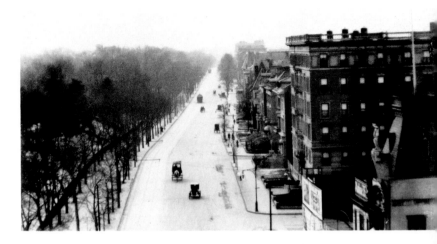

Harvey C. Randall of No. 448 Ninth Street - ca. 1910

Mr. Randall (ca. 1817-1912) was 93 years old when a neighbor, Dr. Ralph I. Lloyd photographed him in front of his residence. You're looking northwest, toward Seventh Avenue.

Prospect Park West, southwest from Grand Army Plaza - 1910

This photograph was taken from the top of the Arch. The mansard roof of the Plaza Hotel is at the lower right. The six-story Hampton Apartments are just past President Street. Once known as the *Gold Coast*, this residential strip is still one of Brooklyn's finest, boasting spacious apartments and luxurious townhouses.

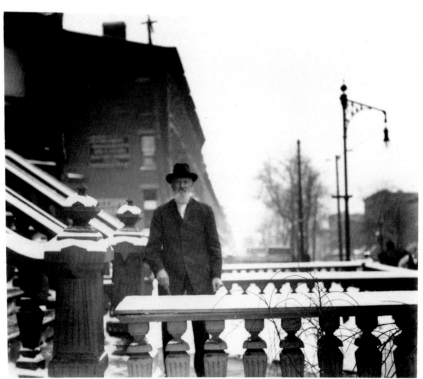

Nos. 231-239 Fourth Avenue, corner of President Street - 1910

Scalzo's paint and hardware store served this section of South Brooklyn. Horses got their meals next door.

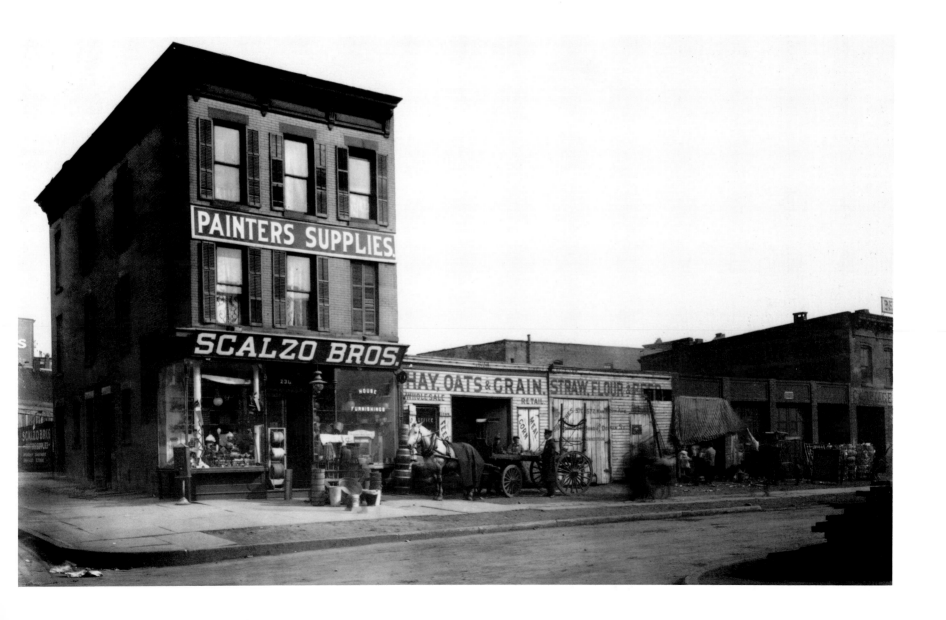

P.J. Connolly's Subway Café - northeast corner of Fourth Avenue & Seventh Street - 1911

Empty kegs of beer stand on the corner to be picked up. Many businesses along Fourth Avenue were named for the subway, which was then under construction. A good lunch of beef stew could be purchased for a dime, and washed down with a nickel's worth of Gambrinus beer.

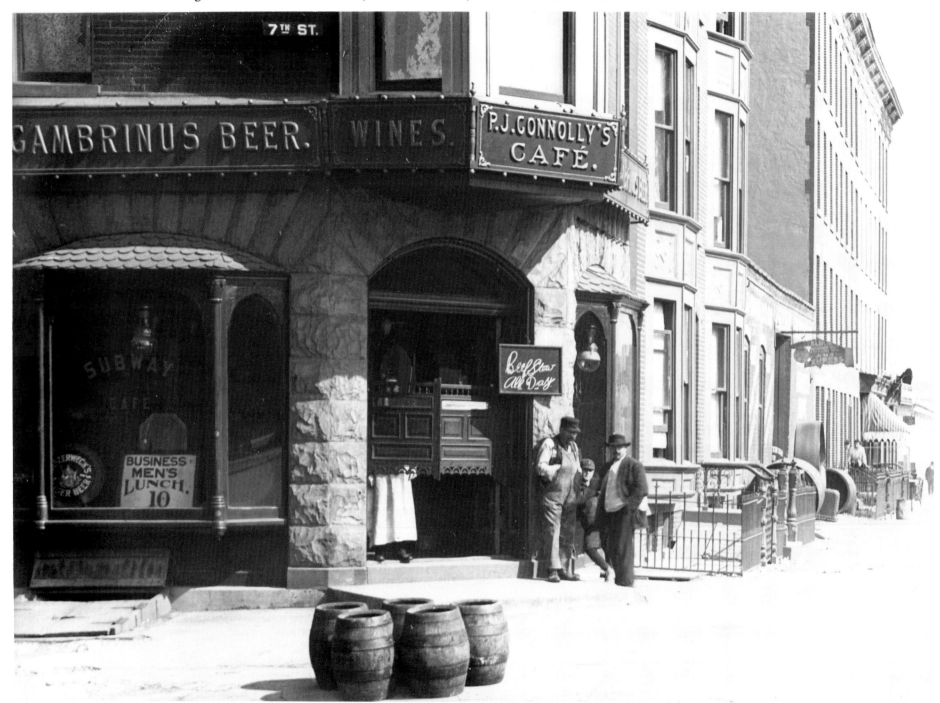

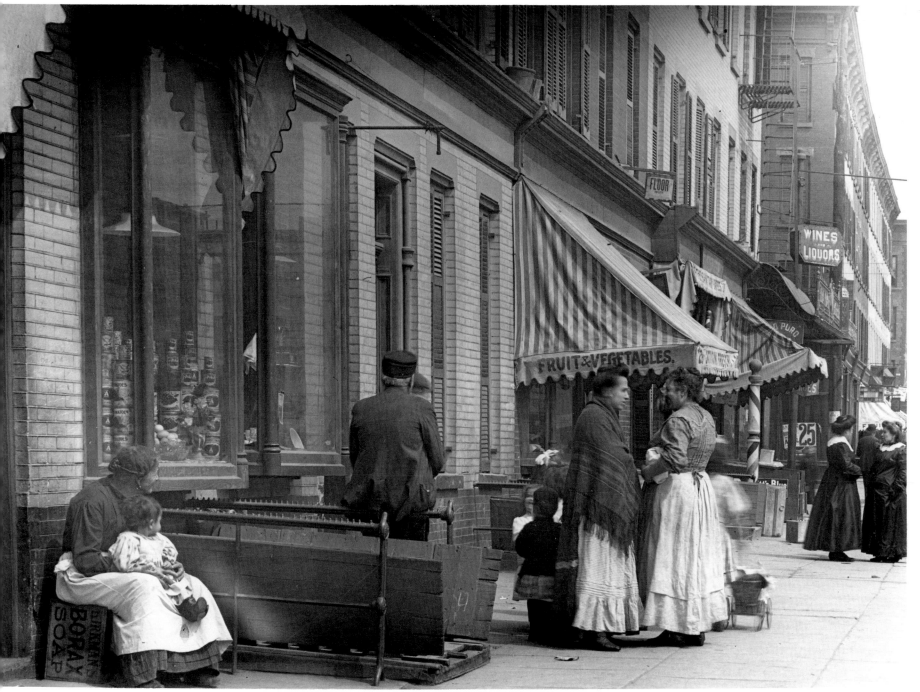

Fourth Avenue, northeast to Union Street - 1911

Recent arrivals from Italy, wearing their provincial garments, interact on the avenue.

Fourth Avenue & Baltic Street, looking south - 1911

Neighborhood residents watch a four-horse team pull a large pipe. The heavy weight of the load caused the wooden wheels to sink in the mud. Leonard Schwortzreich's dress factory was located at No. 119 Fourth Avenue.

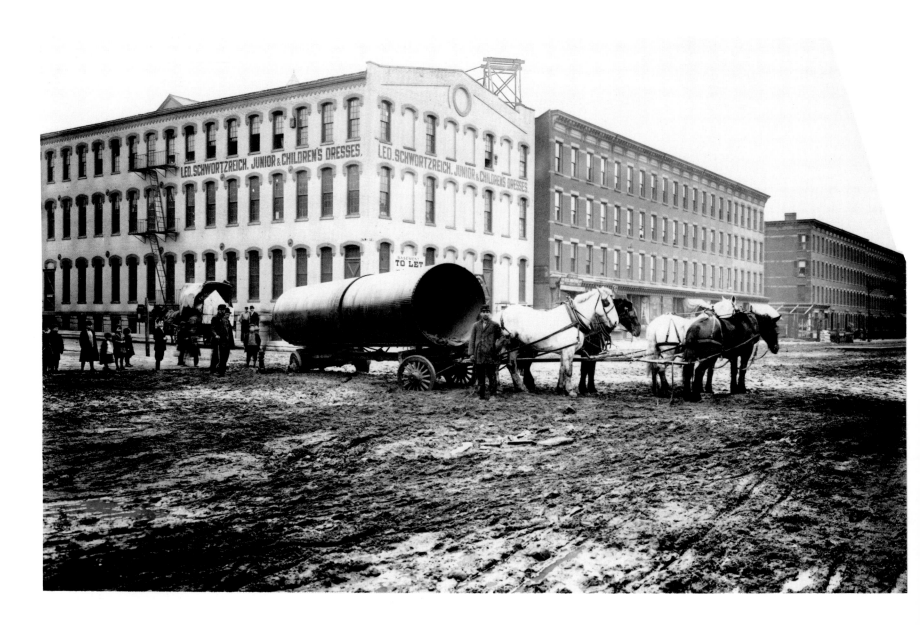

ca. 1897 BROOKLYN DAILY EAGLE

BASE BALL GOSSIP.

More About New Grounds—Ebbets Replies to the Cranks.

Local base ball circles were stirred up to a considerable degree by the story in Wednesday's Eagle relating to the two offers of sites for new grounds for the Brooklyn Club. It was strong evidence that the management is hard at work trying to meet the popular demand for removal from Eastern Park, and the cranks were pleased accordingly. Of course, nothing definite has been done as yet so far as accepting either proposition is concerned, but it does not require a stretch of imagination to state that Mr. Leary's offer will probably not be accepted. President Ebbets holds that the location of a base ball park in any section of the city causes an increase of business and a boom in real estate in the immediate vicinity, and that those benefited should offer some inducements. The building of stands and fences is a more difficult undertaking than the mere rental, as the former is an immediate necessity and entails considerable expense, while the latter requires only a nominal sum at the beginning of the playing season. Mr. Leary has built an athletic field across the river, where land for such purposes is difficult to secure, and he apparently estimates the value of a site in the borough of Brooklyn, where there is room for dozens of such inclosures, from the standpoint of Berkeley Oval. The latter, it is said, rents for $15,000; but no such price can be secured here.

Of course, it is not certain that the offer of the Consumers' Park Company will be accepted, although the general sentiment is that the proposition is exceedingly generous. The location of the proposed park, although described at length, mystified a number of cranks residing in distant parts of the city, and a search for maps of the locality resulted. When the site was finally traced the cranks agreed that it was fairly easy of access to all sections and that nearly every surface road had lines passing within a radius of half a dozen blocks.

Of the four remaining propositions which Mr. Ebbets has under consideration two are in South Brooklyn. Old Washington Park on Fifth avenue has been advanced as a possible site, but this is practically out of the question, as it is half filled in and would probably take many months to place in proper shape for playing purposes. The Litchfield property, bounded by Third and Fourth avenues, First and Third streets, is adaptable for a fine base ball park and would probably be secured if the railroad companies offered suitable inducements.

According to the cranks, any place is preferable to Eastern Park.

Entrance to Washington Park Baseball Grounds - 1911
Northwest corner of Fourth Avenue and Third Street

This stadium, the second on this site, was home to the Brooklyn Dodgers from 1898 through 1912. Its seating capacity was about 16,000. When the Dodgers moved to Ebbets Field in 1913, The Brooklyn Tip-Tops, owned by the Ward Baking Company, played at Washington Park as a member of the Federal League. Although the stadium was demolished in 1926, its 20-foot-high left field brick wall still stands along Third Avenue. The wall is the oldest surviving section of any baseball stadium. It is currently used by the Consolidated Edison Company, which has occupied the site for over 70 years.

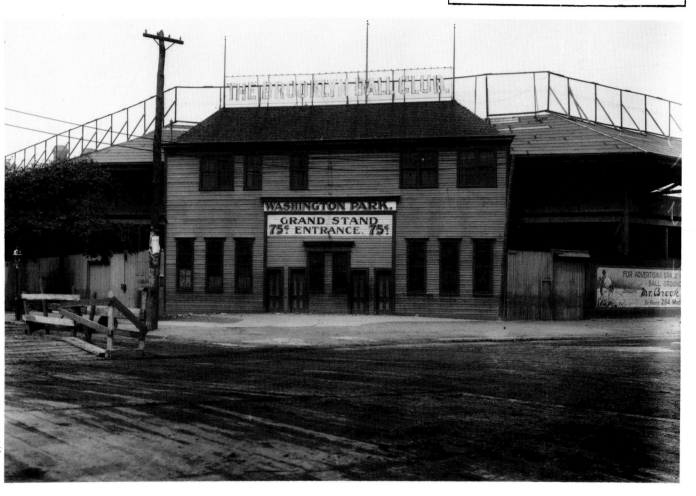

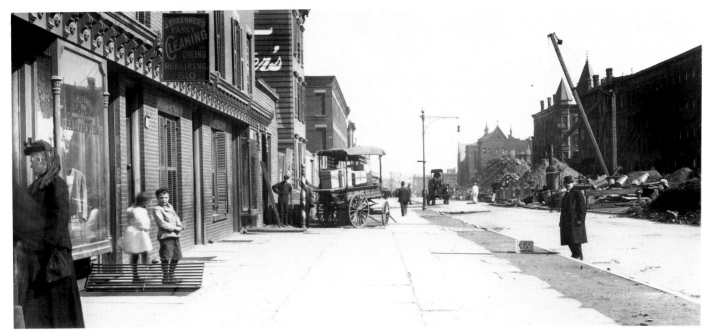

Fourth Avenue, northeast to Twelfth Street - 1911

The woman at the far left is about to enter J. Greenberg's cleaning and dyeing shop at No. 510. The Fourth Avenue subway construction project is going on to the right.

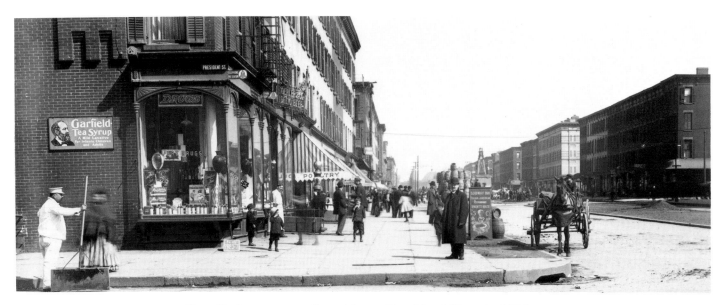

Fourth Avenue, northeast from President Street - 1911

The corner pharmacy occupies No. 236. Note the street cleaner dressed in white at the far left. The sign to the left of the horse advertises the *"Subway Inn"*, which was actually a *spaghetti house*.

Acme Hall - Built by C. Nickenig in 1890, this ornate Romanesque-style structure "furnished South Brooklyn with a suitable place of amusement." It boasted an excellent restaurant and café. The buff-brick building, trimmed with Amherst stone, boasted a 15-foot-high tower topped with a flagpole whose flag bore the hall's name. The main entrance to Acme Hall was on Ninth Street. There were bowling alleys in the basement, and a billiard parlor on the second floor. It served as social center where political and fraternal organizations met. It was bought in 1945 by restaurateur Ernest F. Felzmann for about $100,000. It was rebuilt in the early 1980s by developer Howard Pronsky, and in 1986 underwent a $750,000 restoration. The *Old-House Journal* became a tenant there in 1989.

Acme Hall, Seventh Avenue & Ninth Street - ca. 1912

A brave man poses while replacing the gilded eagle atop the Acme flagpole.

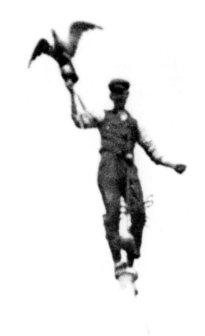

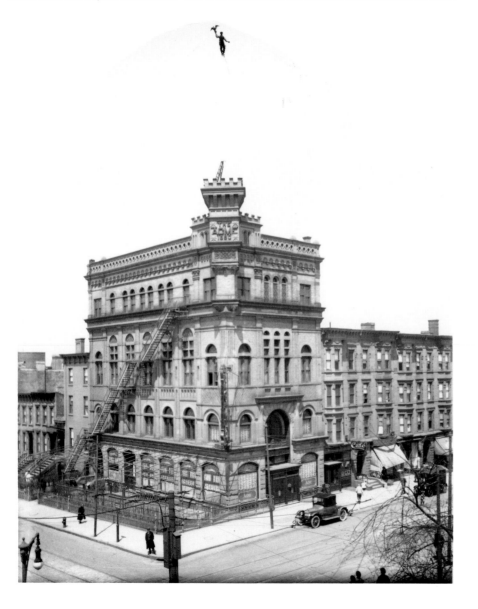

THE ACME
CAFE and RESTAURANT
FOR
LADIES and GENTLEMEN

QUALITY — SERVICE — CLEANLINESS — MUSIC

LUNCHEON & DINNER A LA CARTE
Catering to Theatre Parties
a Specialty

1919

Nos. 204-210 Fourth Avenue, corner of Sackett Street - 1912

Giugliano's Law Office, Cona's Bar, and the Italian-American printing company (*stamperia*) line the avenue. On the corner is the Subway Pool Parlor, run by Mancaruso and Carfano. A strong Italian influence still exists in South Brooklyn today.

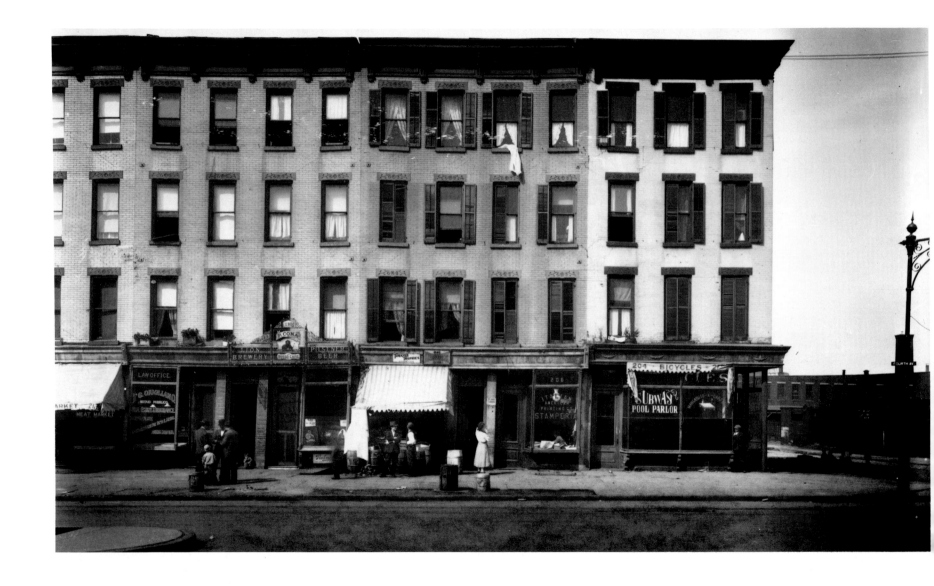

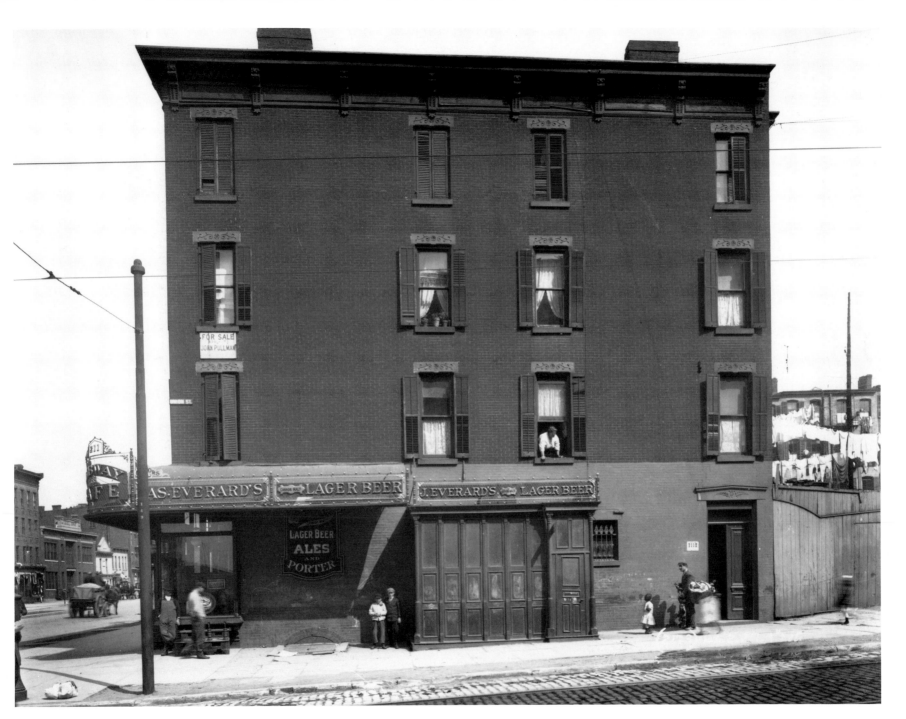

Looking northeast across Union Street to No. 211 Fourth Avenue - 1912

James Everard's Subway Café occupied this corner store. During Prohibition, it became a branch of the Bank of America. Note the porcelain "Union Street" sign on the corner of the building and the clotheslines to the far right.

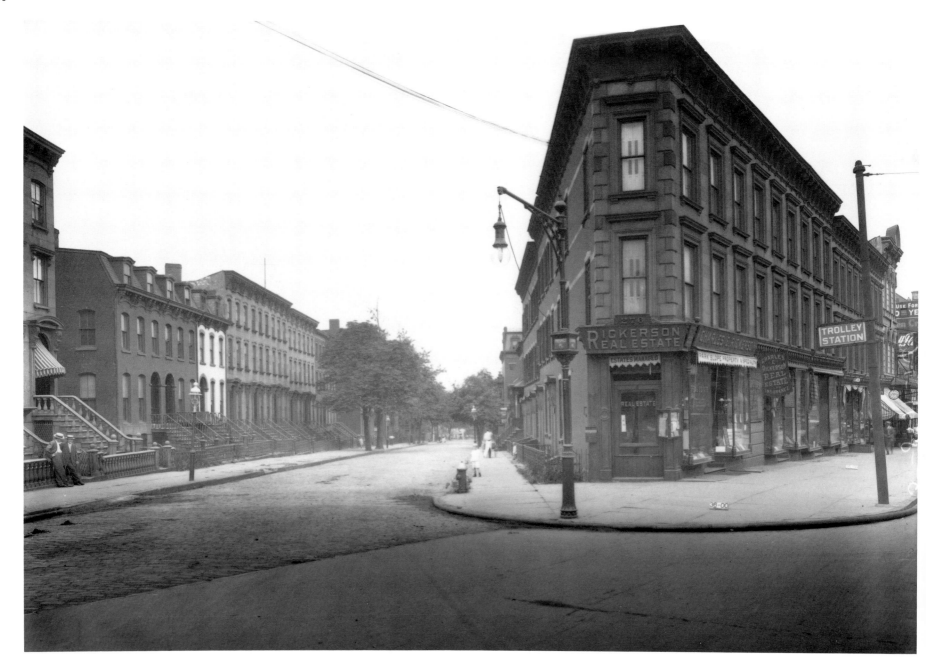

Prospect Place, northwest from Flatbush Avenue - 1914

Charles E. Rickerson, located at No. 276 Flatbush Avenue, specialized in Park Slope property. (Detail at right.)

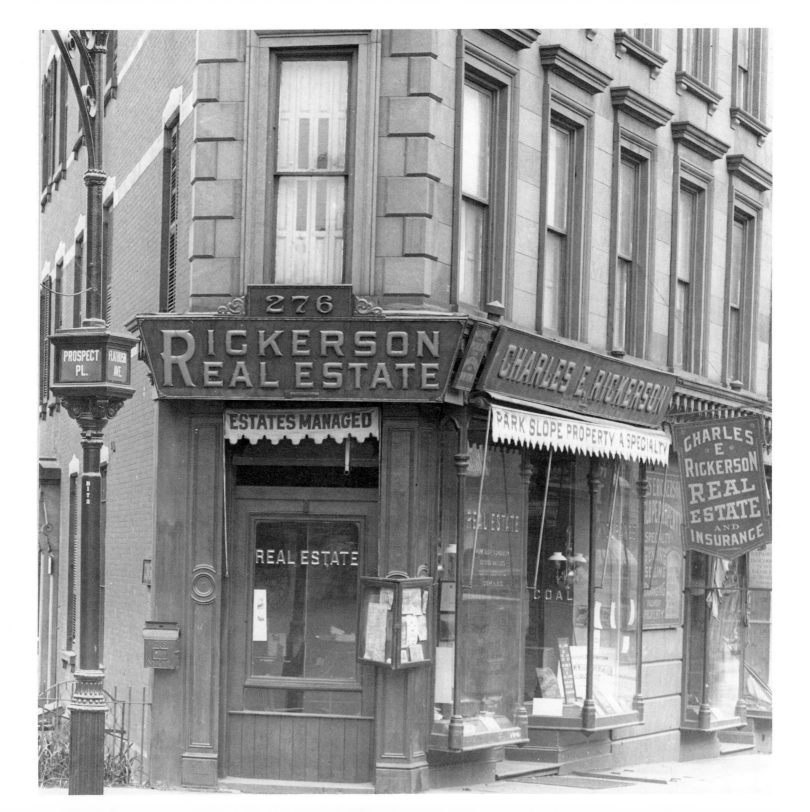

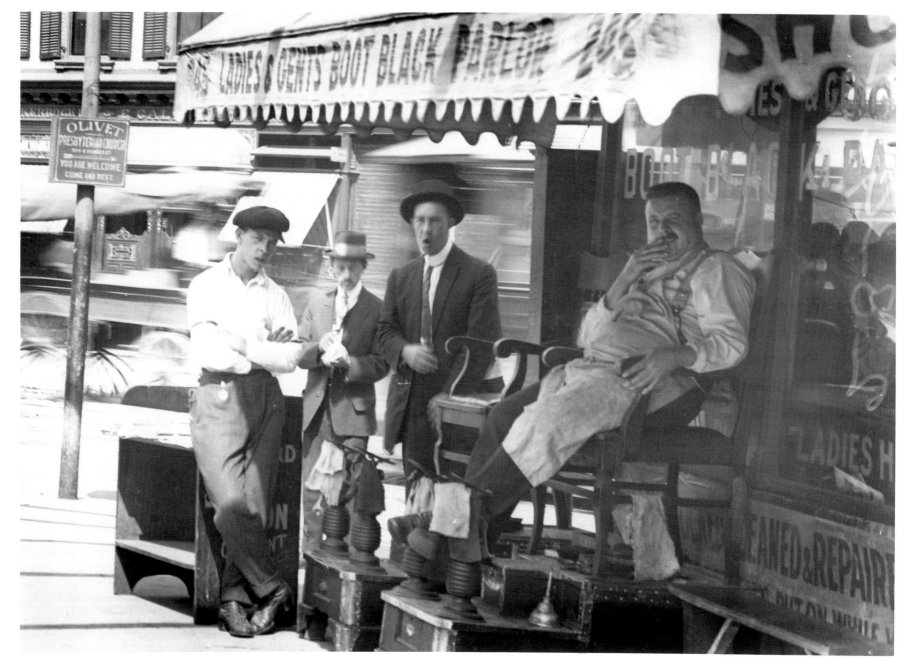

Bootblack Parlor at No. 245 Flatbush Avenue - 1914

This establishment was located at the north end of the triangular building, south of Bergen Street. The sign at the left reminds passers by that the Olivet Presbyterian Church is just up Bergen Street.

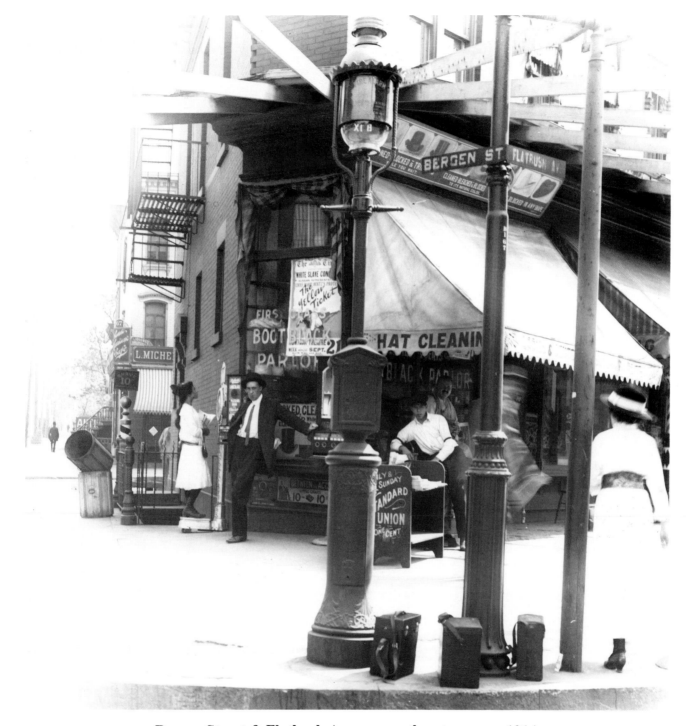

Bergen Street & Flatbush Avenue, southeast corner - 1914

Another angle of the bootblack parlor. A schoolgirl weighs herself on Bergen Street. Wood slats were often installed to support canvas awnings which blocked the sunlight. The cases in the foreground belonged to the photographer.

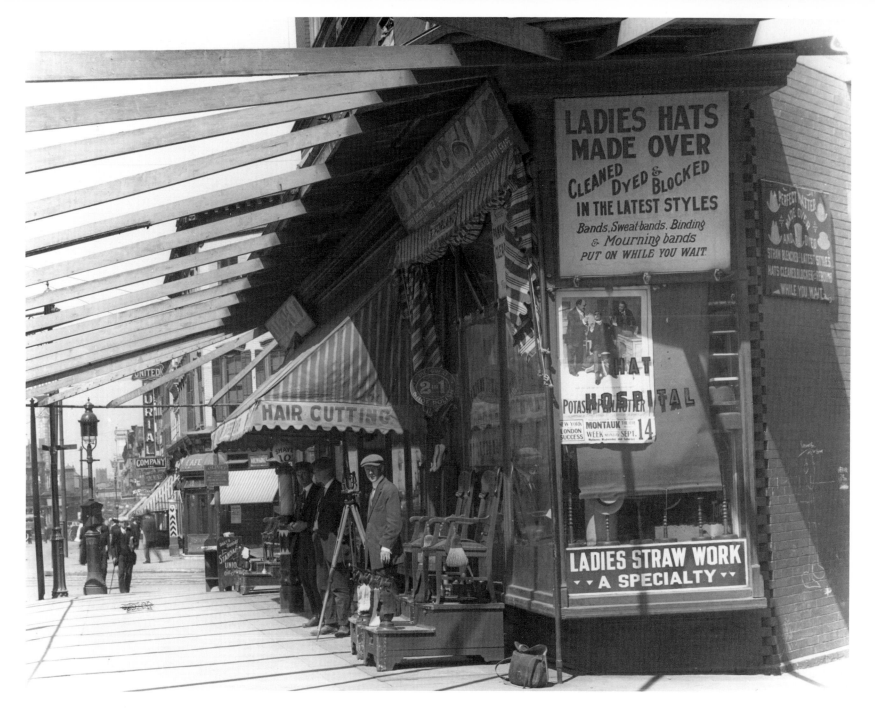

Northeast corner of Flatbush & Sixth Avenues - 1914

The triangular building bounded by Flatbush and Sixth Avenues and Dean Street still stands. A hat hospital occupied the southernmost store in 1914. A surveyor poses next to an unoccupied bootblack stand. A poster advertising *Potash Perlmutter*, which was then playing at the nearby Montauk Theatre, hangs in the window.

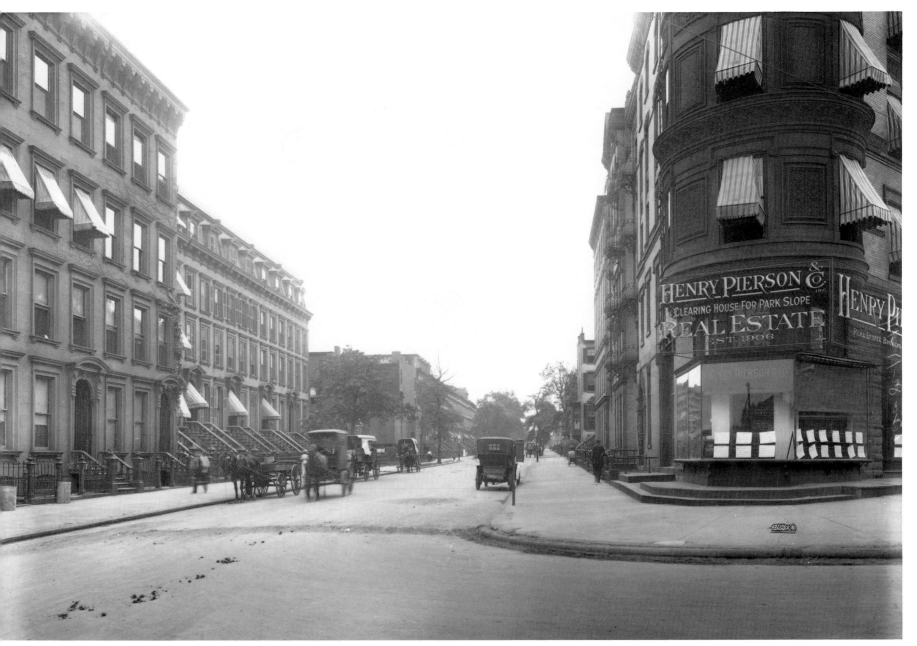

Prospect Place, east from Flatbush Avenue - 1914

Bordering the Prospect Heights section, Henry Pierson established his clearing house for Park Slope real estate in 1906. As is the practice today, listings are posted on the window. At this time, typical brownstones cost between eight and twelve thousand dollars.

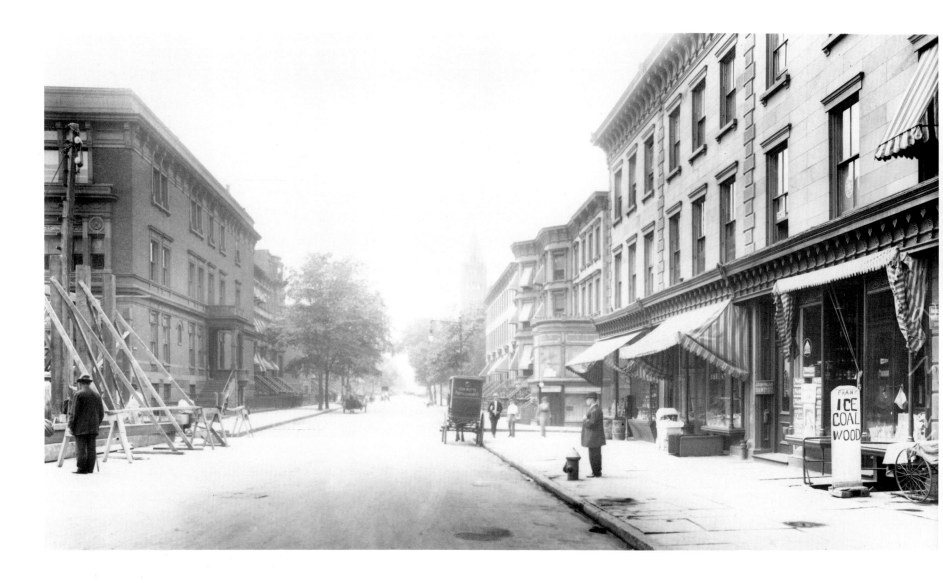

Sixth Avenue, south from Flatbush Avenue - 1914

The tower of St. Augustine's church at Sterling Place is visible, and still stands today. The building at left, was the Carleton Club House at the turn of the century.

Intersection of Flatbush, Sixth and St. Marks Avenues - 1914

This ornate equestrian fountain was presented to the City of Brooklyn by John Hooper in 1896. The buildings behind the monument are Nos. 80, 78, and 76 Sixth Avenue.

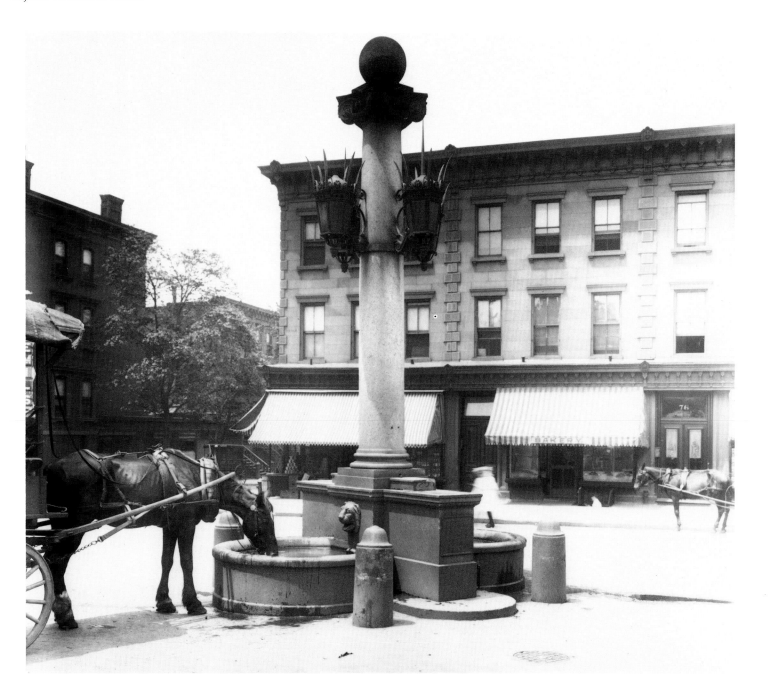

Flatbush & Sixth Avenues, northwest corner - 1914

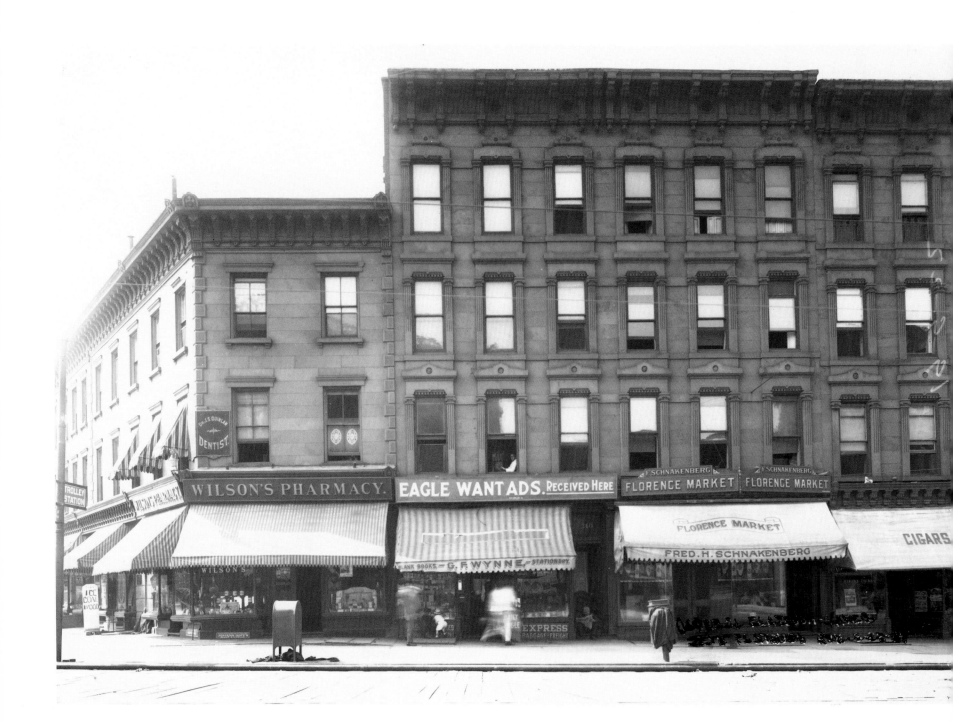

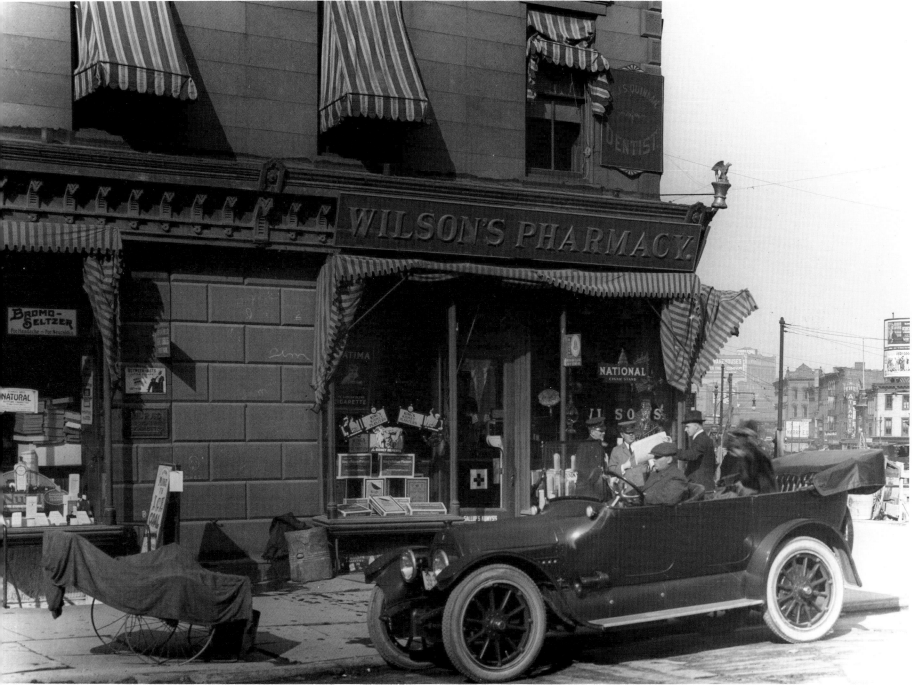

Wilson's Pharmacy - northwest corner of Sixth & Flatbush Avenues - 1914

A policeman and a trolley company employee study a document held by a gentleman. J.S. Quinlan practiced dentistry upstairs. Note the graffiti on the wall. Bromo-Seltzer is advertised in the far left window.

Flatbush Avenue & Dean Street, looking north - 1914

A northbound train turns onto Flatbush Avenue. For well over 50 years, Triangle Sporting Goods occupied the building in the center of the picture.

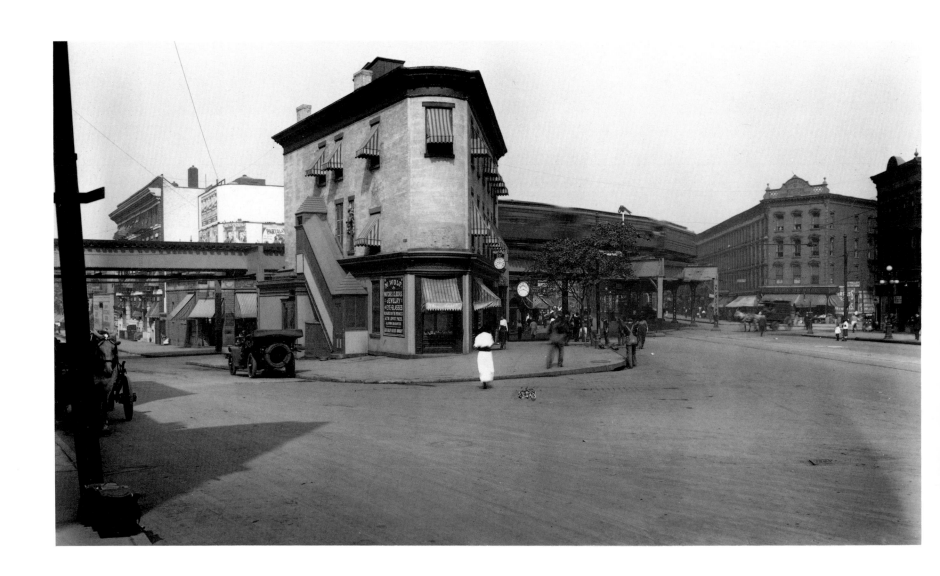

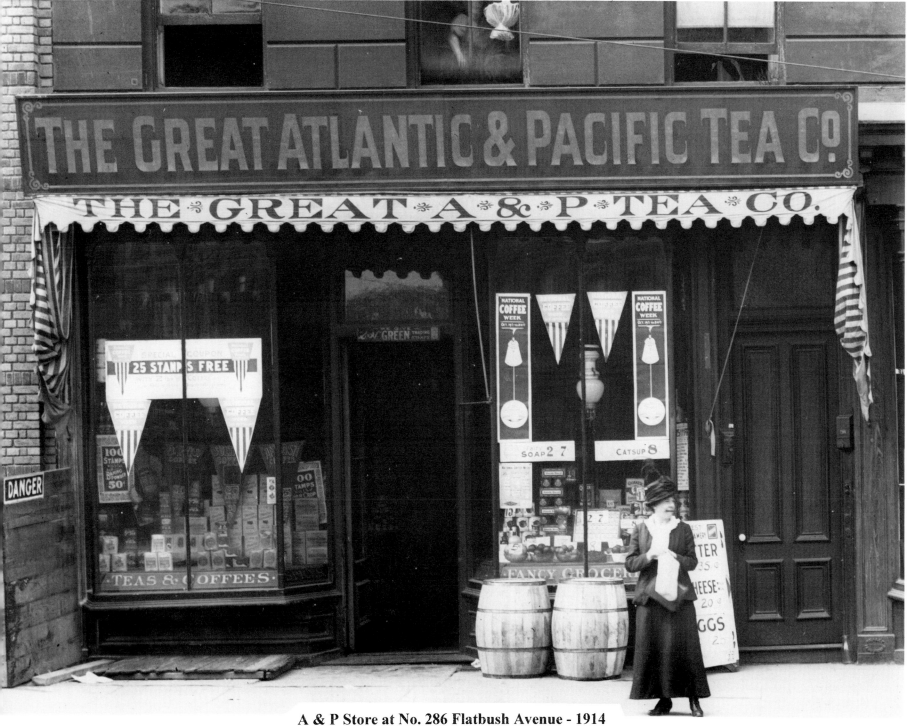

A & P Store at No. 286 Flatbush Avenue - 1914

This venerable grocery chain boasted a dozen Brooklyn locations in 1914. Note the woman upstairs cleaning her windows.

Flatbush Avenue, north from Seventh Avenue - 1914

Postal substation 86 was on the northwest corner of the intersection. Glass street signs were illuminated at night by a gas flame. A woman awaits the southbound Flatbush Avenue trolley.

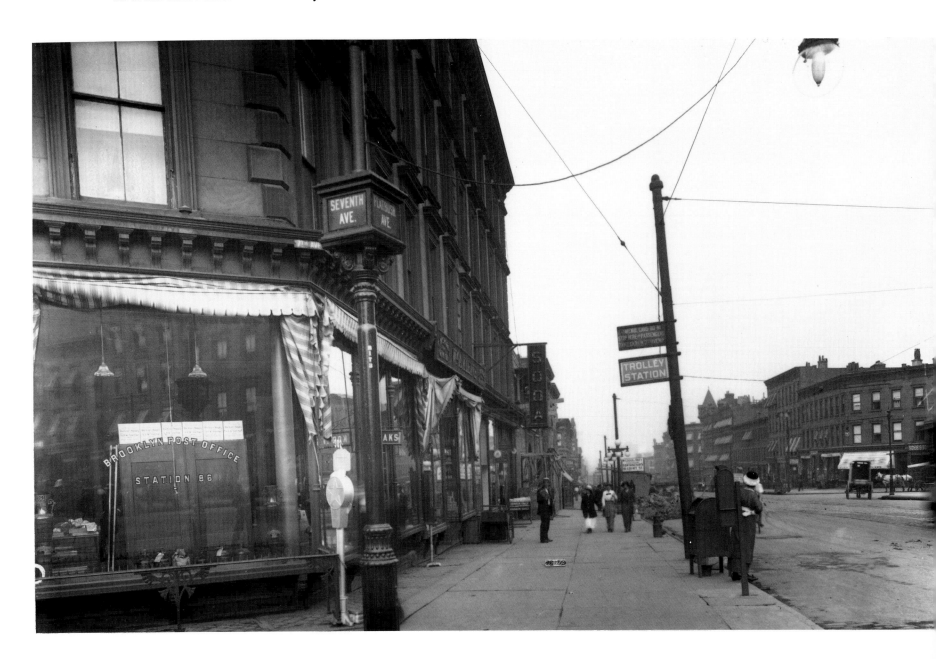

North side of Fifth Avenue, southwest from Flatbush Avenue - 1914

William McDougall established his Oyster Bay Restaurant in 1876 at a different location. The Brooklyn Union Elevated Railroad's Fifth Avenue Line was completed in 1889.

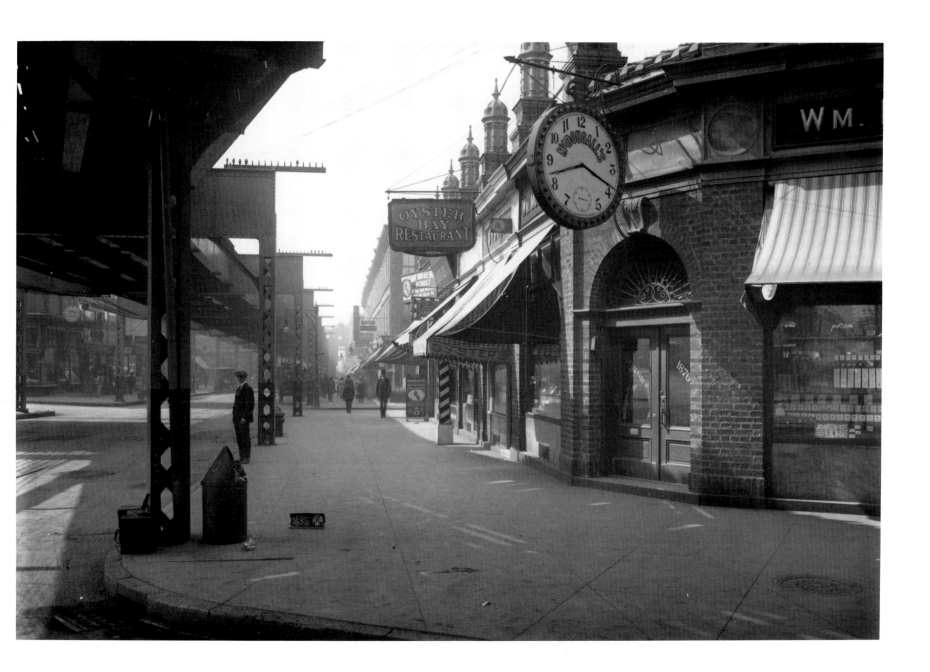

Southwest corner of Flatbush & St. Marks Avenues - 1914

The structure still stands. The porcelain St. Marks Avenue sign is still on the bricks at the corner.

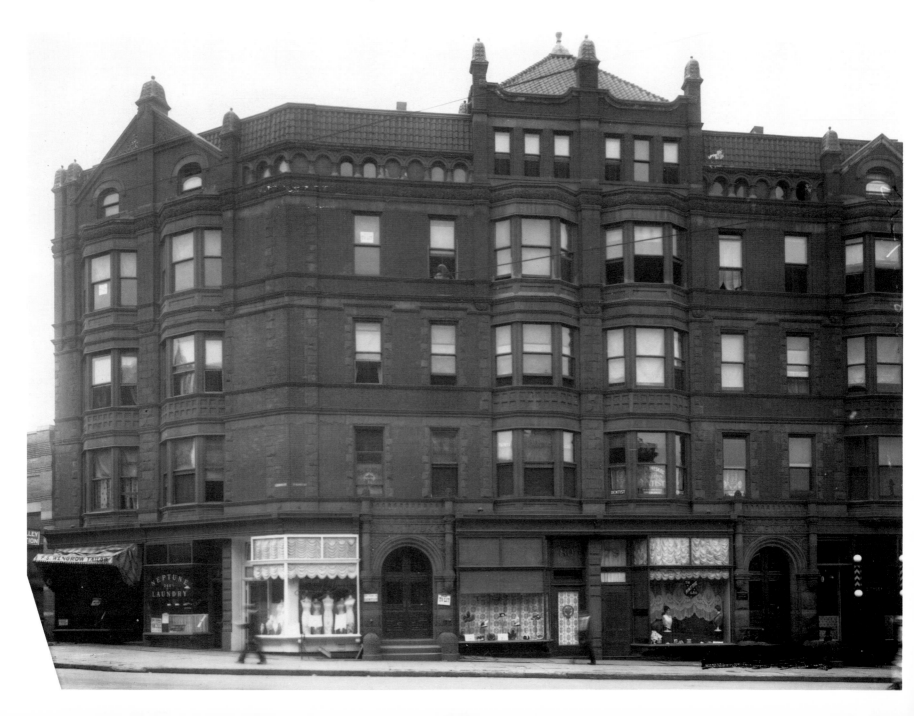

Bunny Theatre, No. 314 Flatbush Avenue, opposite Carlton Avenue - 1914

Comic actor John Bunny owned five theatres in Brooklyn and Manhattan. Silent movies were shown here until eleven o'clock each evening. M. Fernandez & Sons' Cigar Store was located to the right of the main lobby. Note the attractive street lamps and the stained-glass transoms.

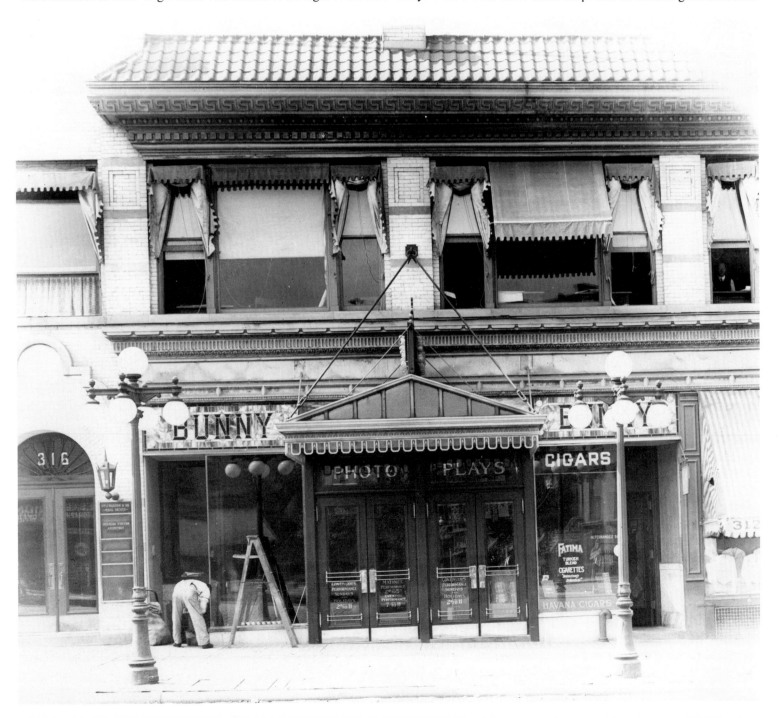

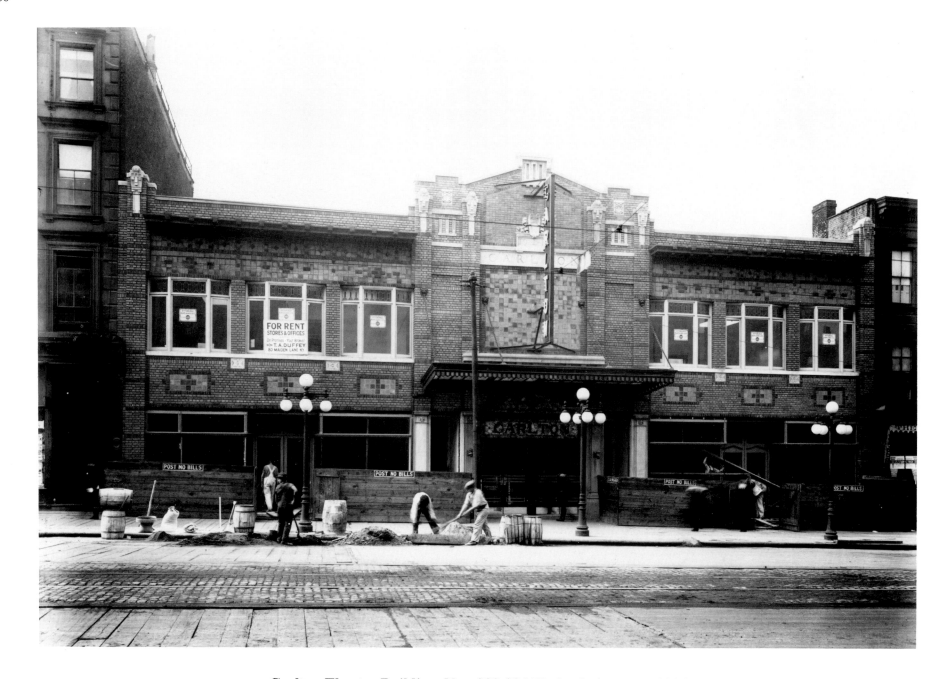

Carlton Theatre Building, Nos. 288-294 Flatbush Avenue - 1914

Office space in this newly constructed building was available through T.A. Duffey, a Manhattan broker. The actual theatre portion of the building was located along Park Place. After its closing in the mid-1970s, the auditorium became a church.

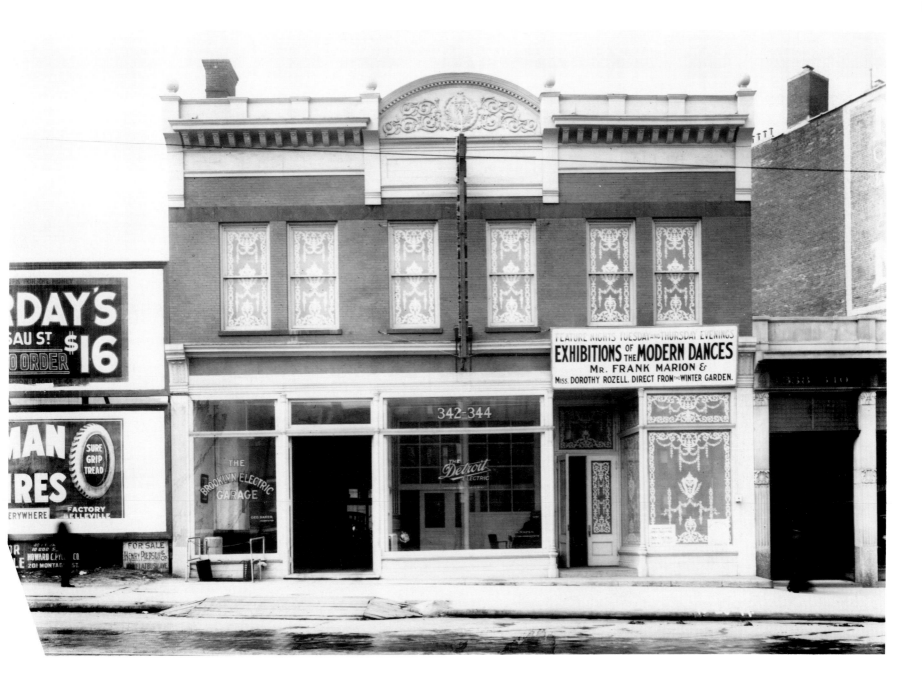

Nos. 342-344 Flatbush Avenue, between Eighth Avenue & Sterling Place - 1914

The showroom of the Detroit Electric Car Co. of N.Y., operated by George Baker, shared this building with a small theatre which presented modern dance performances featuring Frank Marion and Dorothy Rozell, of New York's Winter Garden Theatre.

Flatbush Avenue, north from Plaza Street - 1914

An automobile showroom occupied the corner building at the left. The steeple of the Grace Church, at Eighth Avenue, is visible at the far left.

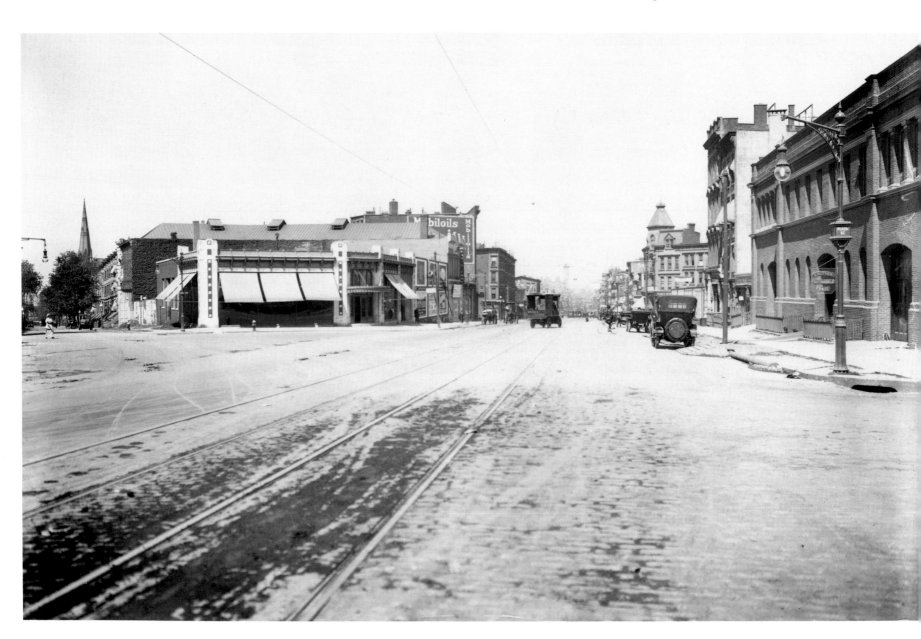

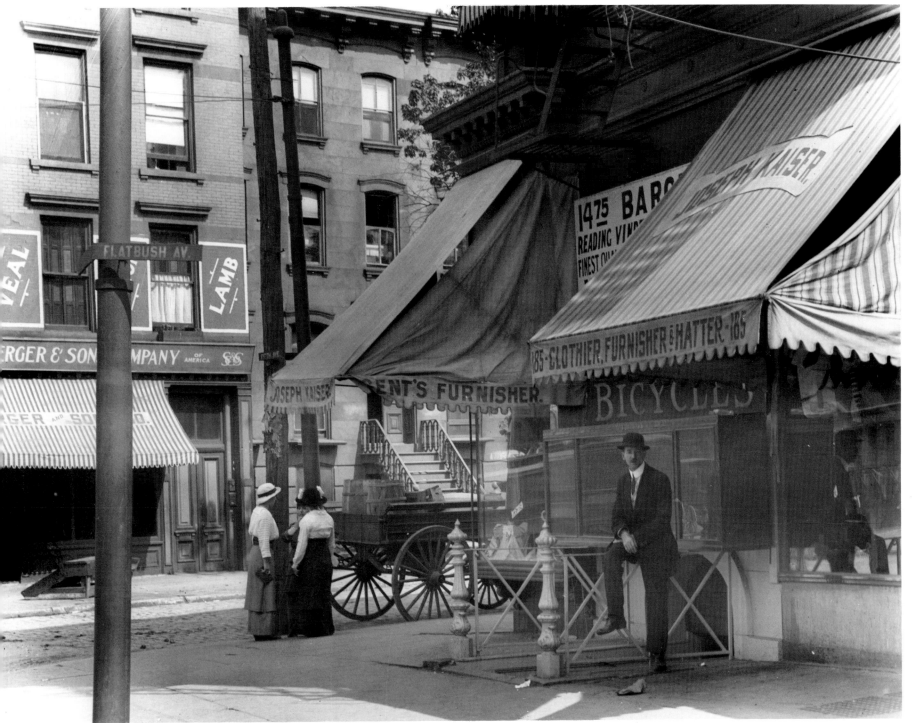

Fifth Avenue, east from Flatbush Avenue to Pacific Street - 1914

Suits could be purchased for $14.75 at Joseph Kaiser's clothing store.

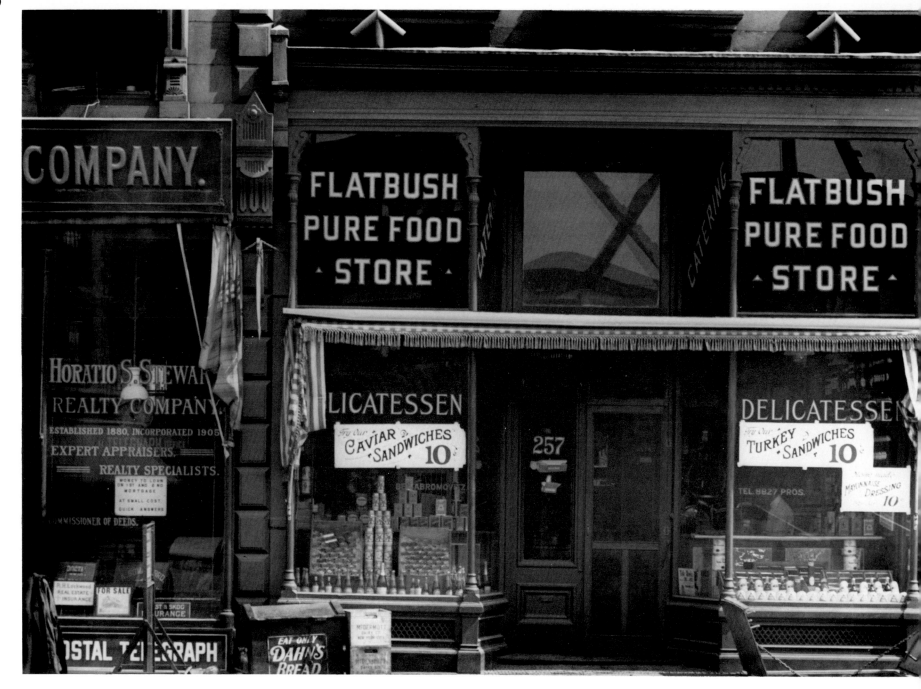

Flatbush Pure Food Store - No. 257 Flatbush Avenue - 1914

Owned by Ben Abromovitz, this delicatessen sold turkey or caviar sandwiches for ten cents. Horatio S. Stewart's real estate business was located next door. Note the tasseled awning.

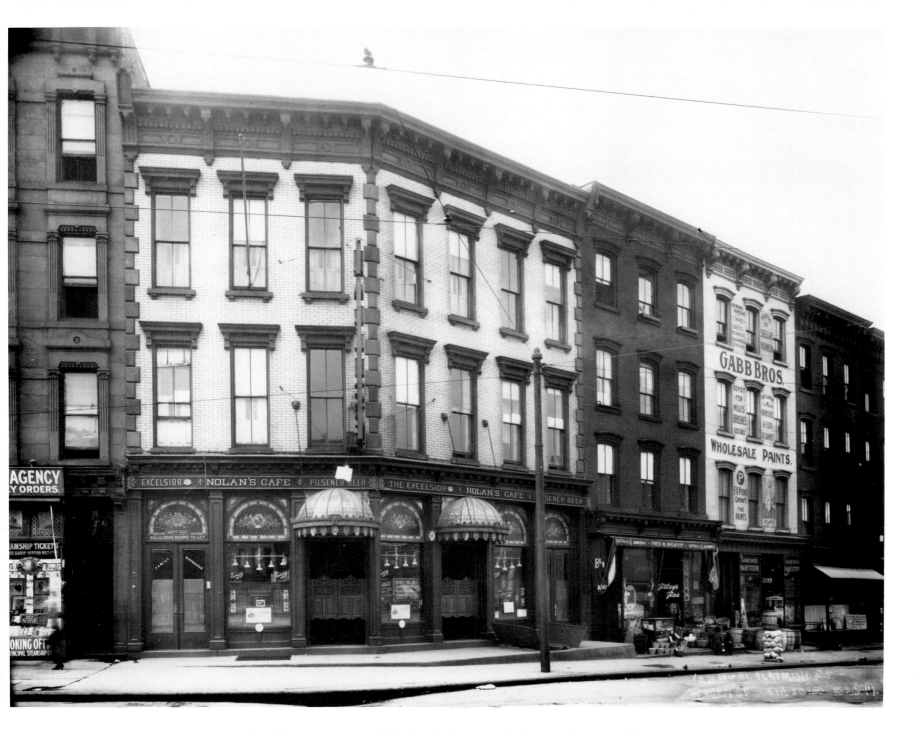

Southwest corner of Flatbush Avenue & Bergen Street - 1914

The corner building housed Nolan's Café which offered Excelsior Pilsener Beer. Unity Hall, where social functions were held, was also there. Gabb Brothers, a wholesale paint dealer, paved the way for Pintchik— currently the borough's largest retailer of paints.

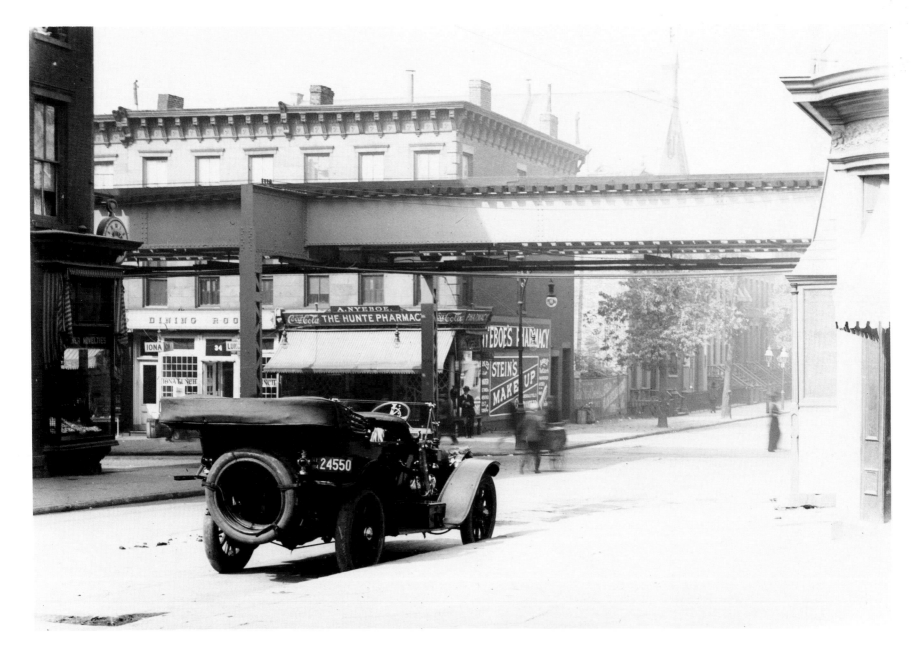

Dean Street, west to Fifth Avenue - 1914

The Iona Dining Room and Nyeboe's Hunte Pharmacy were on Fifth Avenue, just past the el. The roof of Immanuel Church is visible in the distance. Note the steering wheel on the right side of the automobile.

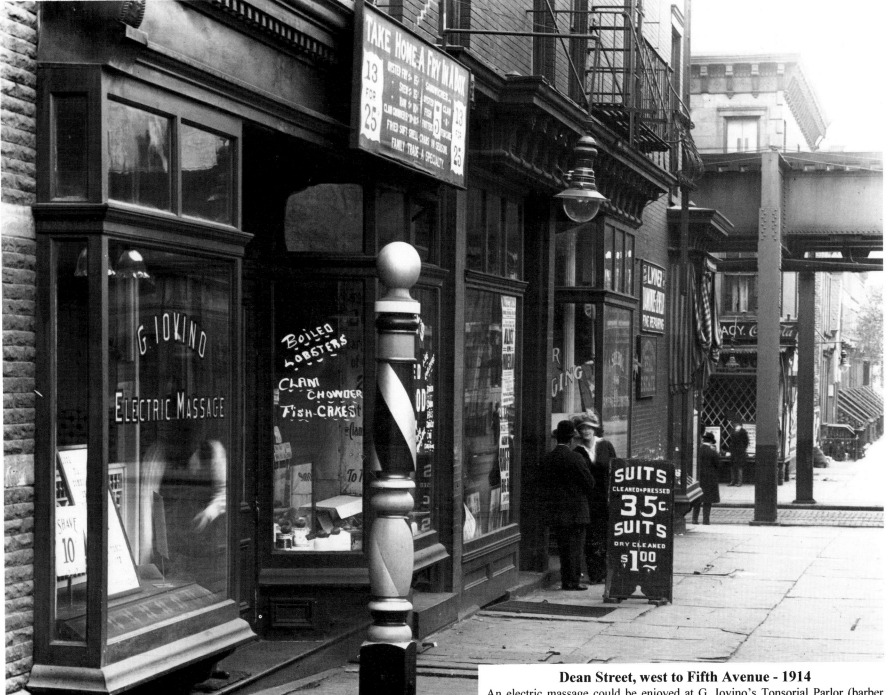

Dean Street, west to Fifth Avenue - 1914
An electric massage could be enjoyed at G. Iovino's Tonsorial Parlor (barber shop). A tailor chats with a female customer. The paint store at No. 446 Dean Street was owned by Isaac Seebol. A section of the Fifth Avenue el is visible.

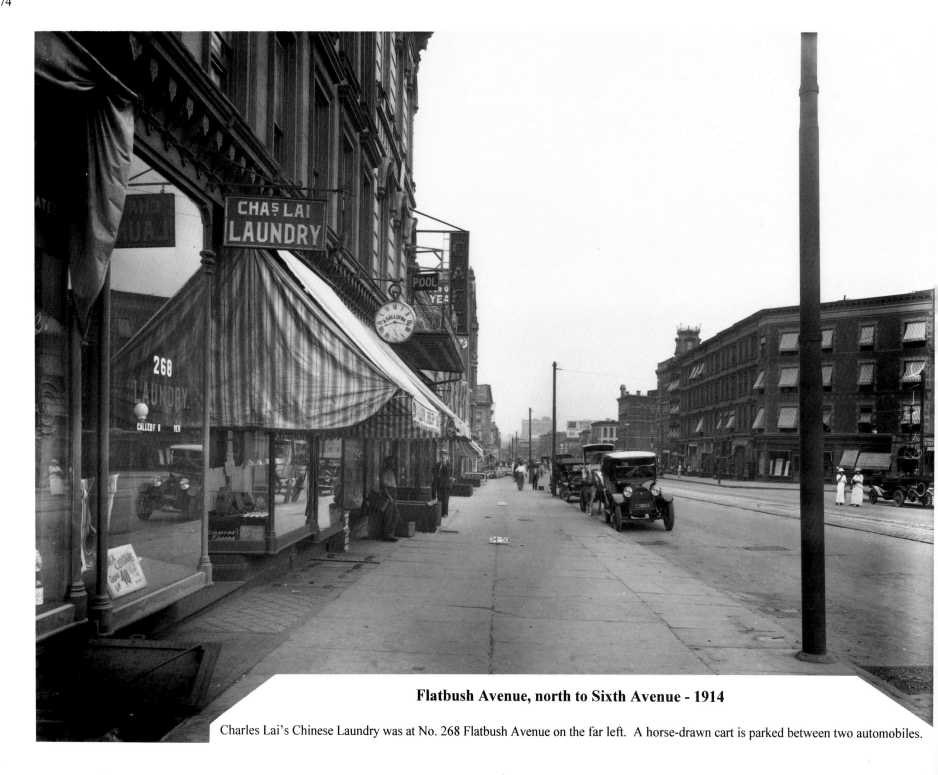

Flatbush Avenue, north to Sixth Avenue - 1914

Charles Lai's Chinese Laundry was at No. 268 Flatbush Avenue on the far left. A horse-drawn cart is parked between two automobiles.

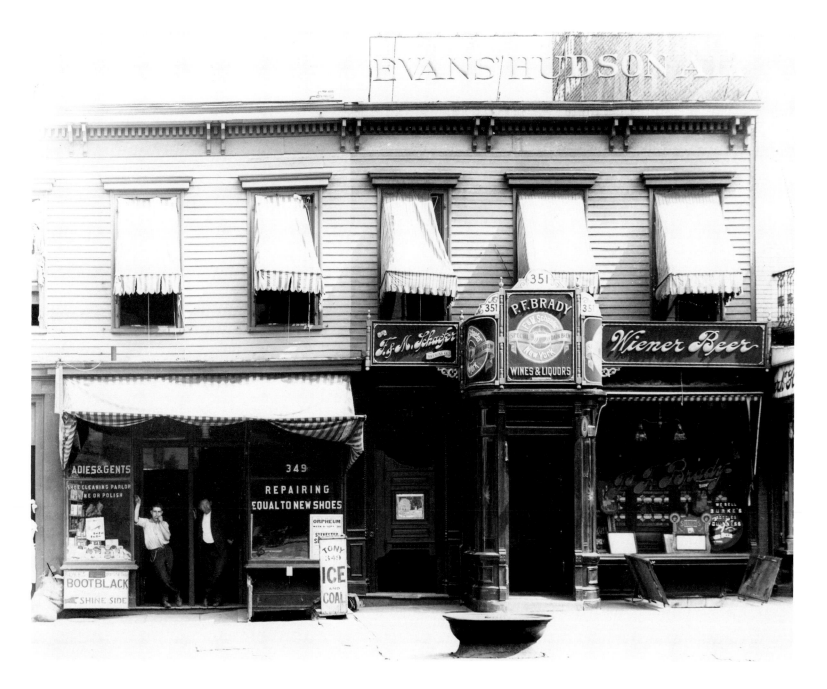

Nos. 349-351 Flatbush Avenue - 1914

Horses could drink water from the basin located on the sidewalk while their owners downed a few cold beers at Brady's Tavern. The bar was proud to serve F. & M. Schaefer's beer, brewed in Brooklyn from 1916 until 1976.

Nos. 162-168 Park Place, west of Flatbush Avenue - 1914

Brush's Dining Room offered oysters to its clientele. The Plaza Theatre showed silent movies. To the far right is Koch's Dance School.

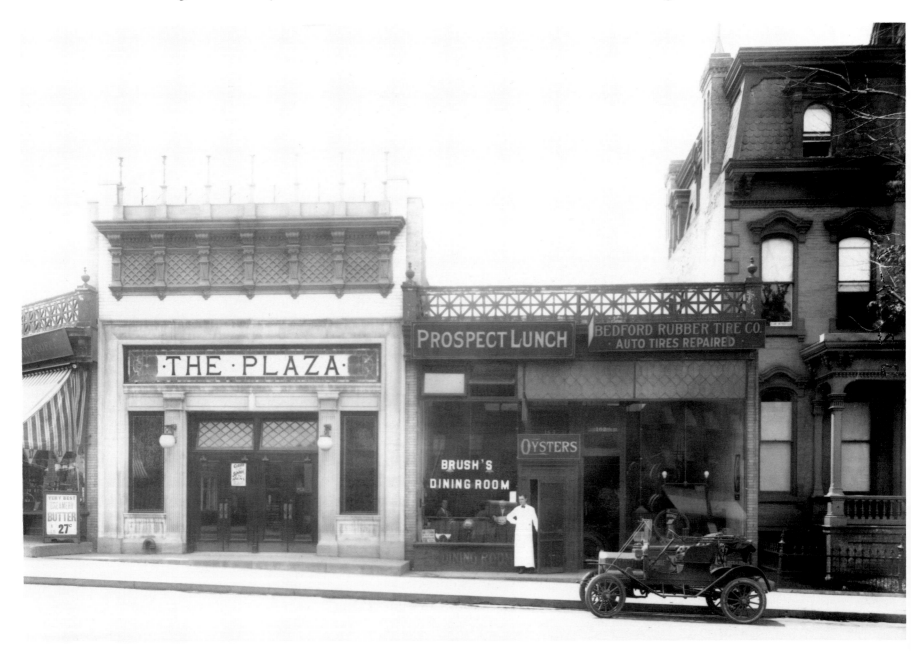

Koch's Dance School – southeast corner of Seventh Avenue & Park Place - 1914

No. 158-160 Park Place was built in 1872 for Joseph P. Durfey, the jeweler. In 1907, Harry C. Koch took possession of the premises. By 1930, the building became a hotel known as The Park Slope House. This attractive structure was demolished in 1932.

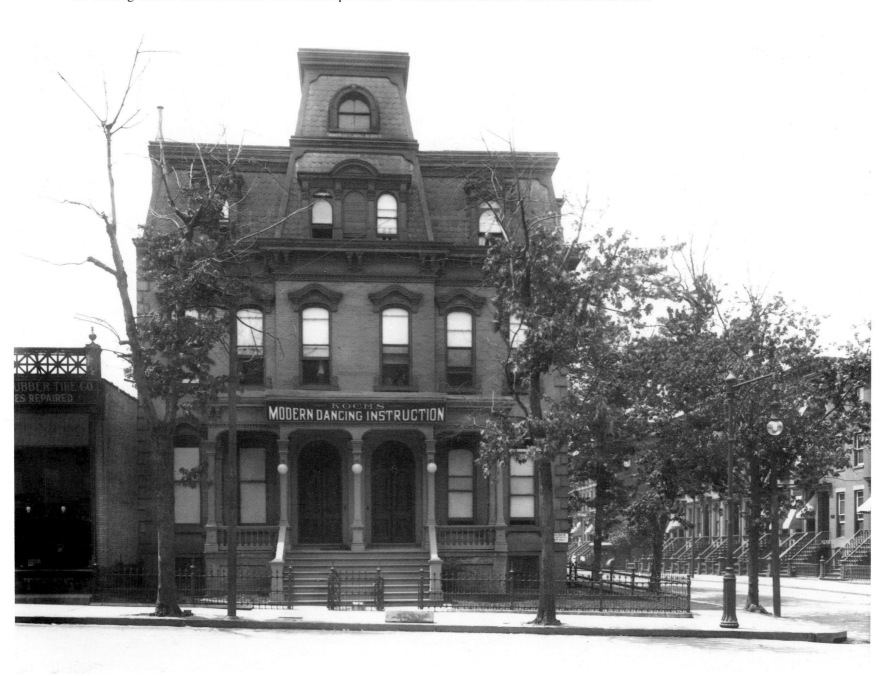

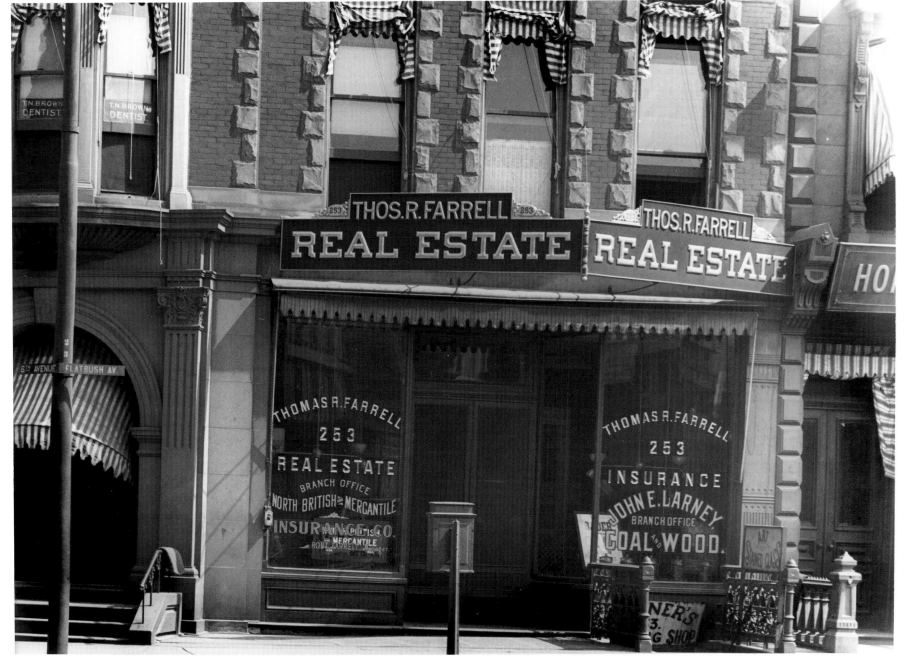

Northeast corner of Flatbush & Sixth Avenues - 1915

The store of Thomas R. Farrell was located at No. 253 Flatbush Avenue. Robert Farrell was manager of the real estate agency which shared its office with John E. Larney, a coal and wood merchant. A stained glass studio was located in the basement.

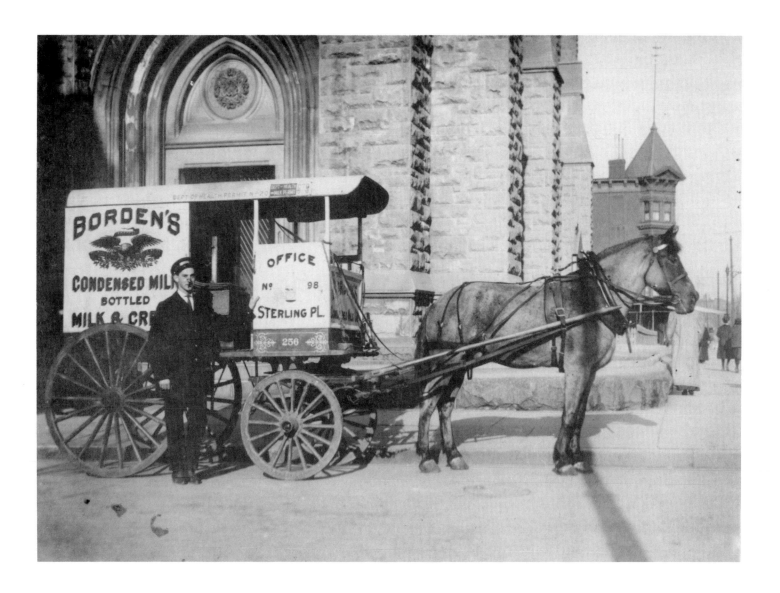

Borden's milk wagon - Carroll Street & Seventh Avenue - ca. 1915

A milkman stands proudly in front of the Carroll Street entrance of the First Reformed Church.

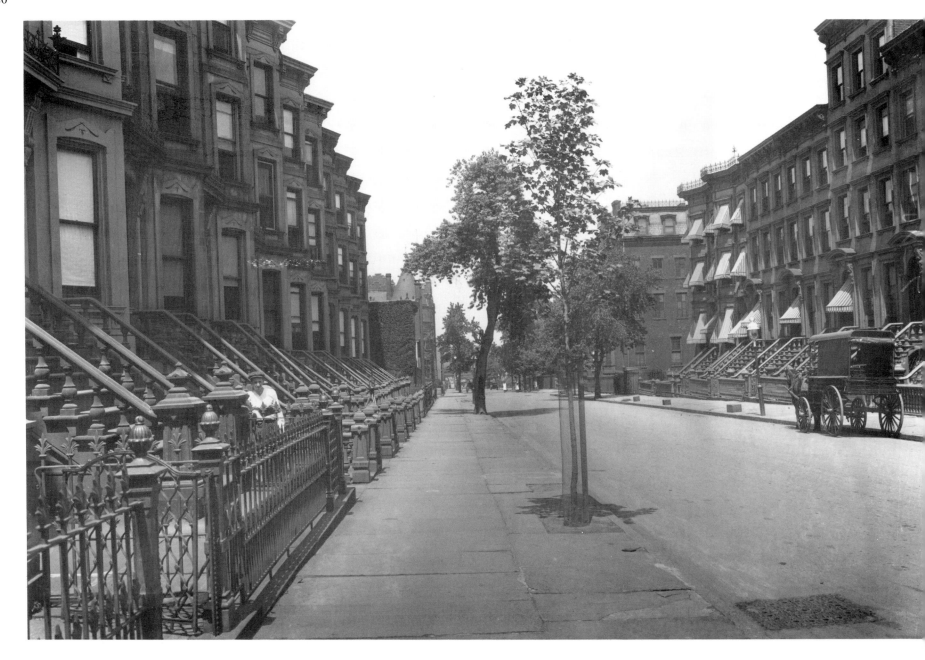

Park Place, northwest to Sixth Avenue - 1915

Now part of the Historic District, these brownstones were built in the 1870s. The blocks on the sidewalk aided passengers alighting horse-drawn carriages.

Eighth Avenue, northeast to Carroll Street - ca. 1915

A woman walks her dog to a hydrant as a man waits in his carriage. On the far left is the J.H. Hannan mansion, designed by C.P.H. Gilbert, and completed around 1888. It was demolished many years ago.

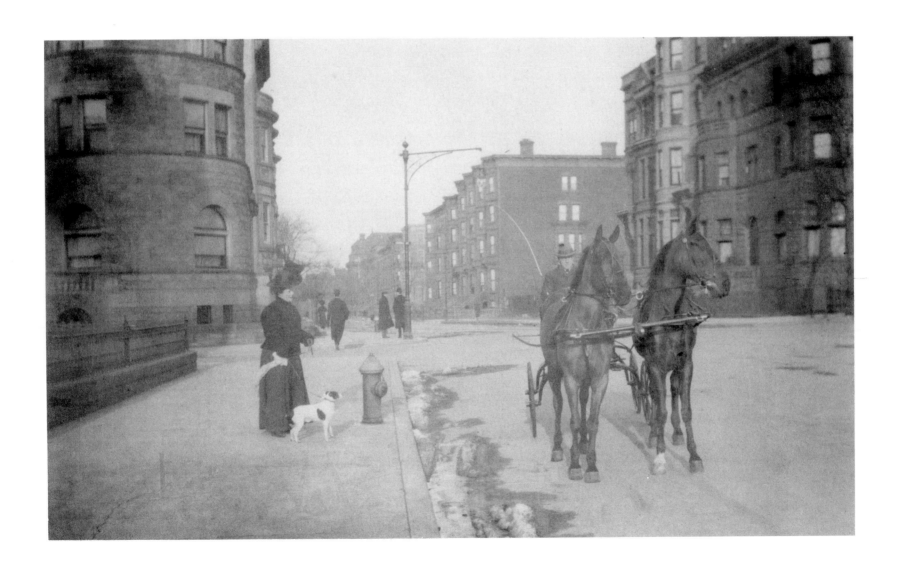

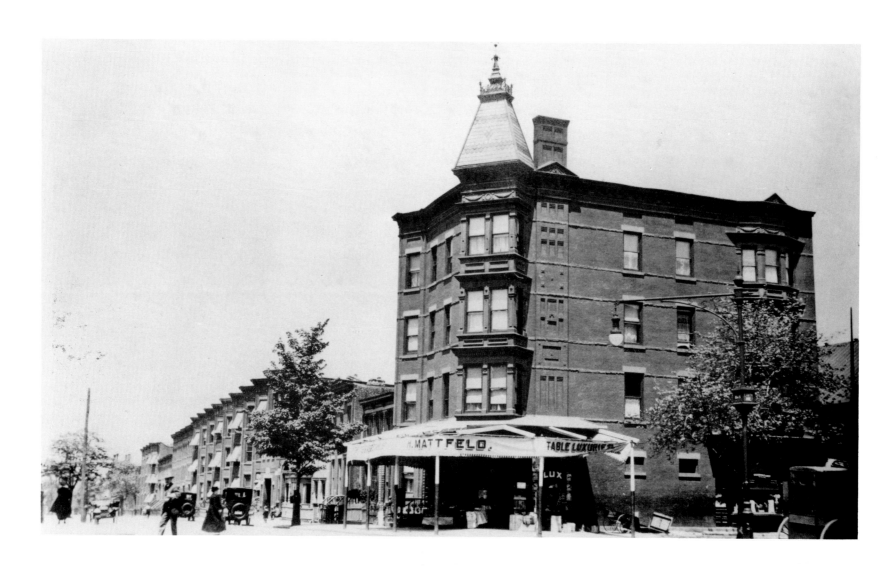

Eighth Avenue & Eleventh Street, northwest corner - 1916

This corner building, then home to H. Mattfeld's grocery, now houses a laundromat.

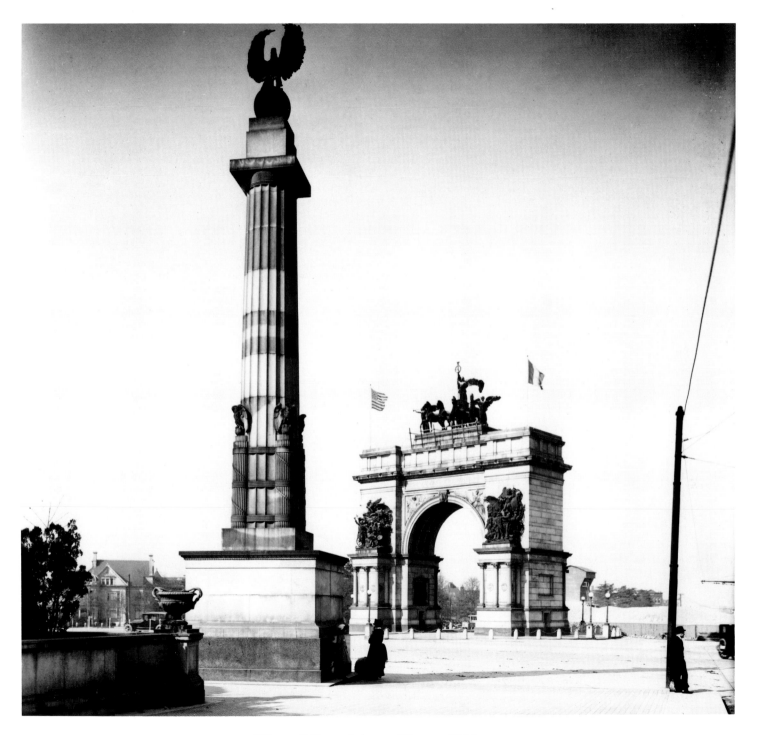

View of Grand Army Plaza - 1916

84

No. 38 Prospect Park West - 1916

This mansion stood on the southwest corner of Garfield Place and Prospect Park West.

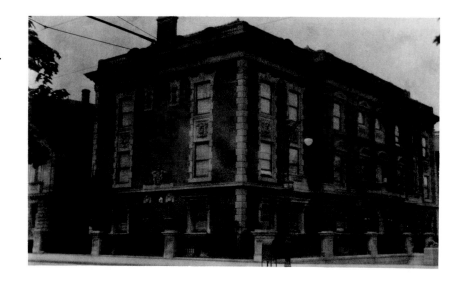

Henry Carlton Hulbert Mansion - No. 49 Prospect Park West - 1916

Hulbert, a millionaire industrialist, hired Montrose W. Morris to design a Romanesque-Revival style mansion. Completed in 1892, the architectural masterpiece has been the home to the Brooklyn Ethical Culture Society since 1928. Partially visible to the left is the former home of William Childs, creator of Bon Ami cleanser. Designed in the Jacobean style by William B. Tubby in 1900, it is currently used as the Meeting House of the Brooklyn Ethical Culture Society.

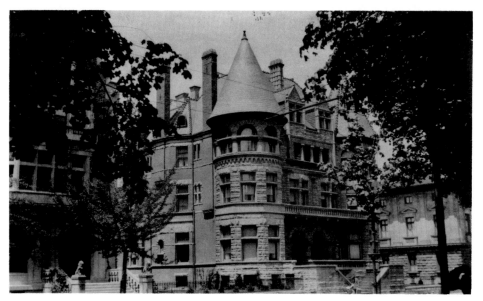

West side Eleventh St., north toward Eighth Ave. - 1916

84

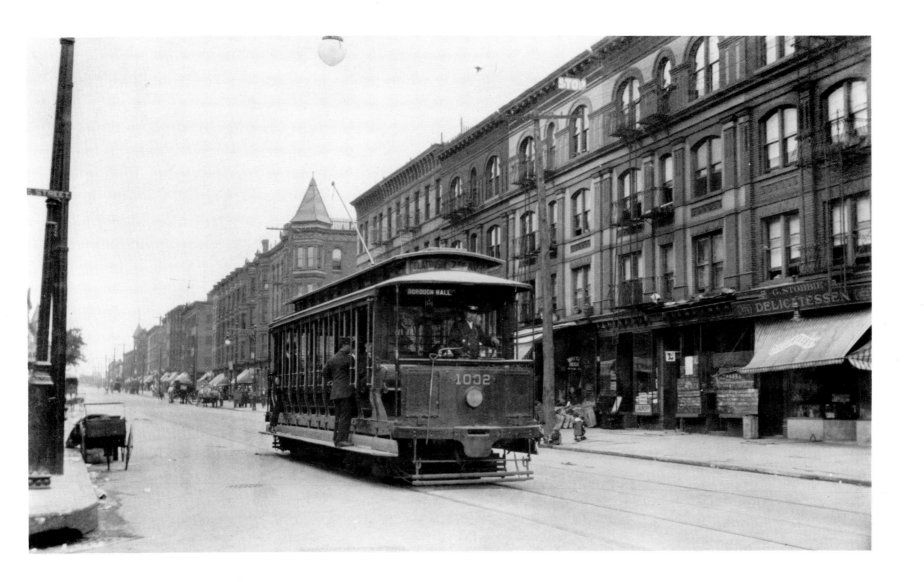

Seventh Avenue, southwest from Eleventh Street - 1916

Built around 1896, open-air Seventh Avenue trolley No. 1002 will turn north onto Flatbush Avenue and proceed to Borough Hall. Many of the early trolleys were converted horse cars. The BRT had two fleets—open cars for summer and closed cars for winter. Motors, truck frames, and controllers were sometimes shared by the fleets to save money. While the off-season fleet was in storage, it was usually cleaned and painted for the new season. Builders such as J.G. Brill, St. Louis, and others,manufactured these "single truck opens." These trolleys seated forty passengers and were in regular use until 1928. After that date, a few were used as work cars.

No. 566 Eleventh St., corner Eighth Avenue - 1916

No. 47 Prospect Park West - 1916

This mansion was located on the northwest corner of First Street and Prospect Park West until the late 1920s.

East side Eleventh St., north to Eighth Avenue - 1916

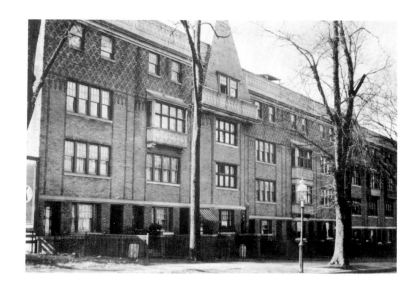

West side Third St., north from Prospect Park West - 1916

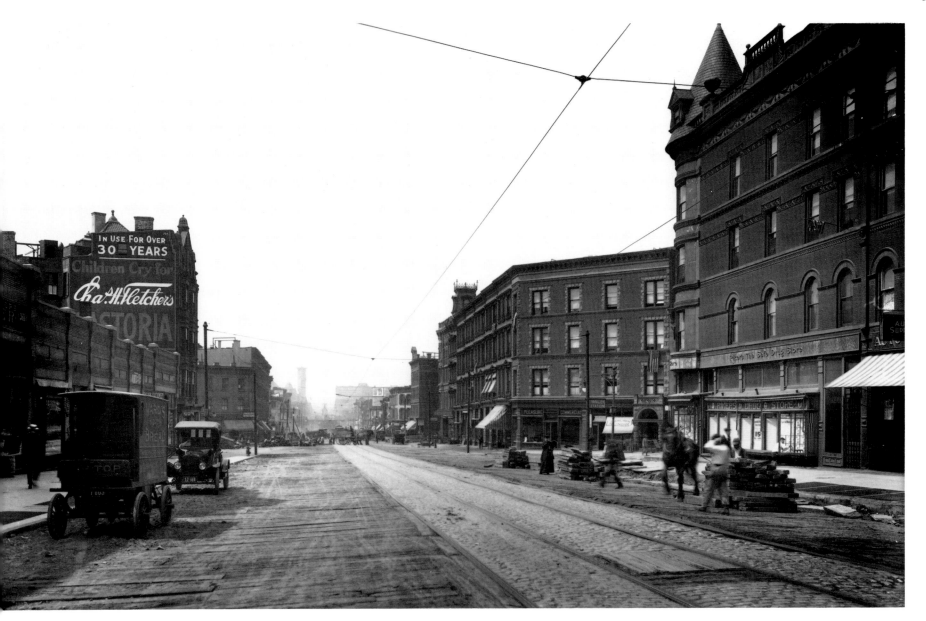

Flatbush Avenue, north to St. Marks Avenue - 1917

A Ward's Tip-Top bread truck is parked at left. An ad for Fletcher's Castoria is plainly visible. A branch store of Riker's Drugs is on the right.
The 17-story tower in the distance, at Fulton and Nevins Streets, rose from Smith, Gray & Company, a leading clothier.

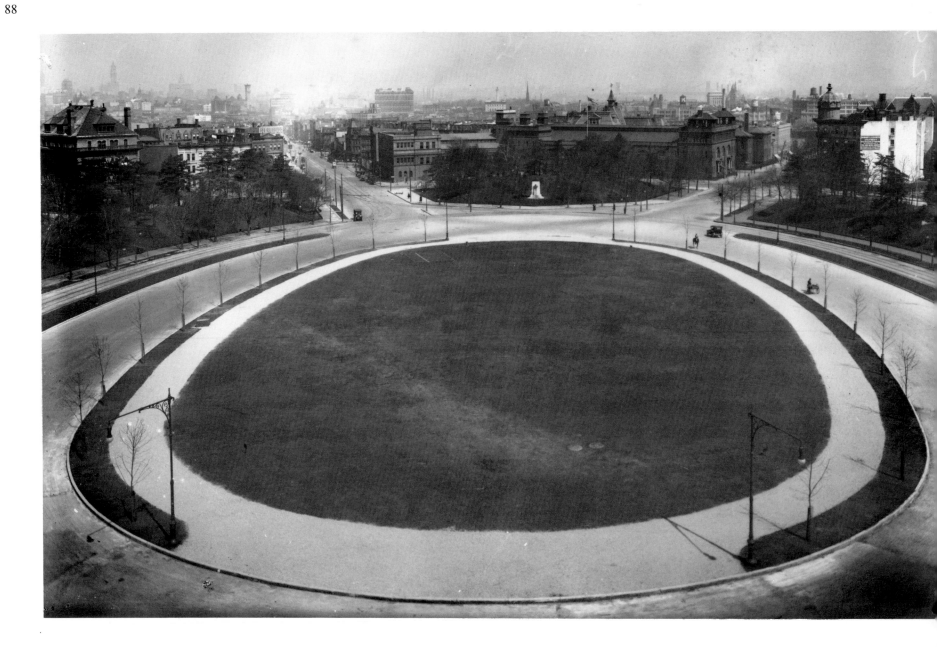

Looking north from the top of the Arch - 1918

Flatbush and Vanderbilt Avenues extend from the Plaza. The Montauk Club is at the far left. The Manhattan towers of the Woolworth and Municipal Buildings are faintly seen beyond the Montauk Club. The oval in the foreground is now occupied by the city's only official monument to President John F. Kennedy. It was designed by Morris Ketchum Jr., and was dedicated in 1965. The oval also now contains the Bailey Fountain, installed in 1932. The oval is currently in need of extensive renovation.

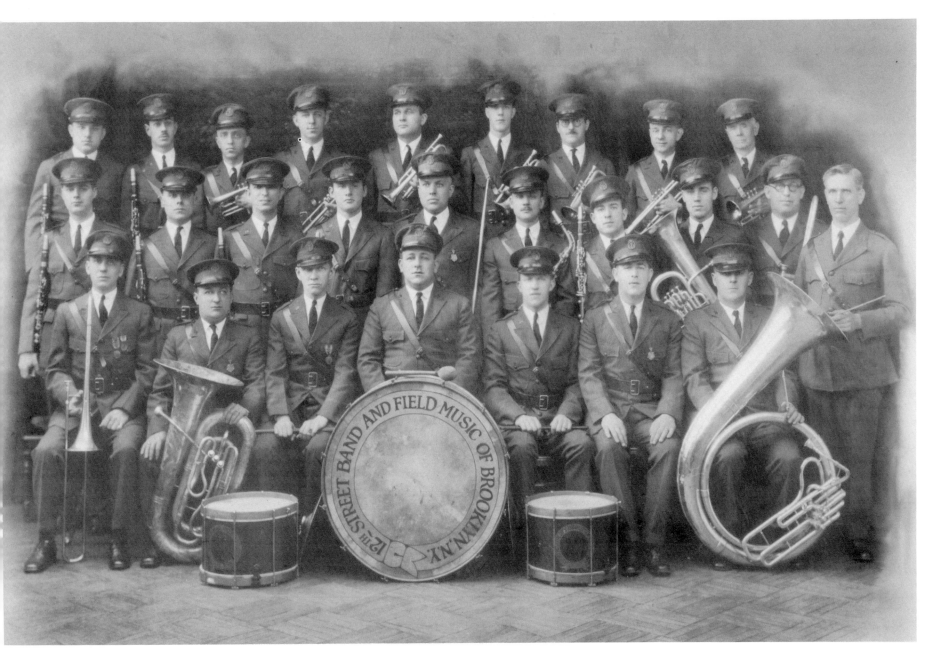

12th Street Band and Field Music of Brooklyn - ca. 1920

This ensemble performed Sousa's marches in Prospect Park and at the Fourteenth Regiment Armory. They also played at parades and other functions.

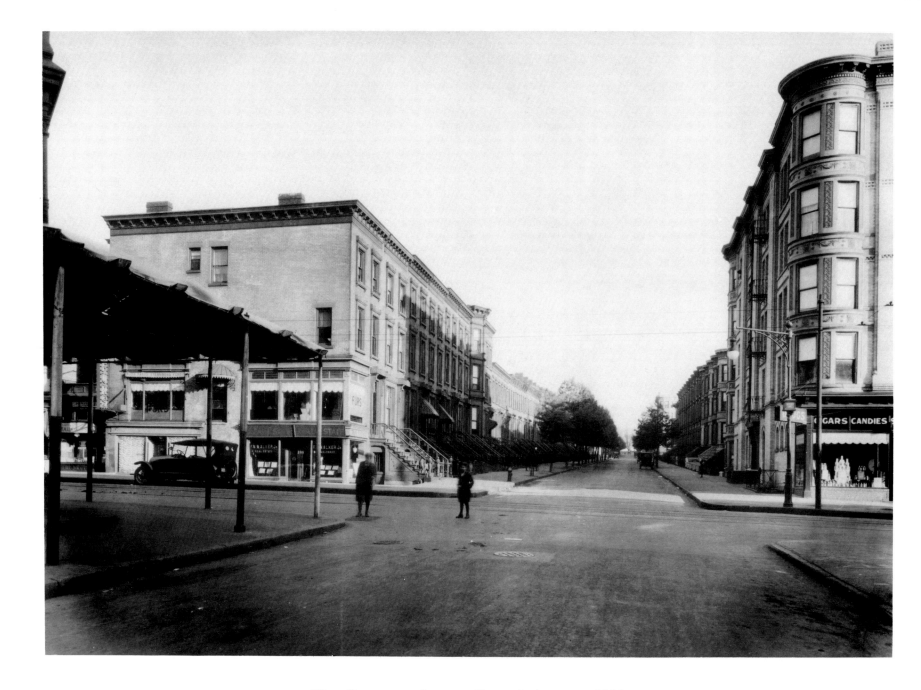

First Street, southeast to Seventh Avenue - 1922

The old Port(e) Road, trod upon by Revolutionary militia, nearly followed the path of today's First Street. Continental troops retreated downhill along this road from the advancing British and Hessian forces.

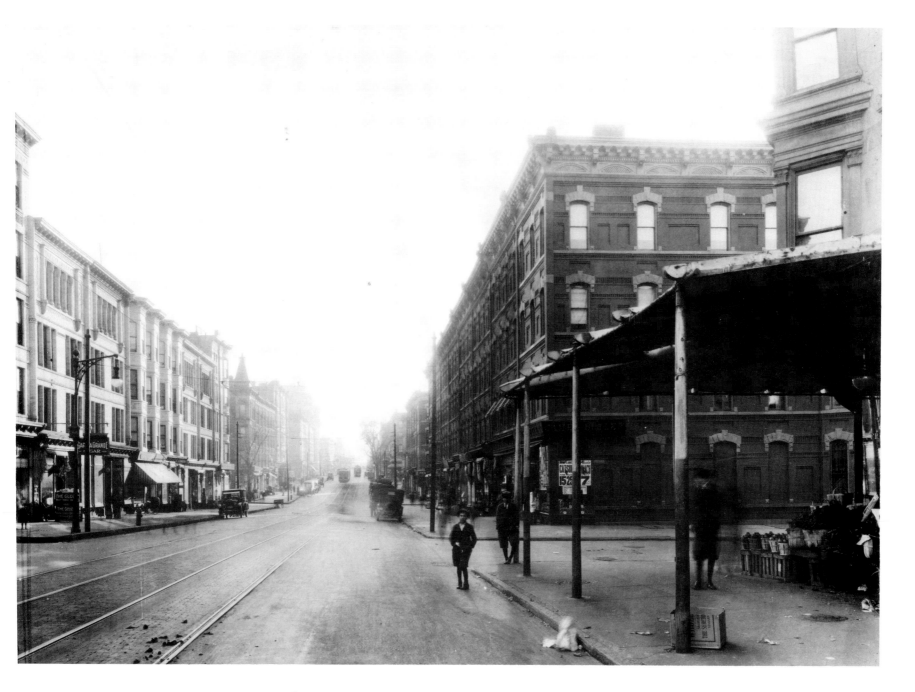

Seventh Avenue, southwest to First Street - 1922

Fresh produce is on sale under the awnings at right. The buildings on the right, across First Street, have been replaced by Public School No. 321, where a weekend flea market is currently held.

Fourth Avenue, northeast to Sackett Street - 1926

Typical scene in Brooklyn's *Little Italy*.

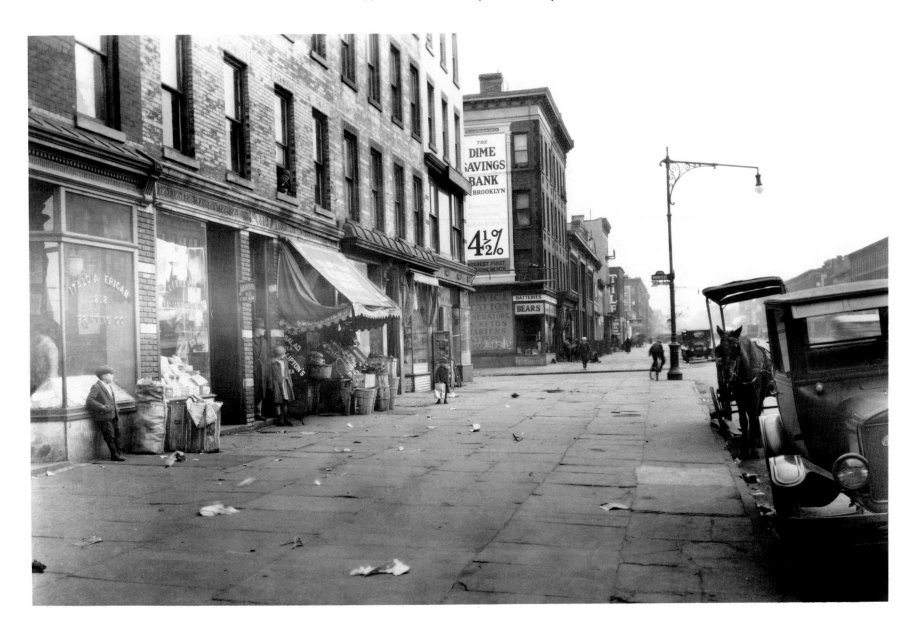

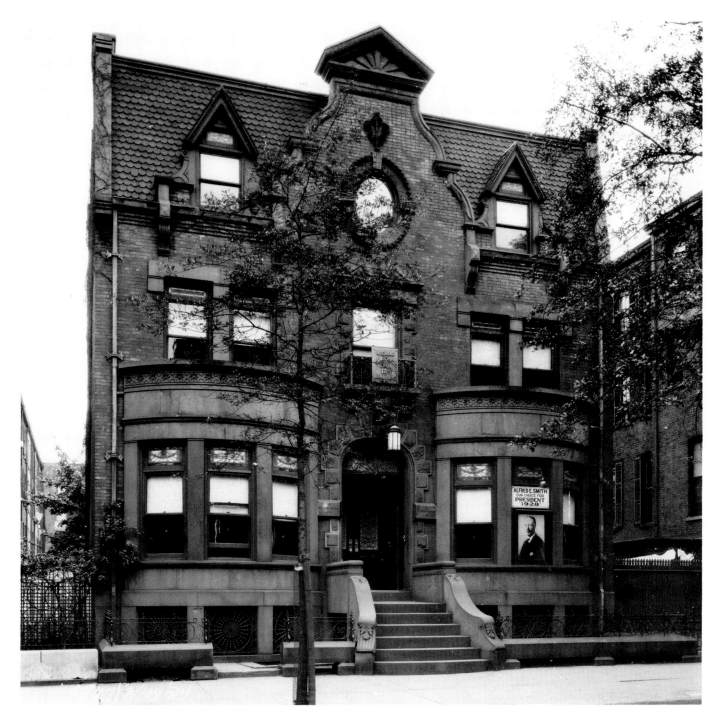

Twelfth Assembly District Regular Democratic Club - 1928

The club was located at No. 911 Eighth Avenue. Its members proudly displayed their endorsement for Alfred E. Smith, Democratic nominee for the upcoming Presidential election.

Seventh Avenue, southwest from Ninth Street - 1928

The subway station would soon be placed near the fire hydrant on the left. The building with the turret and flagpole is at Eleventh Street. Architecturally, this scene looks quite the same seventy years later.

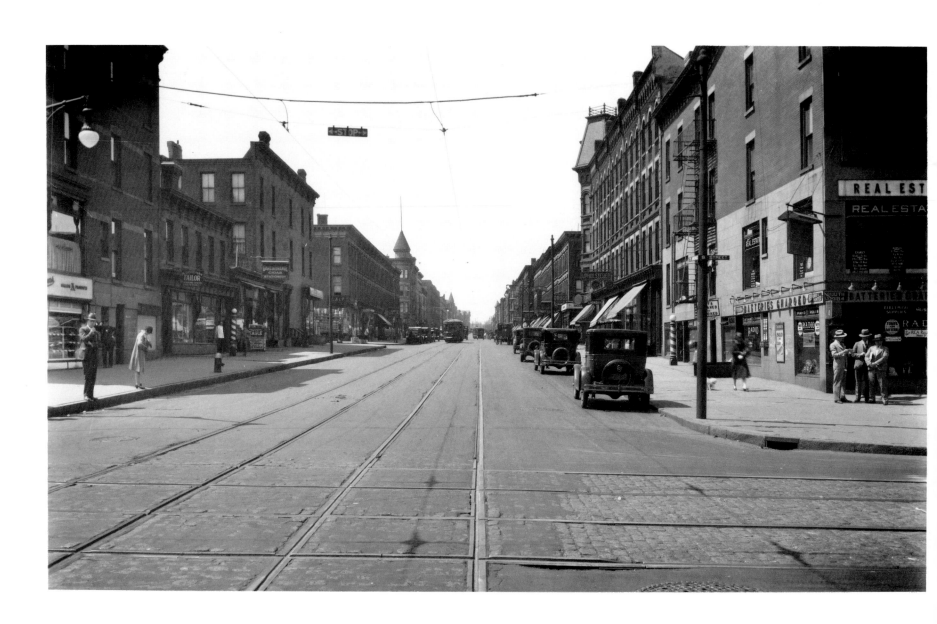

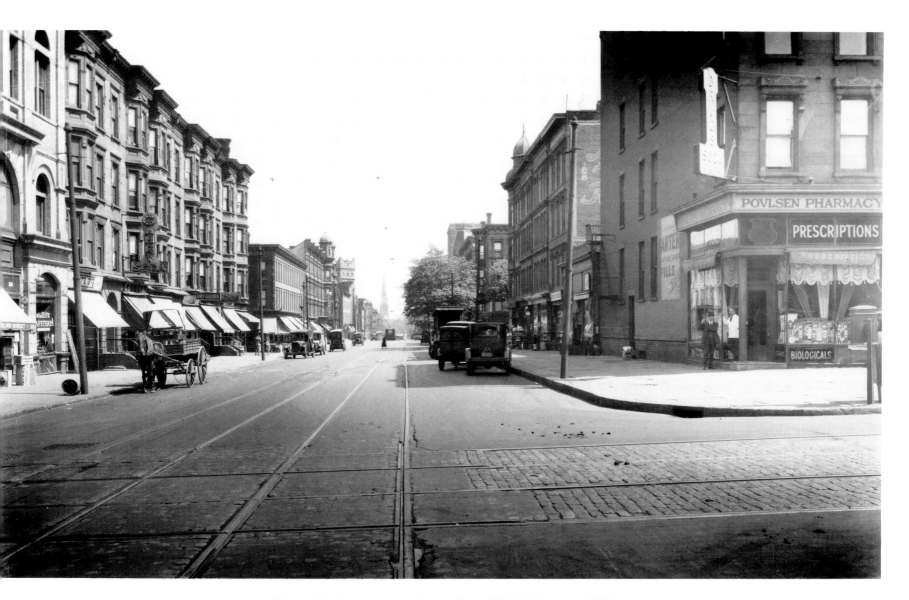

Seventh Avenue, northeast from Ninth Street - 1928

A horse-drawn wagon is parked in front of the Majestic Cafeteria, located in the Acme building, on the far left. Pharmacist C. E. Brennan stands at the entrance to Povlsen's. His Partner was J. J. Cizmowski. The top of the Greenwood Baptist Church, at Sixth Street, is plainly visible. The First Reformed Church is way down the avenue.

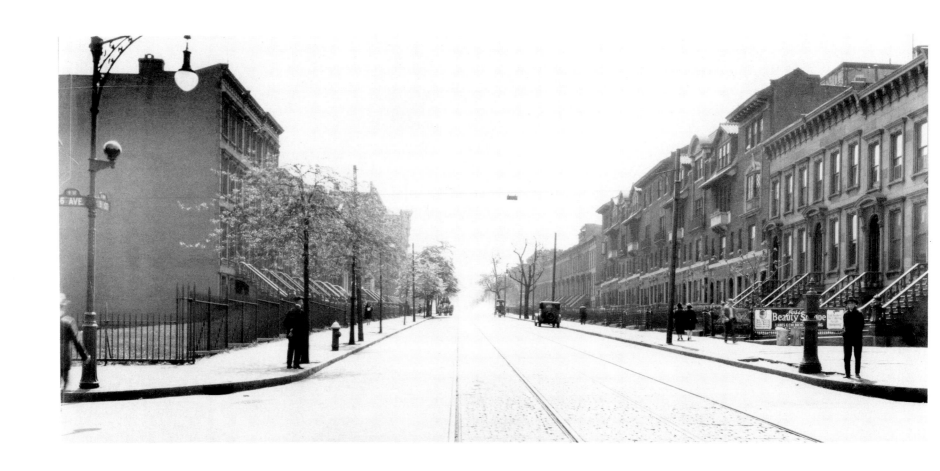

Ninth Street, southeast at Sixth Avenue - 1928

Not much has changed during the past seventy years!

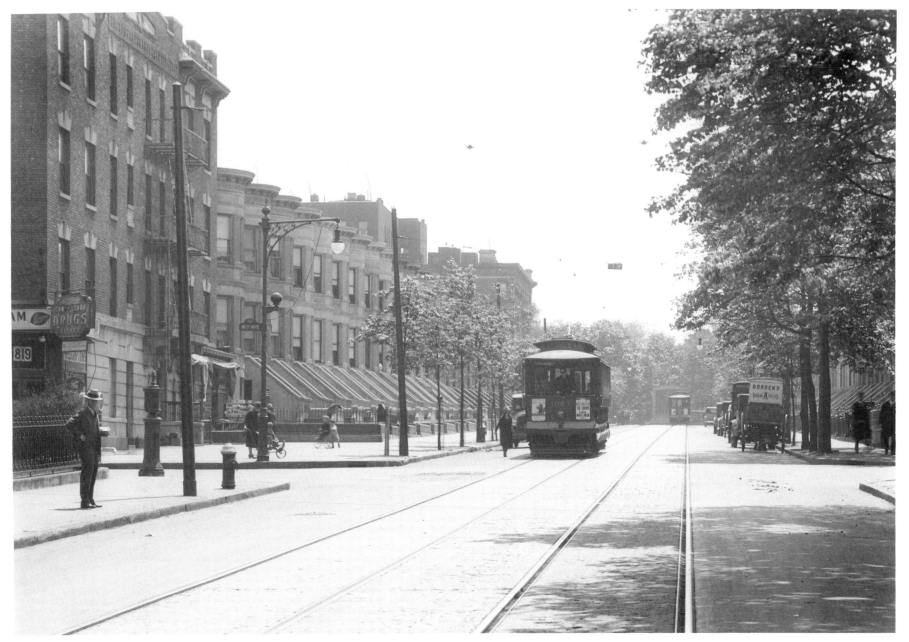

Ninth Street, southeast to Eighth Avenue - 1928

Smith Street trolley No. 1063 picks up a passenger at Eighth Avenue. It will continue downhill and terminate at Fulton Street, downtown. A Borden's milk wagon is parked on the right. In the distance, a southbound trolley, about to turn onto Prospect Park West, partially obscures the Lafayette bronze at the Ninth Street entrance to Prospect Park.

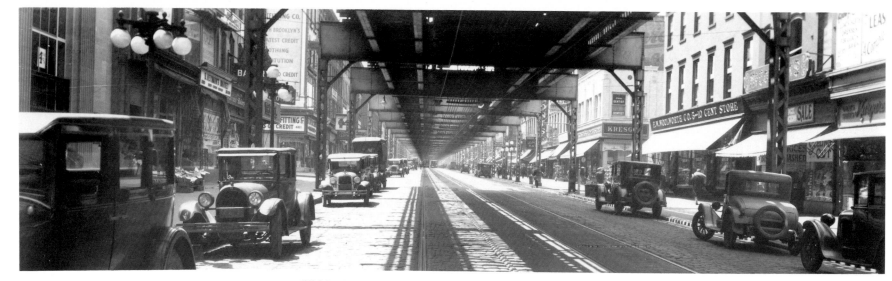

Fifth Avenue, northeast to Tenth Street - 1928

Fifth Avenue was the principal shopping thoroughfare of the area. Until recent years, the rents for commercial storefronts were lower on Seventh Avenue than on Fifth Avenue. Note the Woolworth 5 and 10 Cent Store on the right.

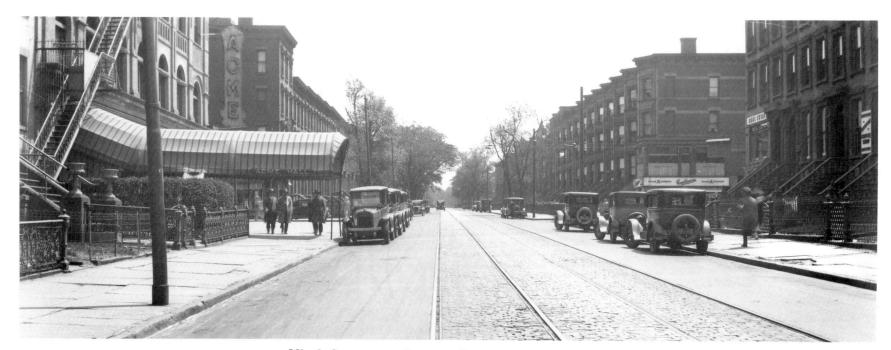

Ninth Street, southeast to Seventh Avenue - 1928

Acme Hall is at left. All buildings in this photo still stand.

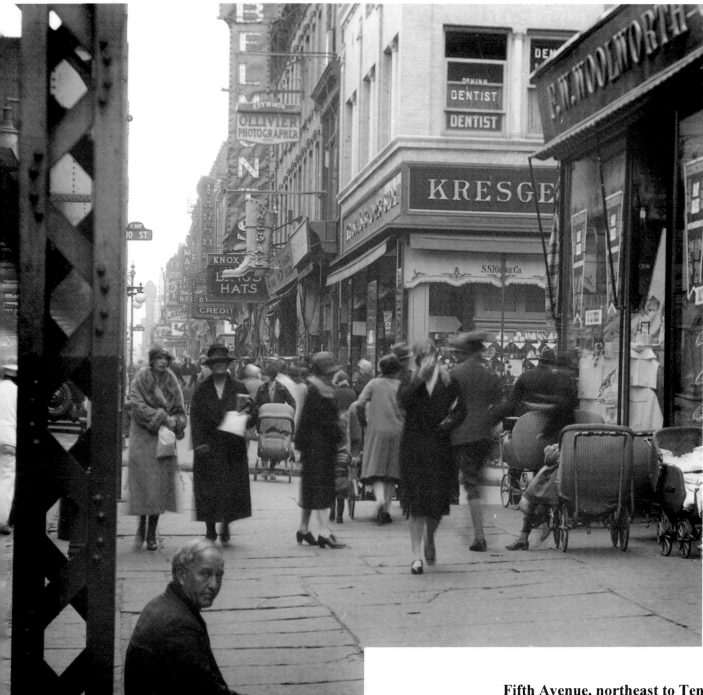

Fifth Avenue, northeast to Tenth Street - 1928

A hopeful beggar sits next to an elevated railroad pillar. Shoppers pass Knox Hats, Regal Shoes, Kresge's, and Woolworth's. Ollivier, the photographer at No. 466, was established in 1876. Note the many baby carriages on the avenue. A street cleaner sweeps at the far left.

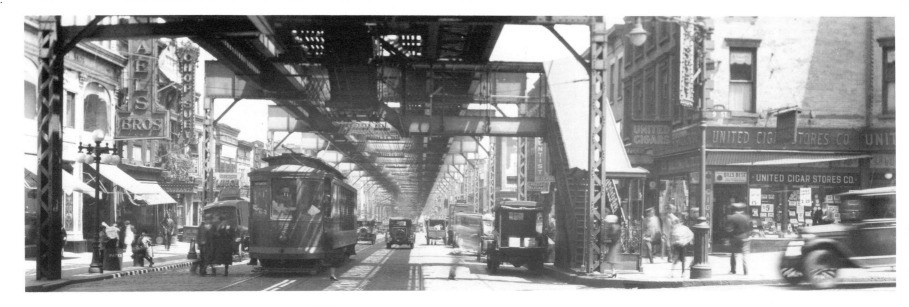

Fifth Avenue, northeast at Ninth Street - 1928

Fifth Avenue trolley No. 4329 is bound for Fort Hamilton. Michael's Bros. Furniture Store and a Chinese restaurant offering *Chop Suey* are on the left. In business until 1996, Michael's was probably Brooklyn's largest furniture retailer and boasted 4 big stores throughout the borough. The shadow of the elevated structure creates a unique pattern upon the cobblestone pavement. A recycling bin for paper stands on the left.

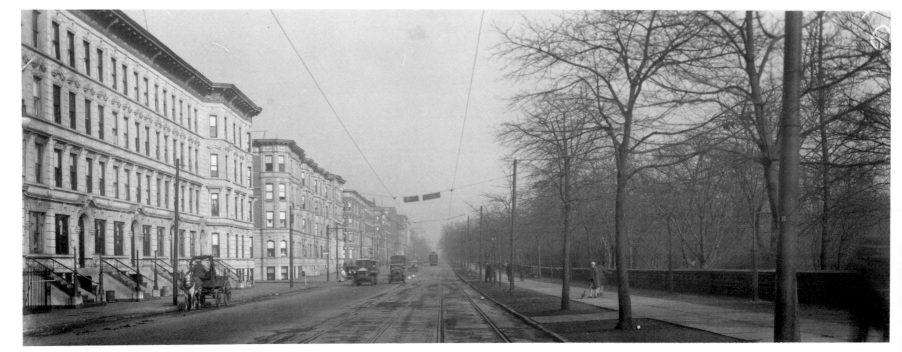

Prospect Park West, northeast from Fourteenth Street - 1928

The flats on the left were built during the first decade of the Twentieth Century.

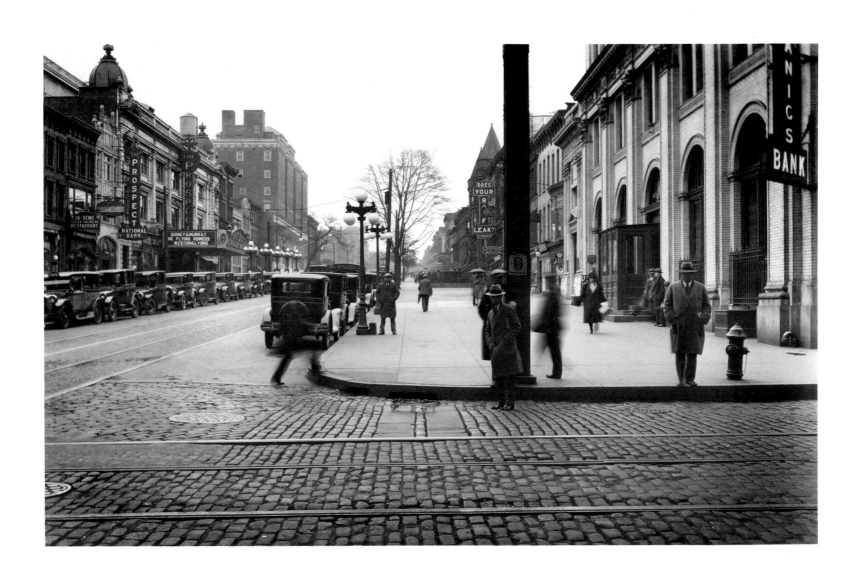

Ninth Street, southeast from Fifth Avenue - 1928

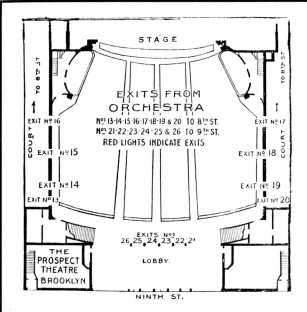

STAGE

EXITS FROM
ORCHESTRA

Nº 13-14-15-16-17-18-19 & 20 TO 8TH ST.
Nº 21-22-23-24-25 & 26 TO 9TH ST.
RED LIGHTS INDICATE EXITS

EXIT Nº 16 EXIT Nº 17

TO 8TH ST. TO 9TH ST.

EXIT Nº 15 COURT EXIT Nº 18

COURT

EXIT Nº 14 EXIT Nº 19

EXIT Nº 13 EXIT Nº 20

EXITS Nº
26, 25, 24, 23, 22, 2'

THE
PROSPECT
THEATRE
BROOKLYN LOBBY.

NINTH ST.

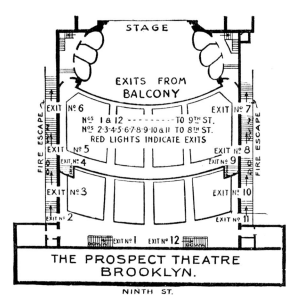

STAGE

EXITS FROM
BALCONY

Nº 1 & 12 -------- TO 9TH ST.
Nº 2-3-4-5-6-7-8-9-10 & 11 TO 8TH ST.
RED LIGHTS INDICATE EXITS

FIRE ESCAPE FIRE ESCAPE

EXIT Nº 6 EXIT Nº 7
EXIT Nº 5 EXIT Nº 8
EXIT Nº 4 EXIT Nº 9
EXIT Nº 3 EXIT Nº 10
EXIT Nº 2 EXIT Nº 11
EXIT Nº 1 EXIT Nº 12

THE PROSPECT THEATRE
BROOKLYN.

NINTH ST.

FIRE NOTICE
Look around NOW and choose the Exit nearest to your
seat. In case of fire, walk (not run) to THAT EXIT. Do
not try to beat your neighbor to the street.
THOMAS J. DRENNAN, Fire Commissioner.

Guide Ptg. & Pub. Co., 353 Jay St., Brooklyn, N. Y.

COMING ATTRACTIONS

MONDAY, MARCH 17, 1919

MARTIN VAN BERGEN

Brooklyn's Favorite Singer

PISANO and BINGHAM

CLAIRE VINCENT and CO.

WOOLSEY and BOYNE

SEVEN GLASGOW MAIDS

AND

JACK SHERRILL

In the Sensational Photoplay Drama

"ONCE TO EVERY MAN"

Featuring the Fastest and Most Exciting Boxing Bout
Ever Photographed

Fifth Year 1918-1919 Twenty-ninth Week

B.F.KEITH'S PROSPECT THEATRE

EDWARD F. ALBEE, President

Daily at 2.00 P. M.

Evening, Feature Picture from 7.00 to 8.00 P. M.
is repeated from 10.00 to 11.00 P. M.
Vaudeville from 8.00 to 10.00 P. M.

Sundays and Holidays, Continuous from 1.30 to
7.00 P. M. Evening at 8.00 P. M.

Thursday, Friday, Saturday and Sunday,

March 13, 14, 15 and 16, 1919

BFK

B.F. KEITH'S PROSPECT THEATRE

NINTH STREET NEAR FIFTH AVE.
BROOKLYN, N.Y.

FANNIE WARD

Who Will Appear In

"COMMON CLAY"

MARCH 20, 21, 22 AND 23

PROGRAM

H. P. HANAFORD, Program Department, 1400 BROADWAY, NEW YORK.

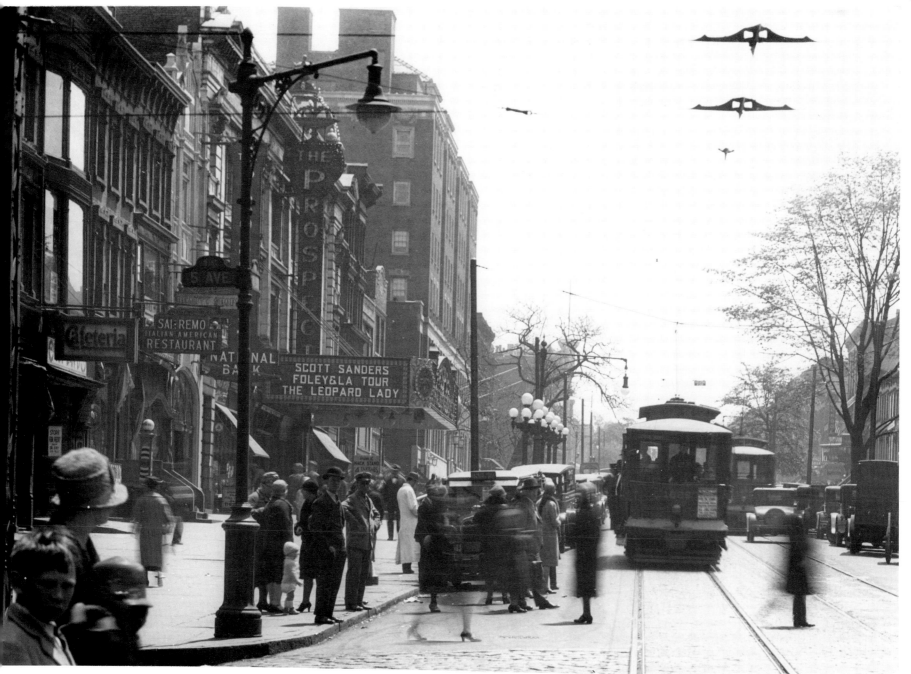

Ninth Street, southeast from Fifth Avenue - 1928

A northbound trolley passes the Prospect Theatre. The recently completed YMCA (Prospect Park branch) is up the block. This photograph was taken from underneath the Fifth Avenue "el".

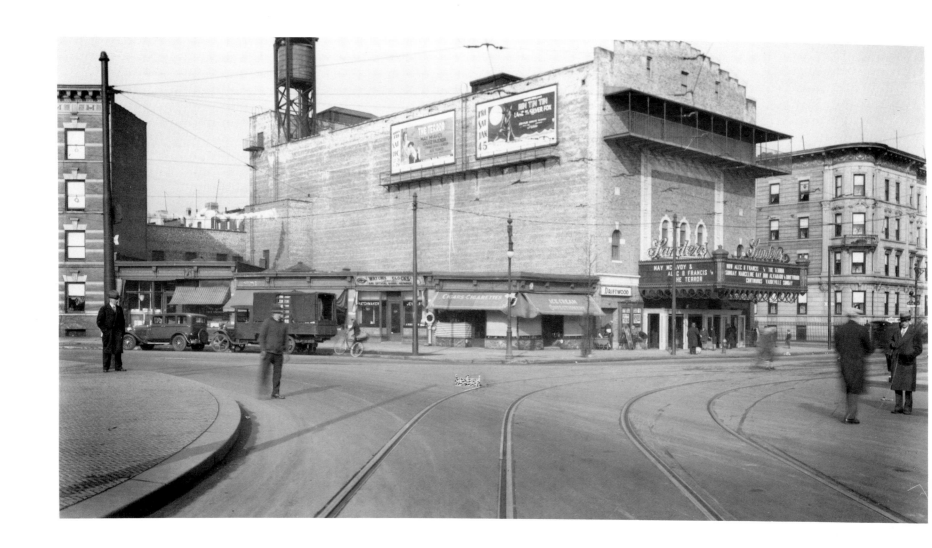

The Sanders Theatre, from Bartel-Pritchard Square - 1928

Built in the mid-1920s, the Sanders closed during the 1980s. It was renovated recently and reopened as a multiplex theatre boasting a new name, The Pavilion.

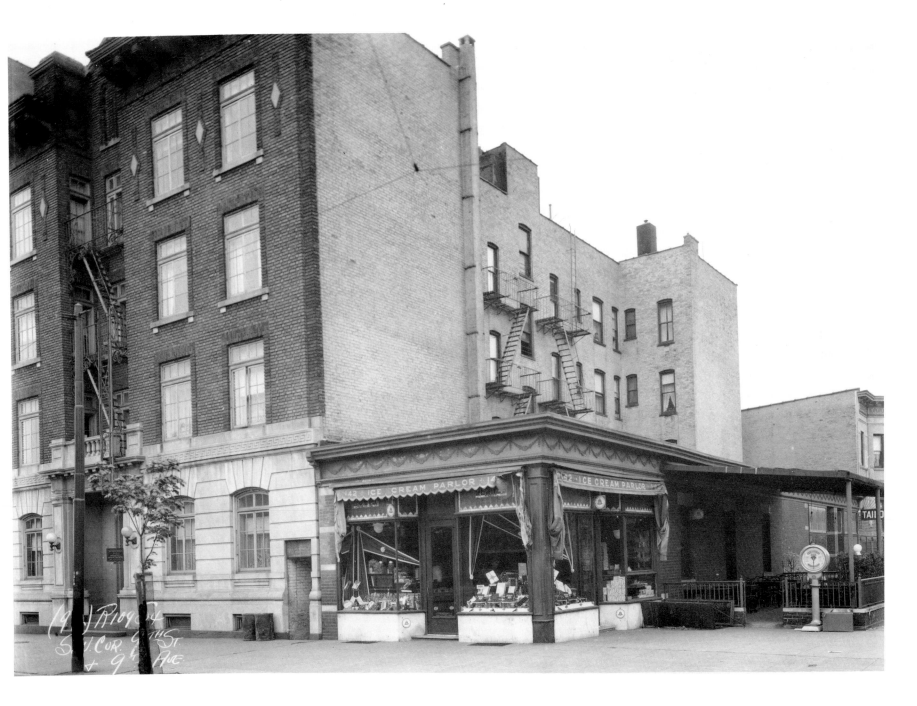

Ice Cream Parlor, No. 142 Prospect Park West, corner Ninth Street - 1928

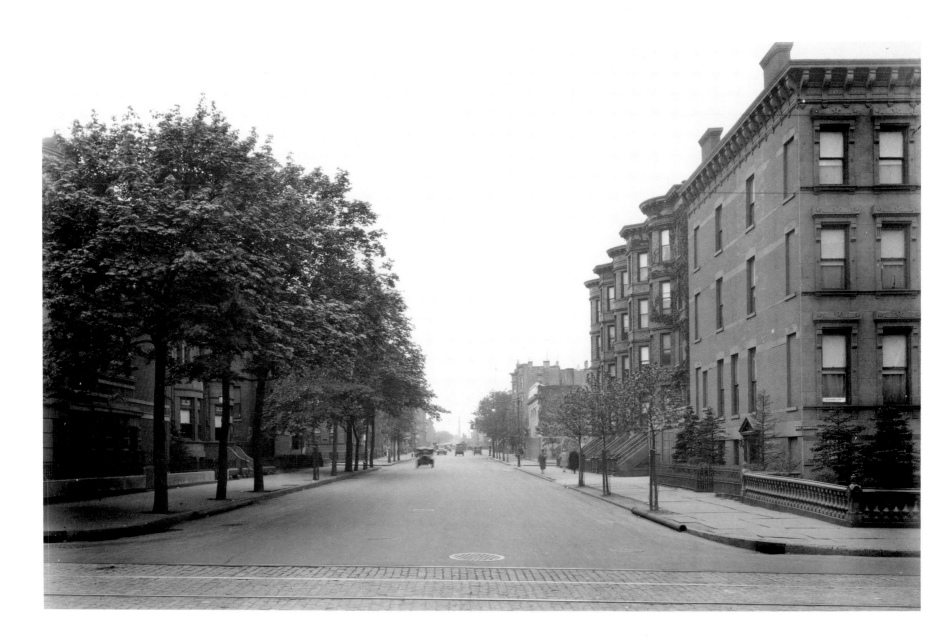

Eighth Avenue, southwest from Ninth Street - 1928

The medical offices of Dr. Herbert C. Fry were located in the corner building, on the right. The smokestack in the distance, near Nineteenth Street, belonged to The Maltime Manufacturing Company.

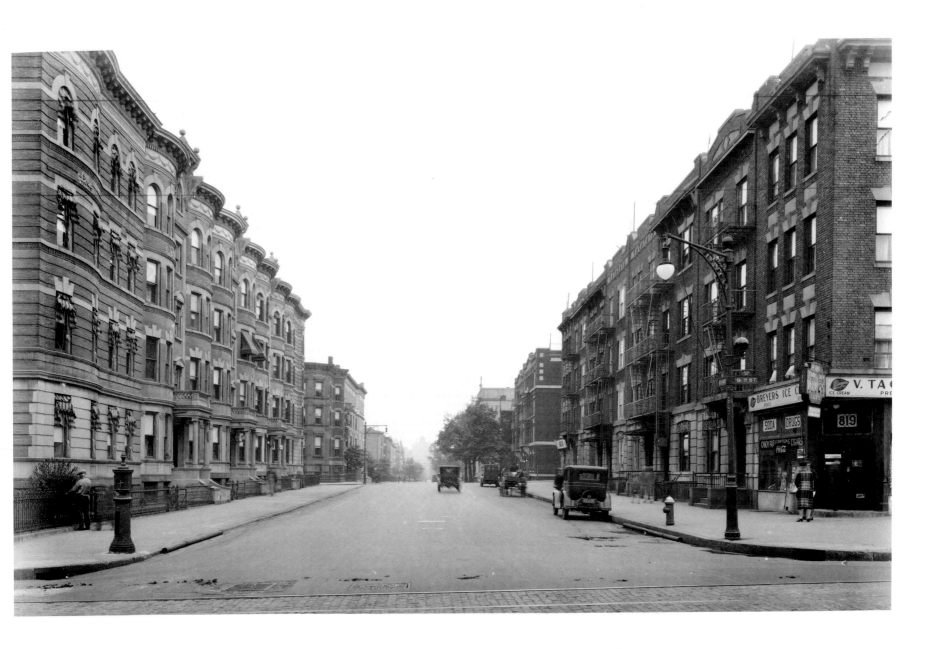

Eighth Avenue, northeast from Ninth Street - 1928

Breyer's ice cream is featured at the corner store. Saint Saviour's Roman Catholic Church is visible on the right, at Sixth Street.

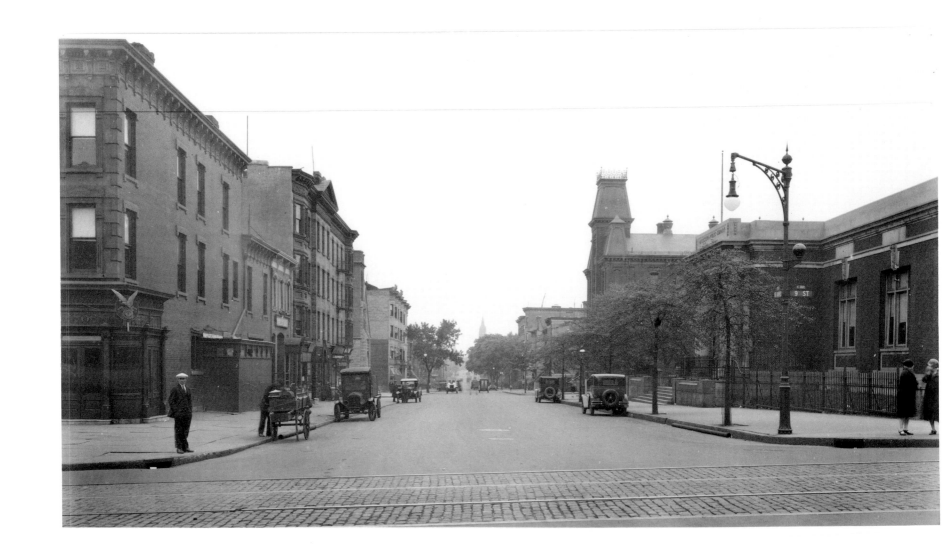

Sixth Avenue, northeast from Ninth Street - 1928

The corner tavern had been closed since the onset of Prohibition, in 1920. To the right is the Brooklyn Public Library. P.S. 39 is just beyond Eighth Street. Way in the distance, at Lincoln Place, is the top of the Sixth Avenue Baptist Church.

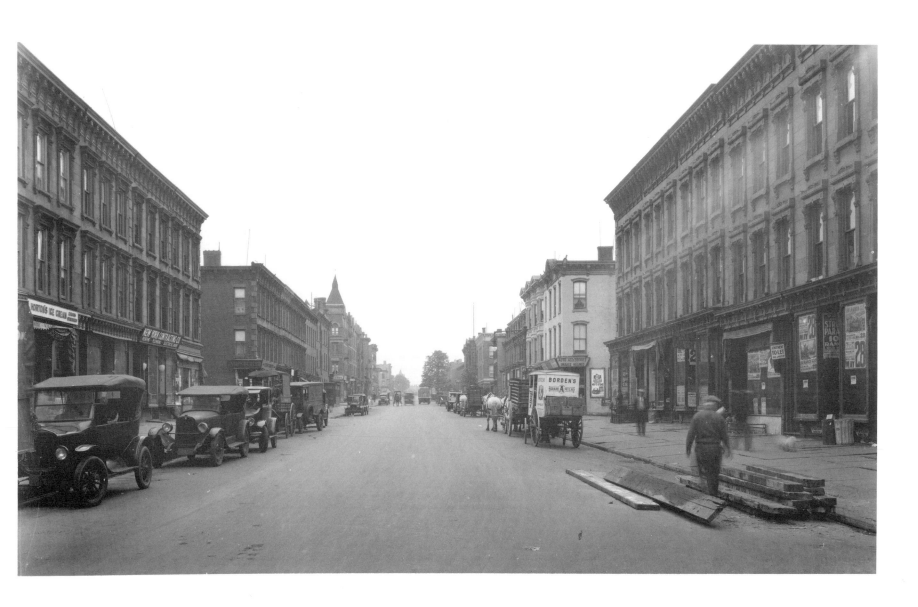

Sixth Avenue, southwest from Ninth Street - 1928

A Borden's milk wagon is parked on the right. A number of stores are vacant a year before the Stock Market would crash. Sixth Avenue, this side of Ninth Street, had many storefronts.

Fourth Avenue, northeast from Sixth Street - 1928

Automobile service businesses line the avenue's west side between Sixth and Third Streets. To the right is the yard of Borden's Milk Company. Washington Park had recently been demolished.

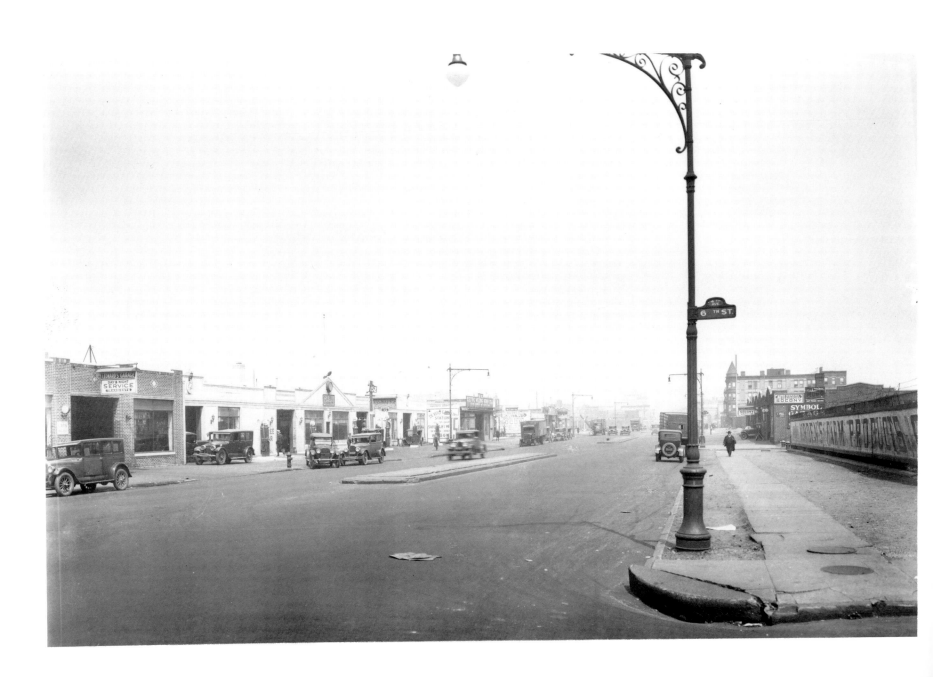

Avon Theatre, No. 289 Ninth Street - 1929

The main entrance to this small theatre was around the corner, at No. 264 Eighth Street. This is a northwest view from Fifth Avenue. A laborer holds a shovel near piled cobblestones.

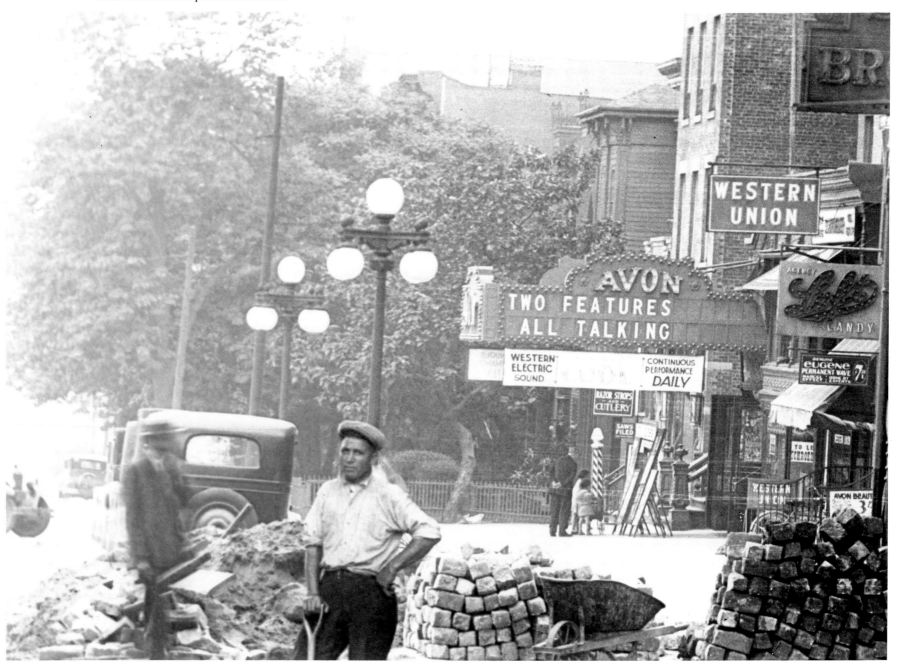

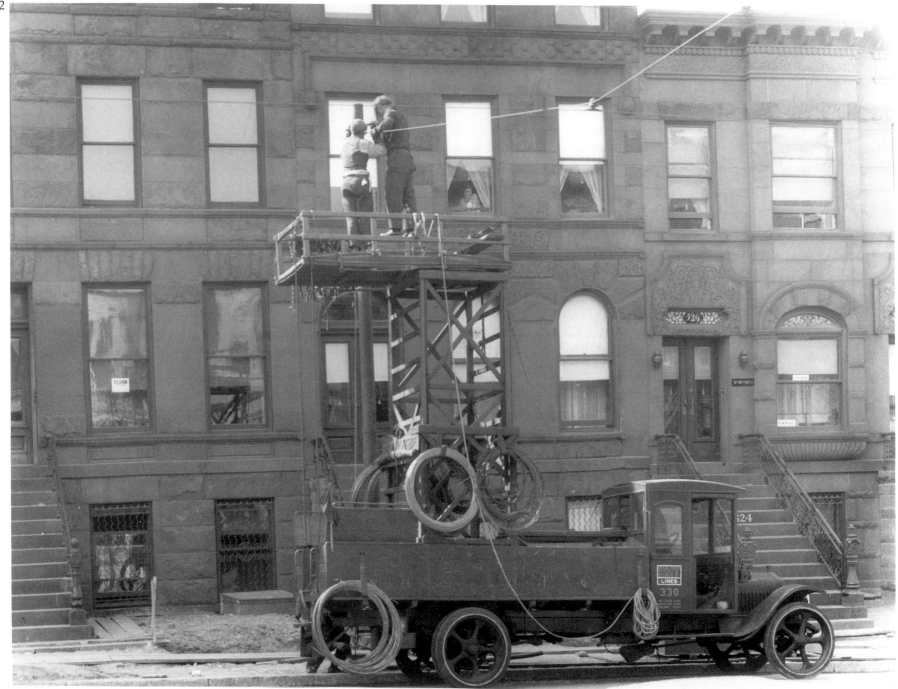

Nos. 524 & 526 Ninth Street - 1930

BMT (Brooklyn-Manhattan Transit) Line workers were busy attaching the cables which suspended the trolley wires above Ninth Street. The cables were affixed to poles set into the sidewalk at prescribed intervals.

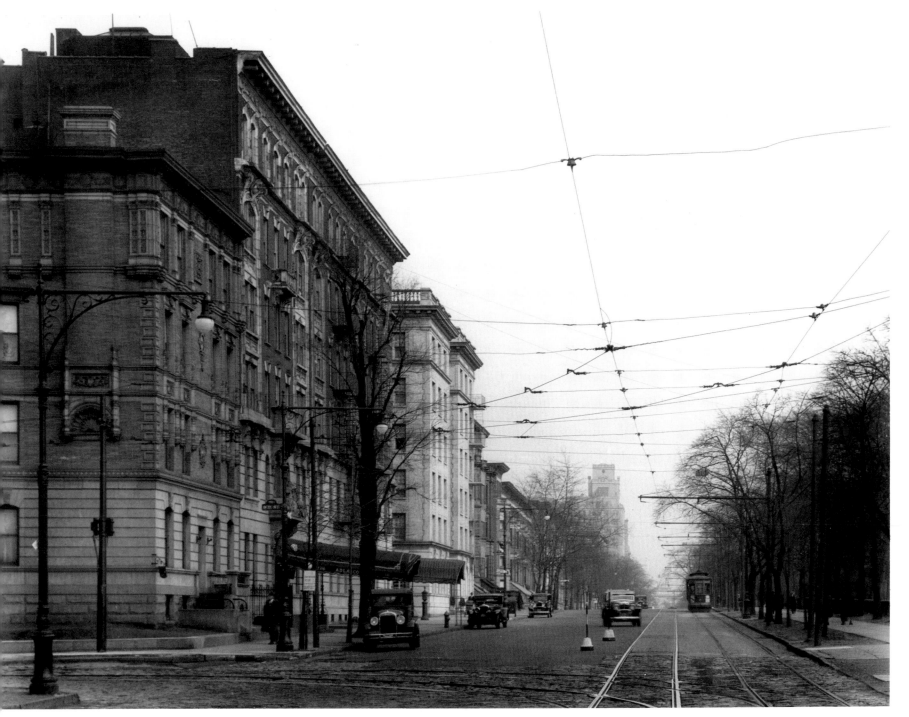

Prospect Park West, northeast at Ninth Street - 1931

The Litchfield, the four-story apartment house at the left, was built around 1900. The six-story buildings with the awnings were put up around 1910.
The light brick apartment house, just past Eighth Street, was erected around 1913.

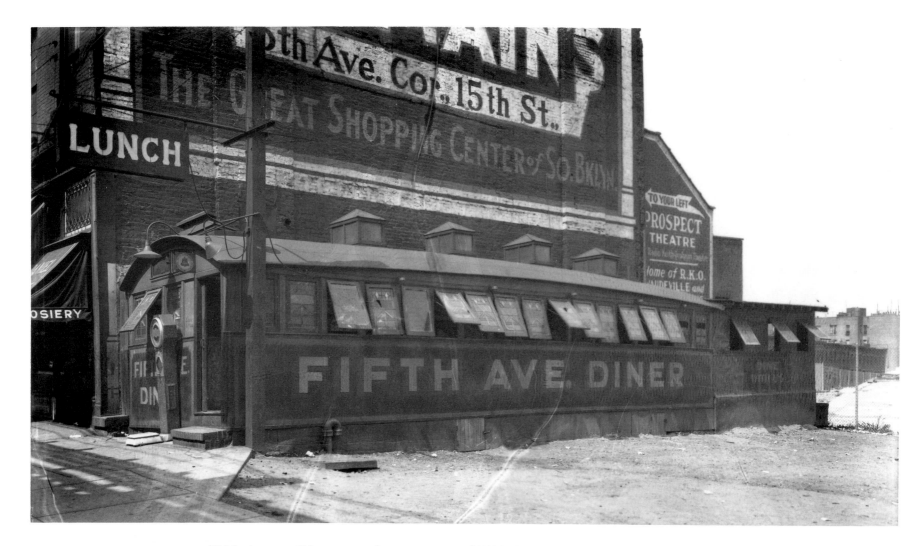

Fifth Avenue Diner - southeast corner of Fifth Avenue and Ninth Street - 1931

This concession, located on land leased from the IND subway, was operated by John J. Reilly and Mauriee T. Moran.

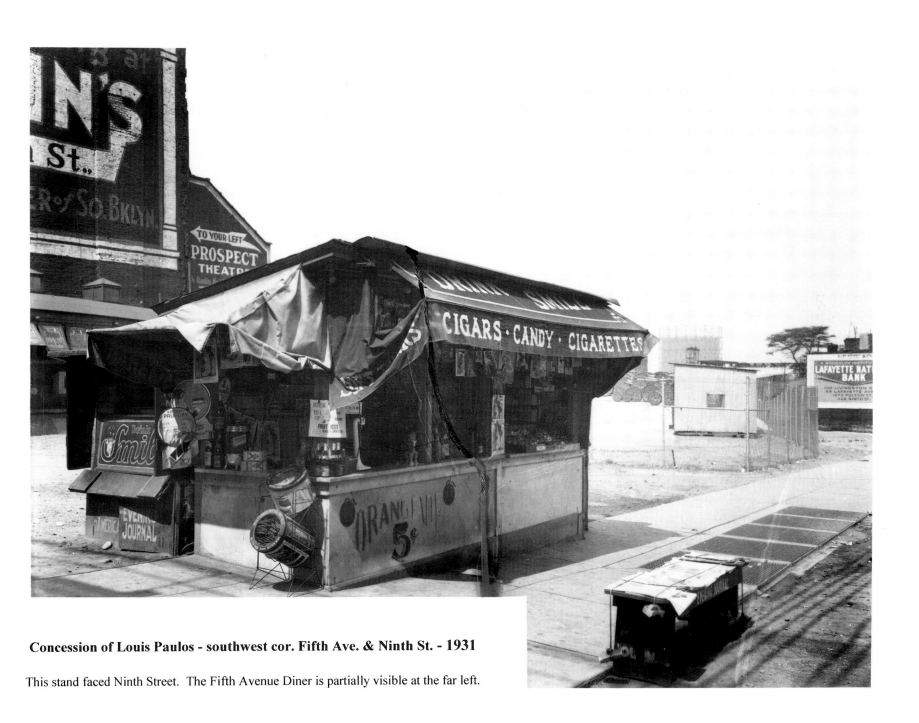

Concession of Louis Paulos - southwest cor. Fifth Ave. & Ninth St. - 1931

This stand faced Ninth Street. The Fifth Avenue Diner is partially visible at the far left.

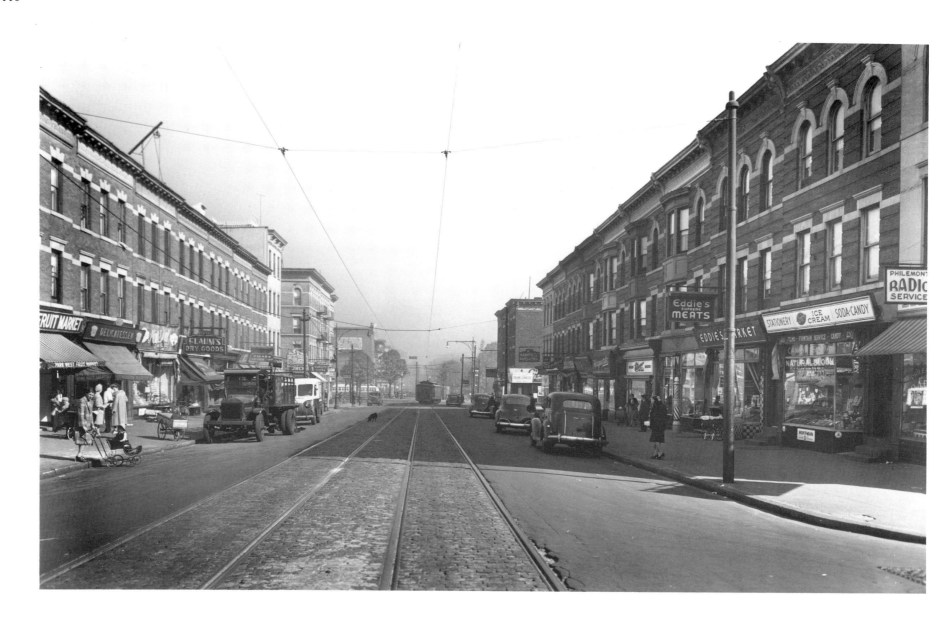

Prospect Park West (Ninth Avenue), northeast from Windsor Place - 1944

Farrell's Bar & Grill is just down the block on the right.

The steeple of the First Reformed Church at Carroll Street, half-a-mile in the distance, is quite clear. Acme Hall, on the left, has had its parapets altered and its corner tower removed.

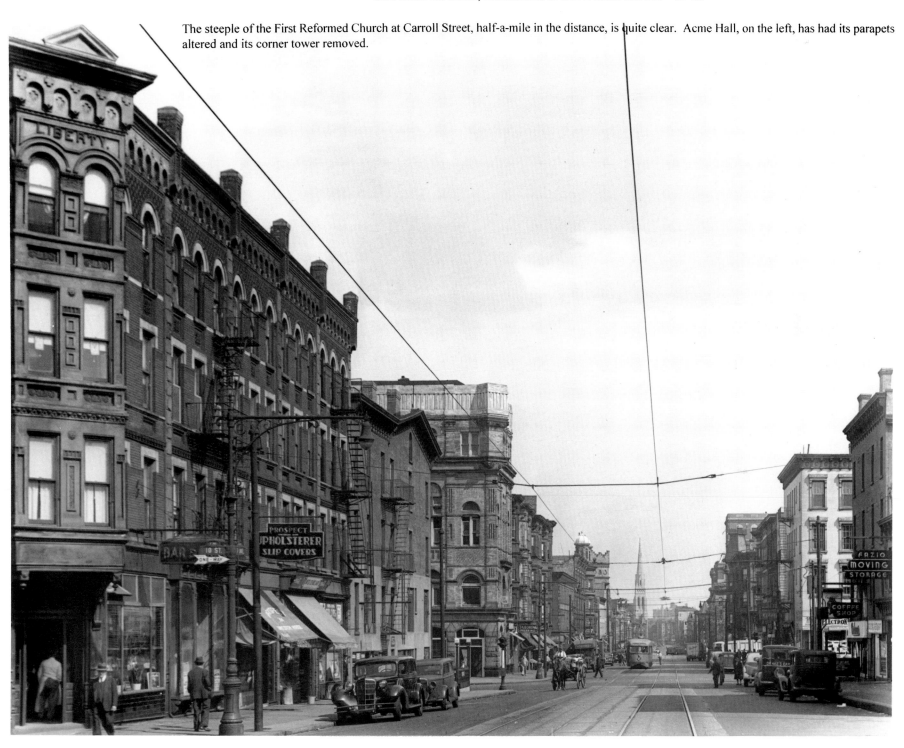

Fifth Avenue, southwest at Baltic Street & Park Place - 1946

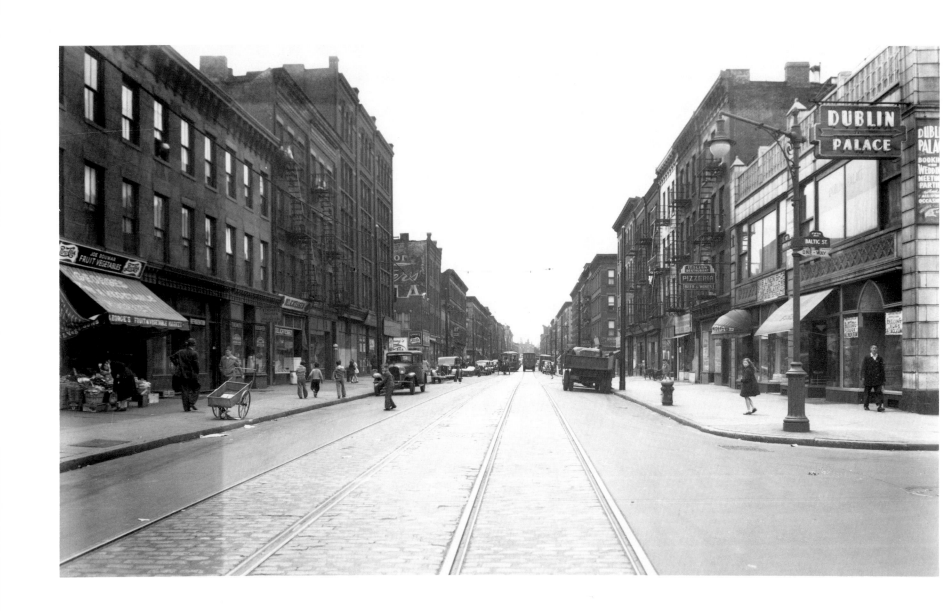

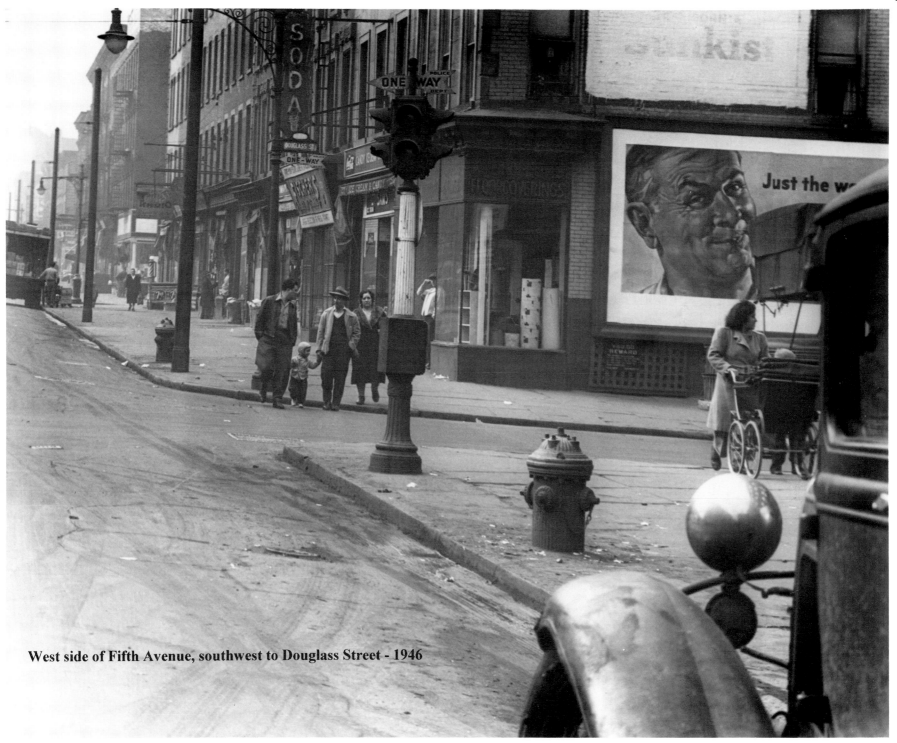

West side of Fifth Avenue, southwest to Douglass Street - 1946

Flatbush Avenue, north from Grand Army Plaza - 1946

The 15-story Park Tower Apartments were built during the 1920s.

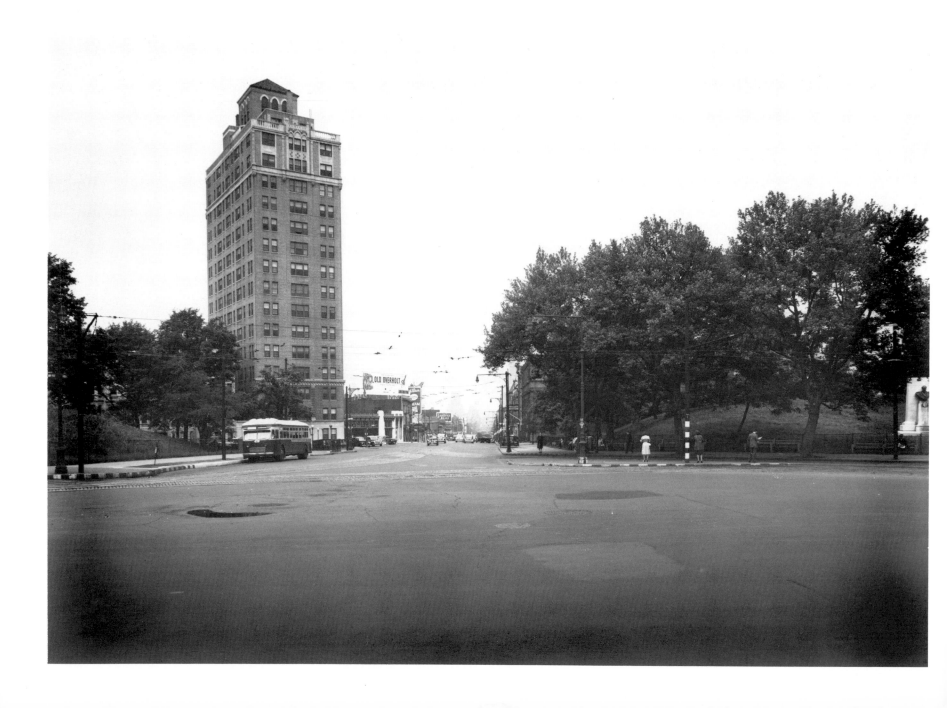

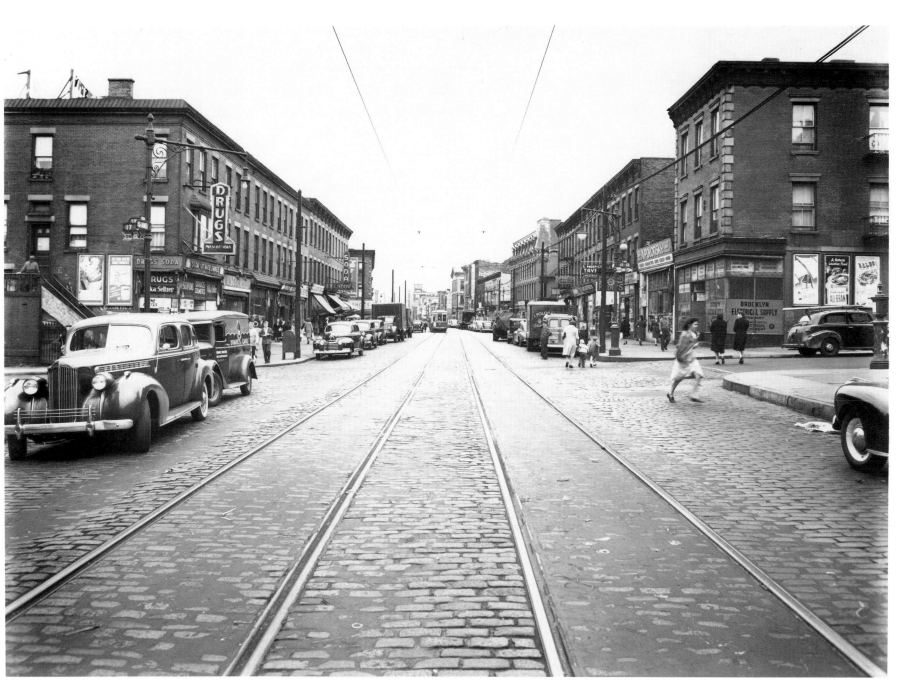

Fifth Avenue, northeast to Seventeenth Street - 1946

A trolley bound for Bay Ridge is passing Prospect Avenue as a woman hurries to the sidewalk on the right. A Drake's Cake delivery truck is parked on the corner, at left.

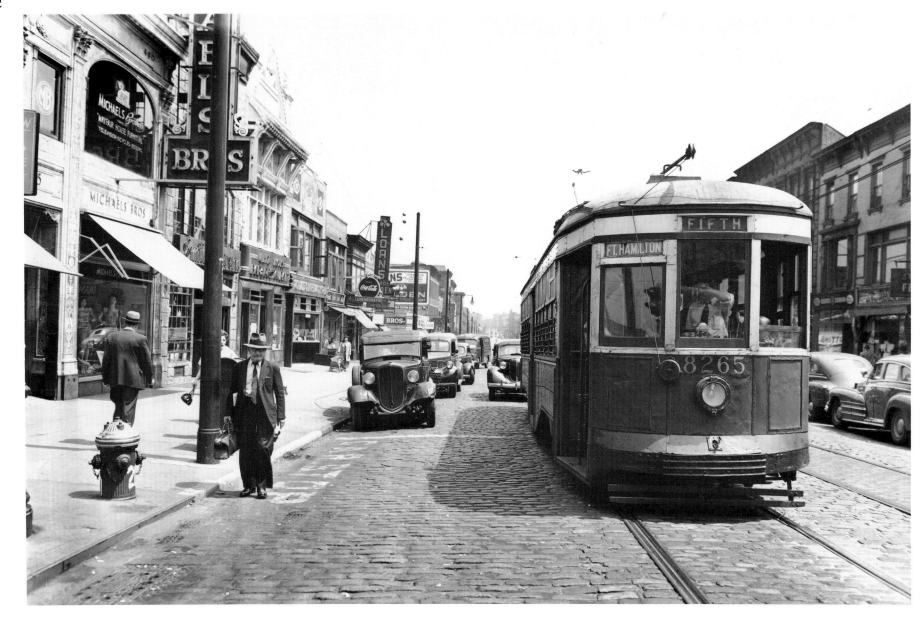

Fifth Avenue, northeast from Ninth Street to Eighth Street - 1947

Trolley No. 8265 stopped in front of Michaels Bros. furniture store.

Fifth Avenue, northeast to Union Street - 1948

The Manufacturer's Trust Company is at Union Street. Cohen's Fifth Avenue Bar and Grill occupied No. 217, on the right. It is now home to Bob & Judi's Coolectibles. This section still has many old-timers, most of whom are of Italian descent. The natives of this quarter still refer to their neighborhood as South Brooklyn. A fitness club, Body Reserve, now occupies the corner bank building.

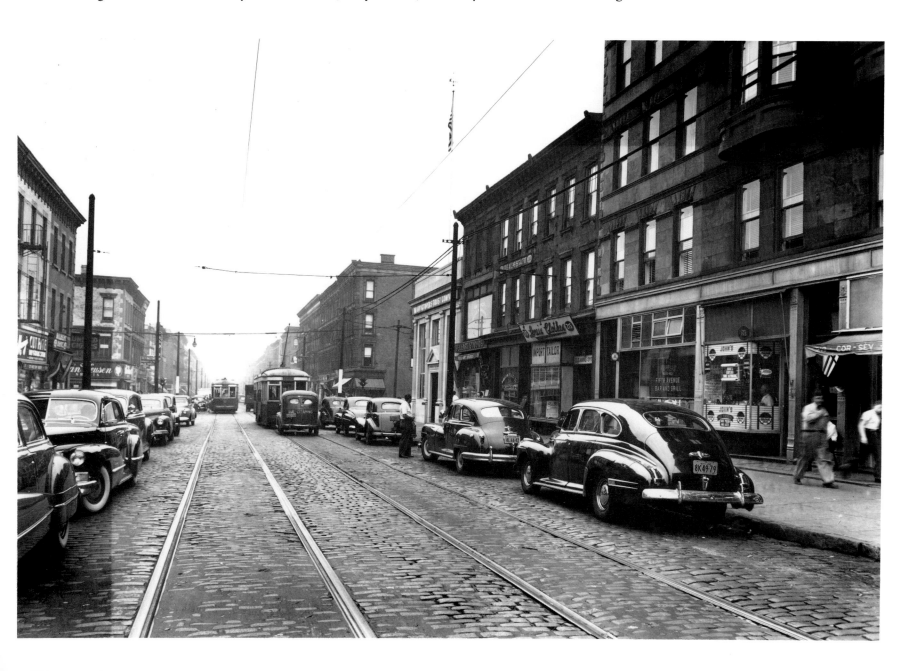

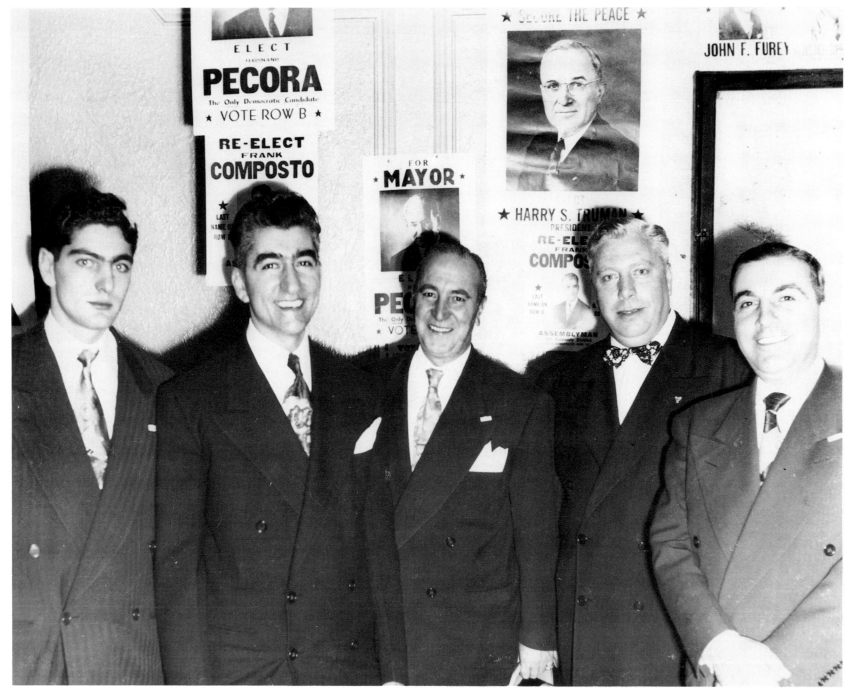

United Mazzini Regular Democratic Club Members - 1948

James (Guy) Mangano, the club leader, is in the center. To his right is the Assemblyman and future Kings County Supreme Court Justice Frank Composto Sr.

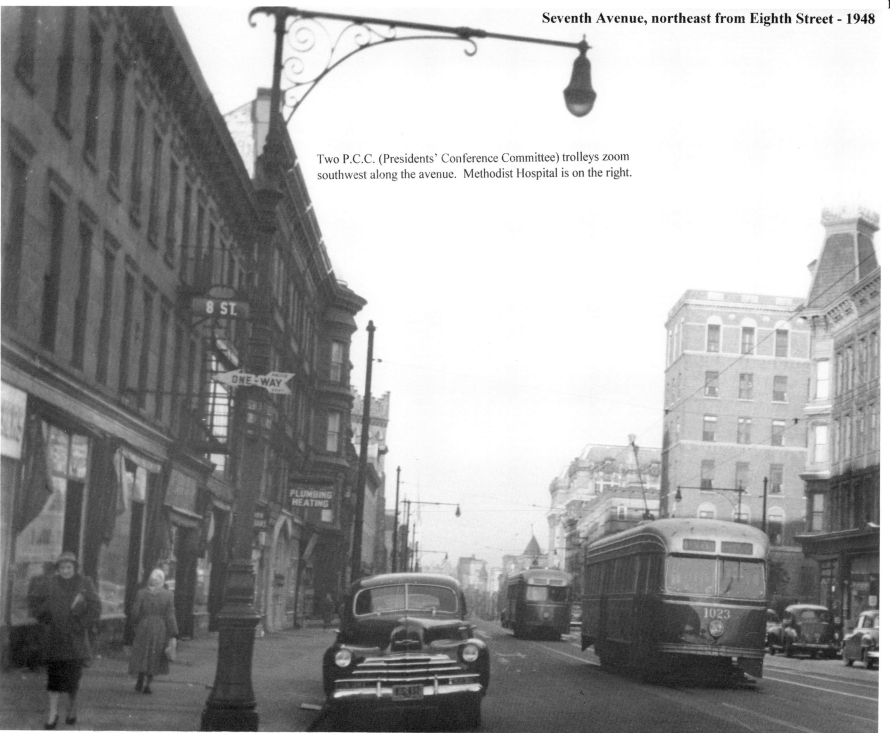

Two P.C.C. (Presidents' Conference Committee) trolleys zoom southwest along the avenue. Methodist Hospital is on the right.

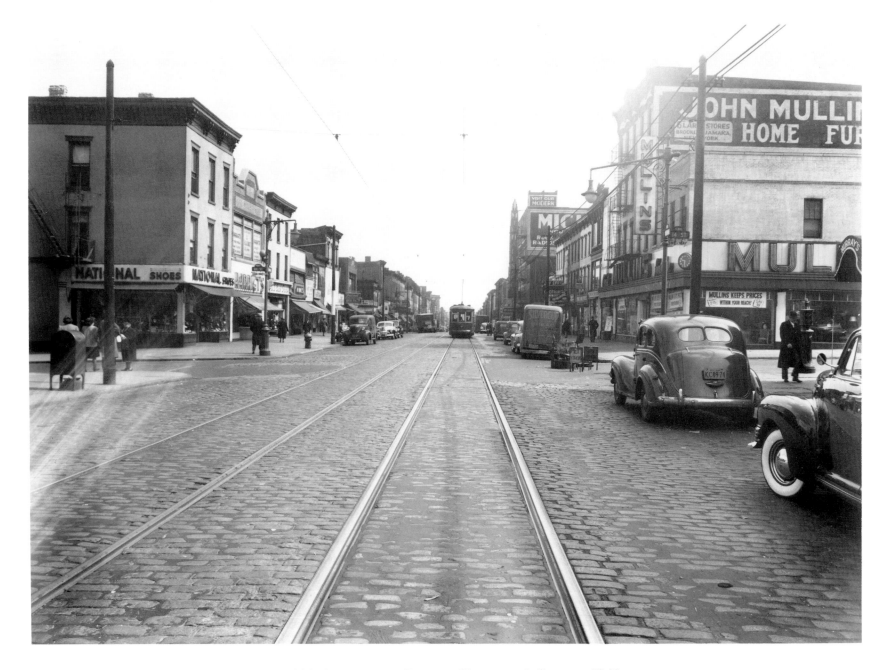

Fifth Avenue, northeast to Fourteenth Street - 1948

John Mullins furniture company, on the right, was founded about 1880 at No. 80 Myrtle Avenue. In 1948, Mullins owned six stores throughout New York City. Further down the block is J. Michael's furniture store, which closed it's four Brooklyn stores in 1996 after about 100 years in business.

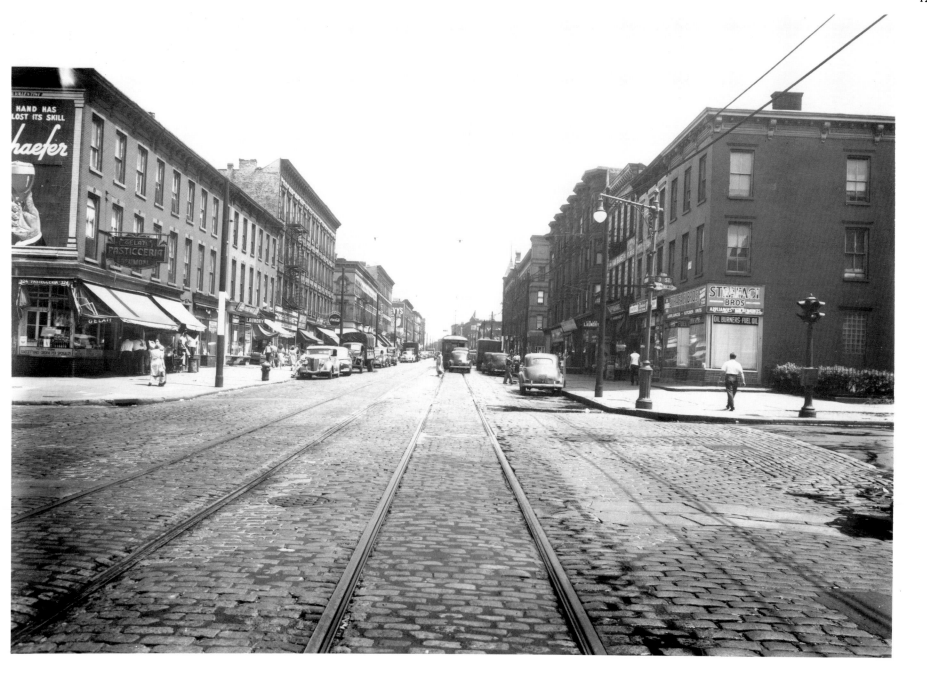

Fifth Avenue, northeast at Third Street - 1948

Gentlemen purchase *gelati* at the corner *pasticceria*. Strafaci Bros. appliance store occupies the opposite corner.

Ninth Street, northwest from Seventh Avenue - 1949

Pedestrians cross while Smith Street trolley No. 8184 waits. The YMCA is beyond Sixth Avenue.

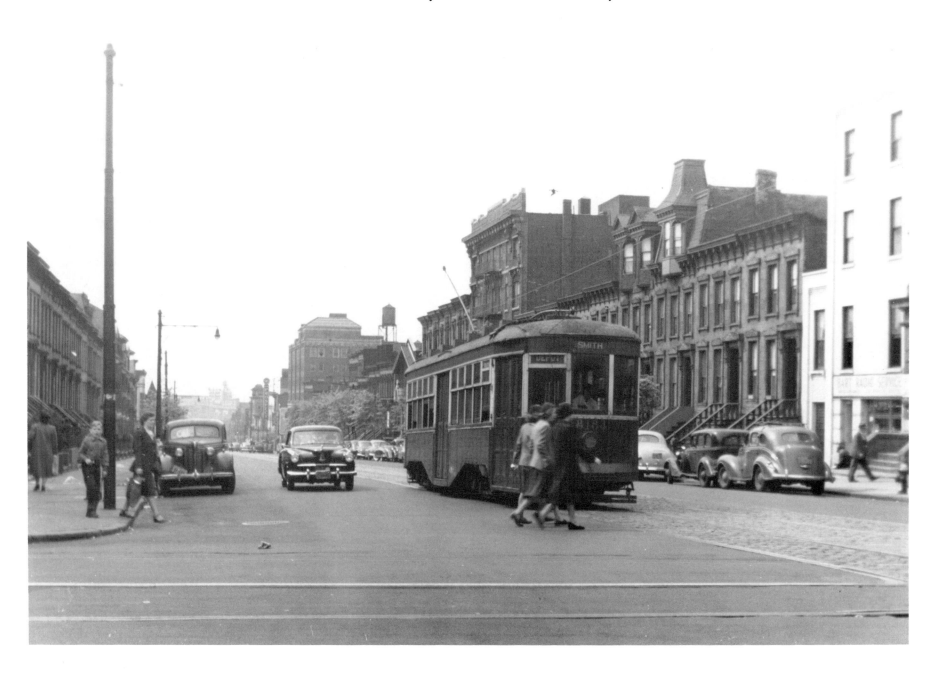

Union & Plaza Streets, looking west - 1949

The fifteen-story flatiron-style apartment house at right was built in the 1920 s. Elks Hall, Post 22, occupied Nos. 912-914 Union Street.

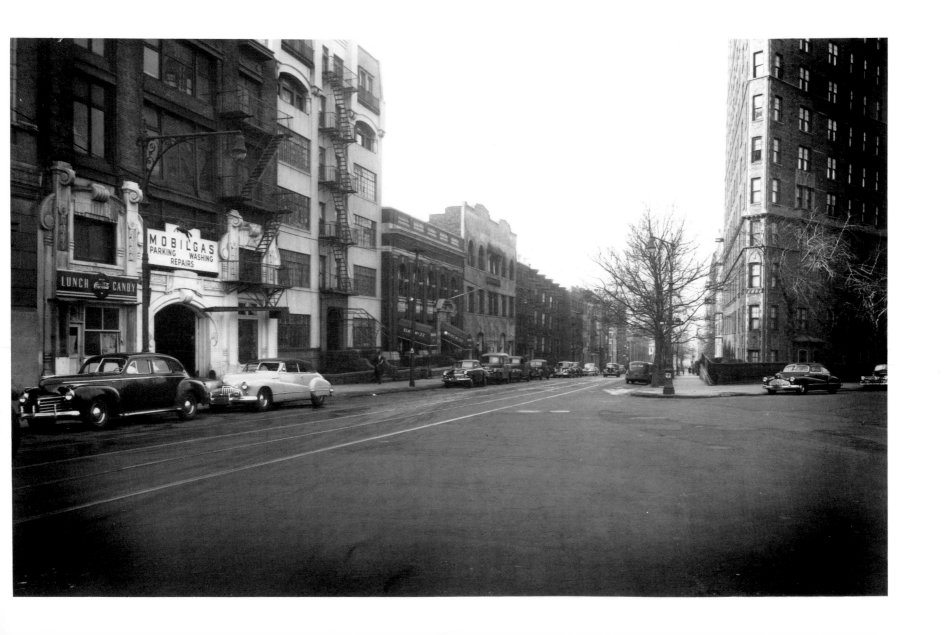

Seventh Avenue, northeast to Garfield Place - 1949

Seventh Avenue trolley No. 8298 is passing Ebinger's Bakery. The First Reformed Dutch Church proudly stands at Carroll Street.

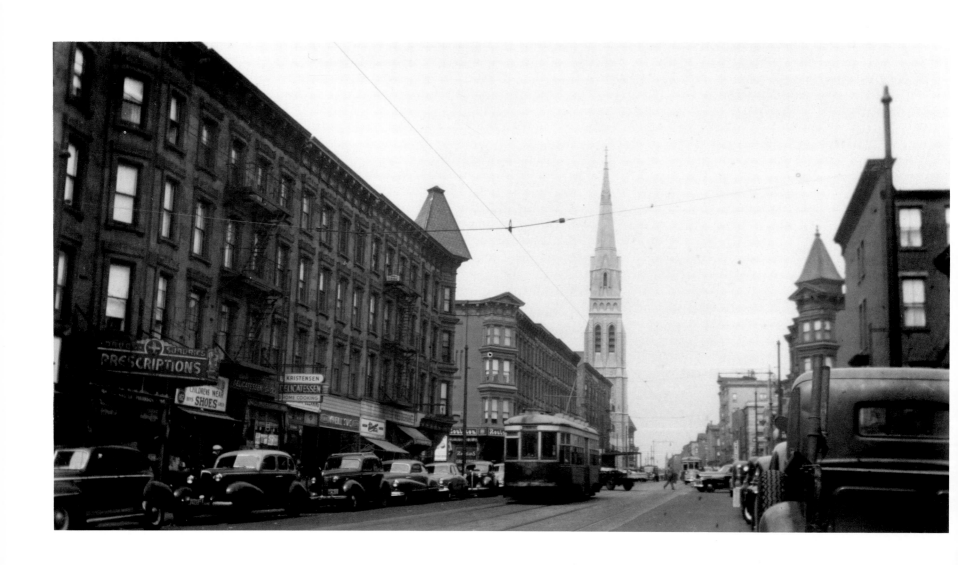

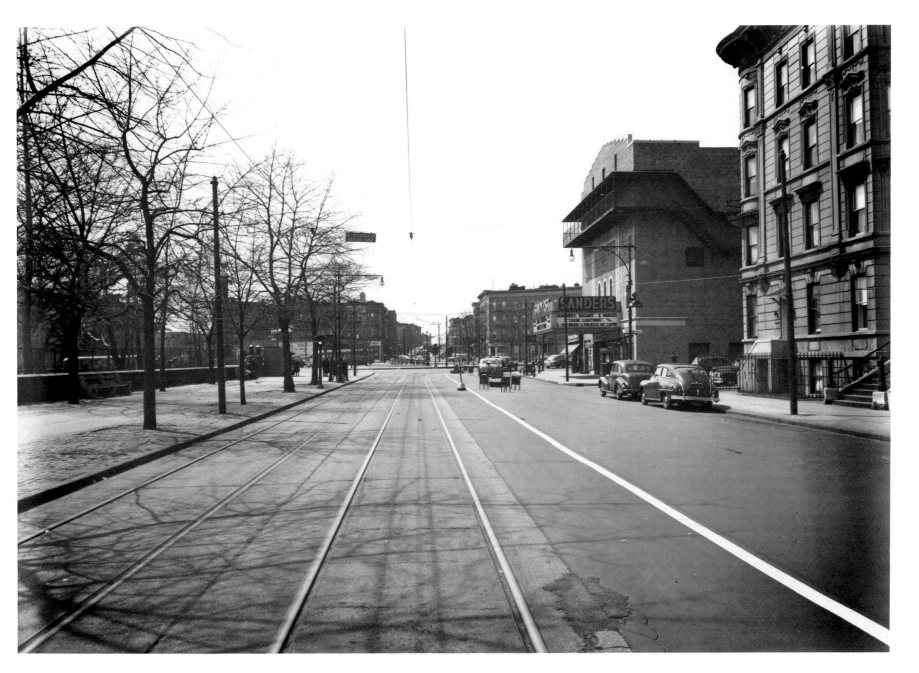

Prospect Park West, southwest to Fourteenth Street and Bartel-Pritchard Square - 1950

In 1906, architect Stanford White designed two urn -topped columns with gas lamps to be placed at Prospect Park's 15th Street entrance. Dedicated in June 1922, the circle was named after WWI Pvts. Emil Bartel of Windsor Place and Wm. J. Pritchard of Bushwick, both killed in France in 1918. In 1965 a black marble monument was dedicated to those who died in war. The modernized marquee on the theatre advertises Humphrey Bogart in the film *Chain Lightning*.

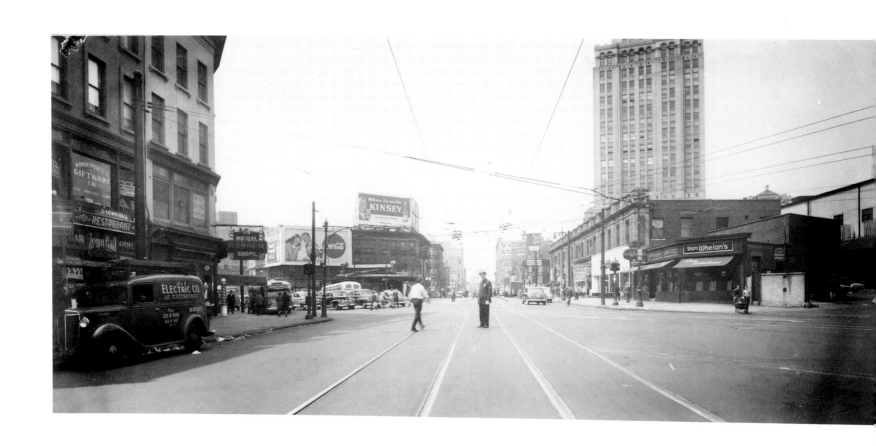

Flatbush Avenue, north to Atlantic Avenue - 1950

The Long Island Railroad station, on the right, was demolished around 1991.

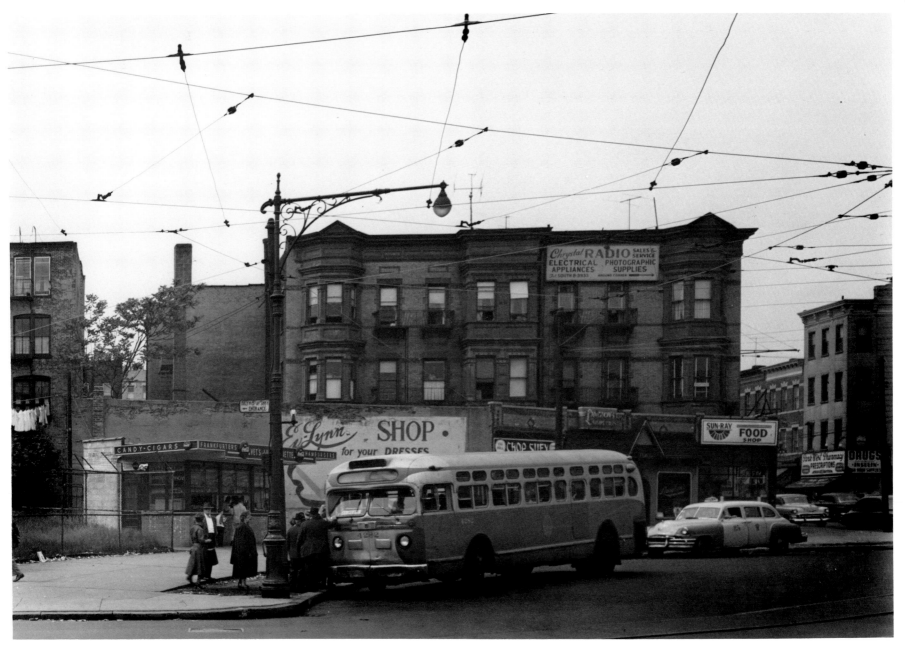

Bartel-Pritchard Square, at Prospect Park Southwest - 1950

Vet's luncheonette sold burgers and hot dogs to those waiting for buses and trolleys.

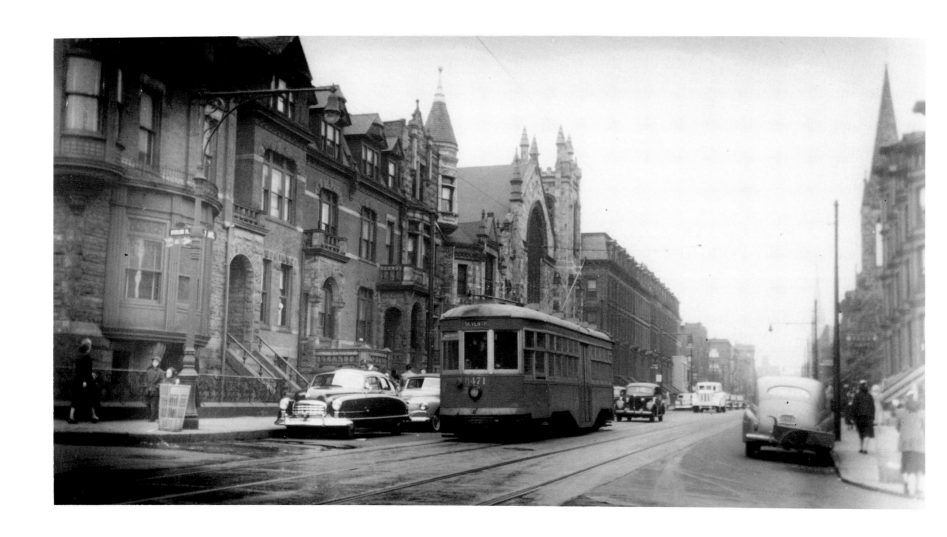

Seventh Avenue, southwest from Sterling Place - 1950

Trolley No. 8471 obscures the lower half of Grace Methodist Episcopal Church. A plane would crash at this intersection ten years later.

Looking west across the Plaza - 1951

The 80-foot–high Soldiers' and Sailors' Memorial Arch, designed by John Hemingway Duncan, was erected in 1892. Its cornerstone was laid in 1889 by former Union general William Tecumseh Sherman. Seriously.

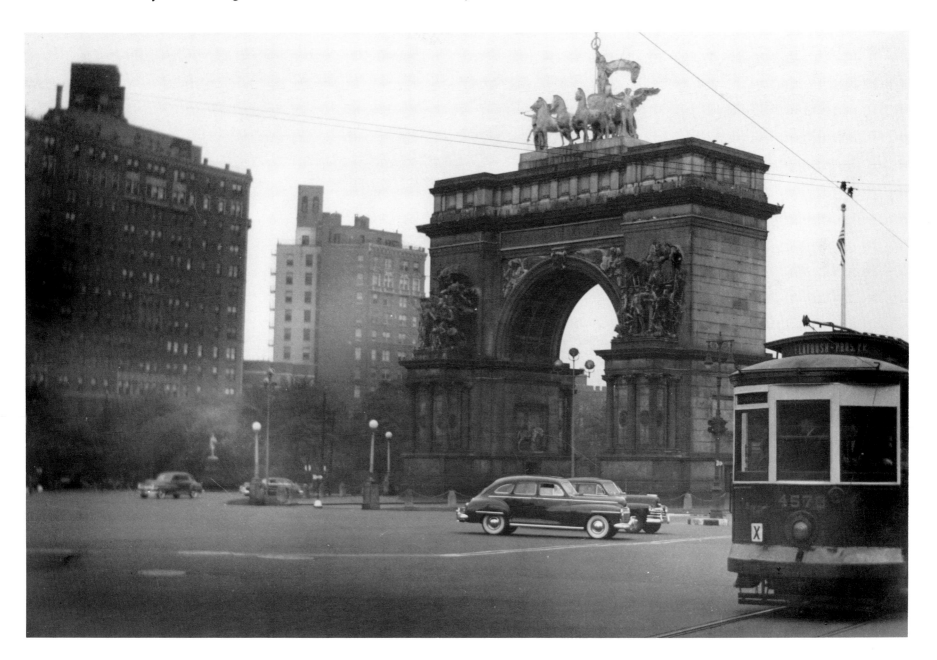

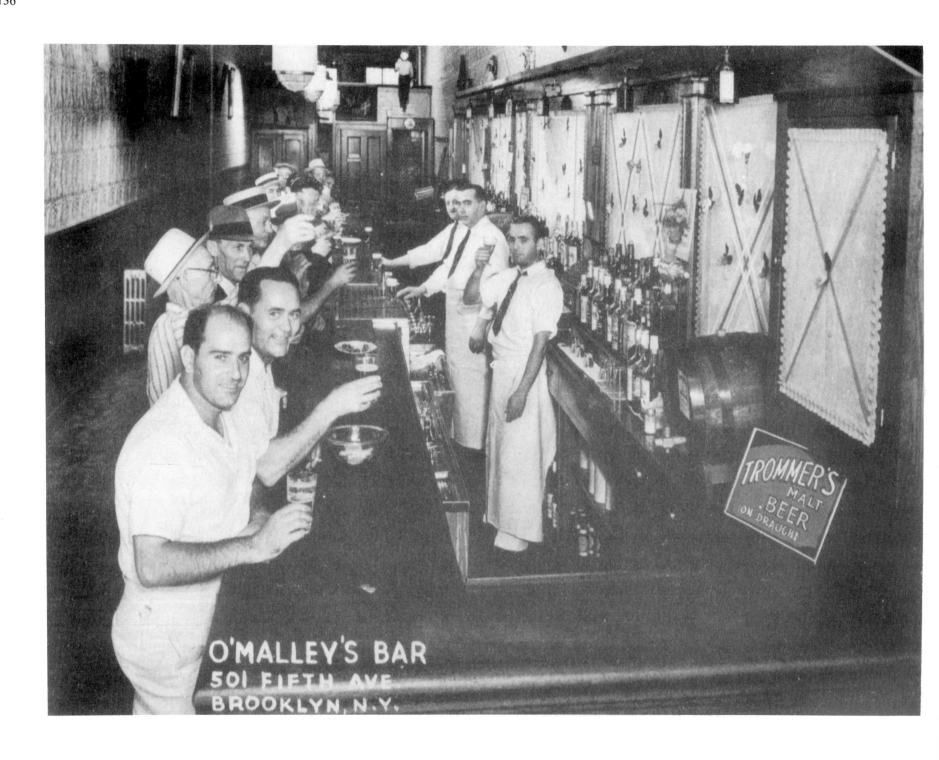

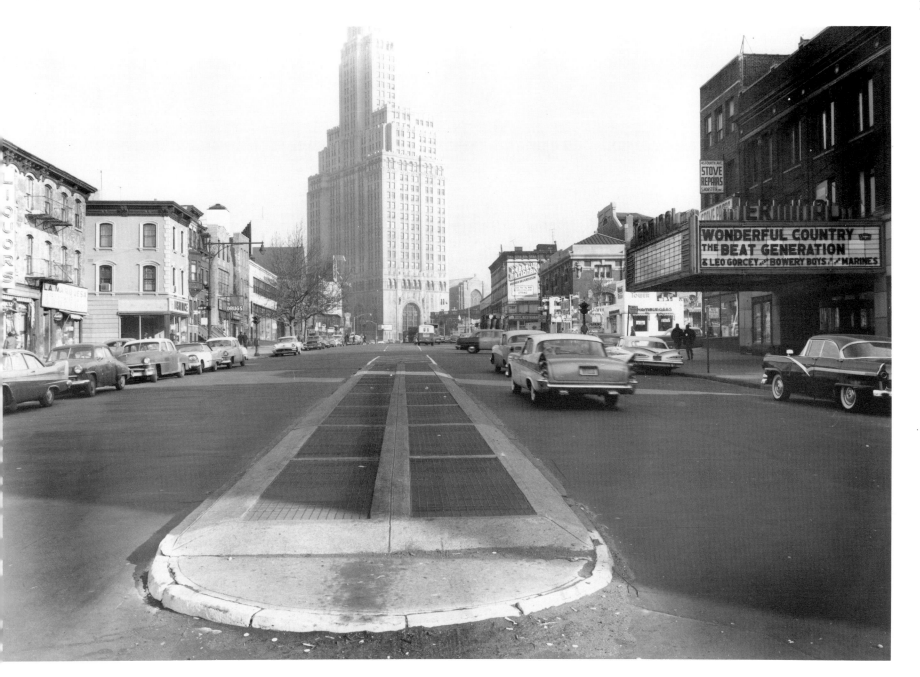

Fourth Avenue, northeast to Dean Street - 1959

The Terminal Theatre opened in the late 1920s. The Pacific Branch of the Brooklyn Public Library, on the right, was the first of the system's Carnegie libraries.

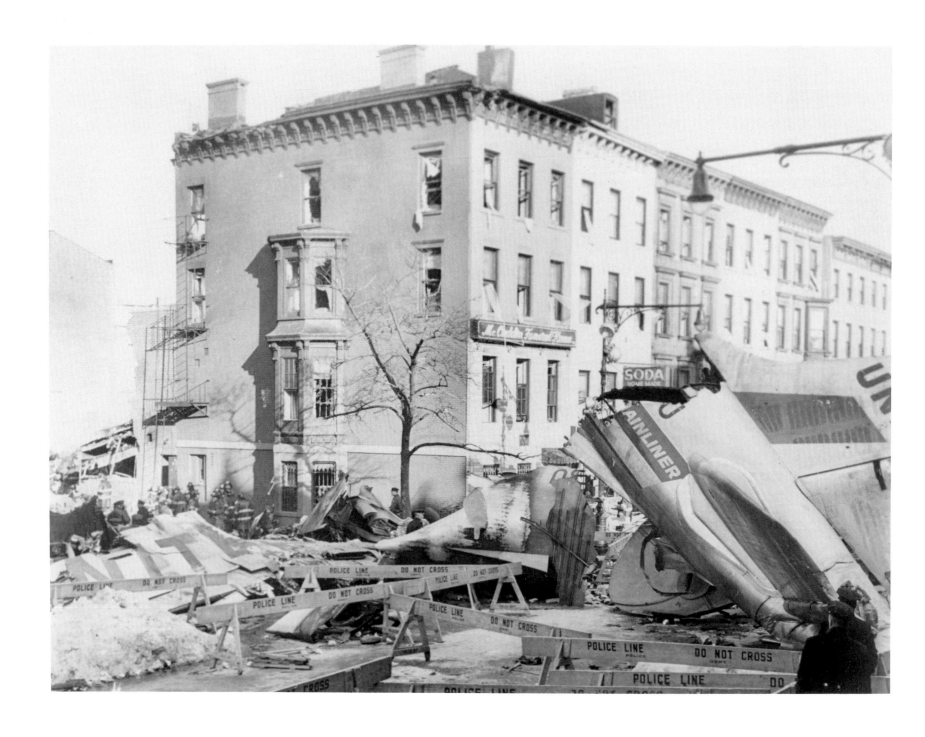

Park Slope Plane Crash

On December 16, 1960, a United Airlines DC-8 carrying 77 people and a TWA Constellation carrying 51 people were both approaching New York City at the same time. Each aircraft was traveling at an altitude of about 5,000 feet and was in constant contact with LaGuardia and Idlewild Airports. When the two blips appeared on the radar screen, the equipment of the era was unable to show how many feet separated the two planes. Suddenly, all communication between pilots and the airports stopped.

The two aircrafts had collided in mid-air. The United DC-8 had plowed into the TWA jet and had one of its wings torn off. The TWA plane crashed on the Miller Army Field in Staten Island killing everyone on board. Miraculously, no one on the ground was injured.

The pilot of the crippled DC-8 tried to head the plane toward LaGuardia Airport, but the plane crashed in Park Slope at Seventh Avenue and Sterling Place. Sections of the plane and fuselage showered cars, houses, stores, and pedestrians in the neighborhood. Eight people on the ground were killed. Debris fell onto the McCaddin Funeral Home which was later used to house displaced residents. This led to further mass confusion as people searching for loved ones were told "they're in McCaddin's" anticipating the worst, rather than that they were just being housed there. The flaming wreckage set the Pillar of Fire Church ablaze and reduced it to a pile of rubble.

From within this scene of destruction and devastation, rescue workers found eleven-year-old Steven Baltz lying in the snow and still breathing. He had sustained two broken legs and was crying for his parents. As it turns out, Steven was the sole survivor of the United DC-8. He was taken to Methodist Hospital, but after 26 hours died from the burns sustained by his lungs from the fire and smoke.

In all, 136 people died in what was the worst aviation disaster of its time.

To this day, there is a memorial display set up in the chapel of Methodist Hospital as a tribute to those who perished in this disaster. Included among the items is pocket change belonging to Steven Baltz.

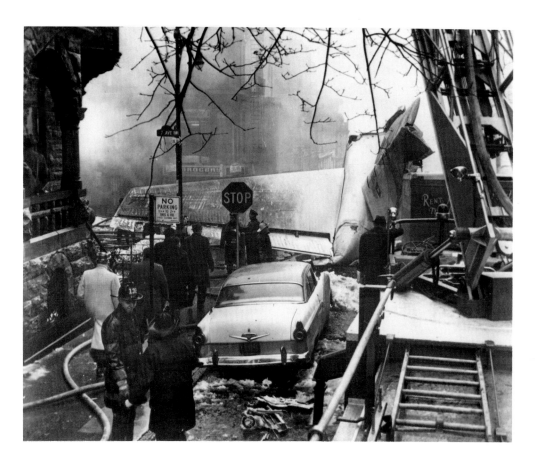

140

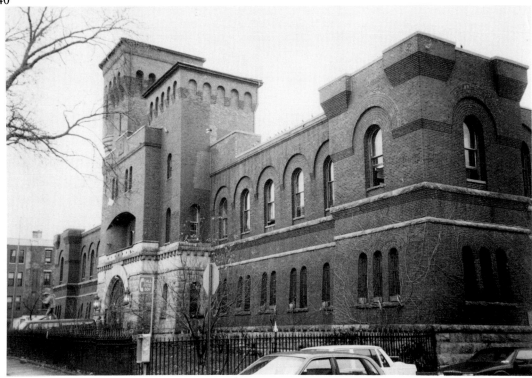

14th Regiment Armory - Eighth Avenue from Fourteenth Street - 1998

This massive 200,000-square-foot brick building with rows of arched windows, turrets at each end, and a four-story tower above the entrance, resembles a medieval castle. It was built in 1893 and was home to the Fighting 14th, which served bravely during the Civil War (1861-1865). It was occupied by the 101st Signal Battalion of the Army National Guard until the state turned it over to the city in 1994. The building has been used to shelter homeless women since 1986, an action which was protested by the neighboring community.

The bronze WWI dough boy at the entrance was taken away by the state, but returned after local veterans and officials told the state that it was donated in 1921 by Gold Star Mothers who lost husbands and sons in WWI. The armory was one of the city's top track and field centers and was recently rented by the city to Hollywood movie crews.

A plaque located at the front of the building states that the stone used for the plaque was originally located on the fields of the Battle of Gettysburg.

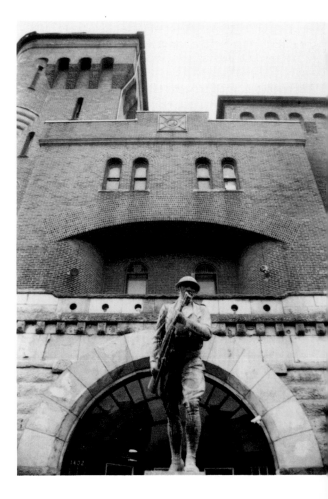

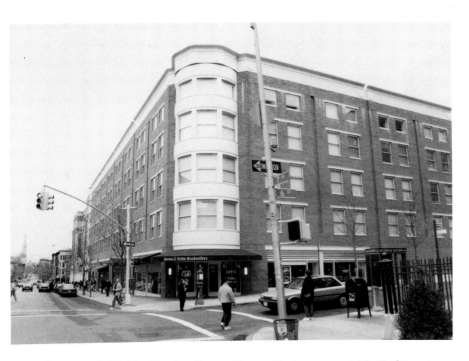

Barnes & Noble Booksellers - Seventh Avenue at Sixth Street

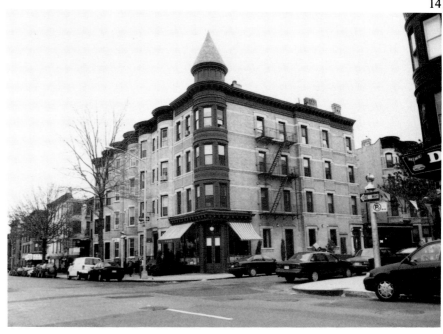

Eighth Avenue at Twelfth Street - 1998

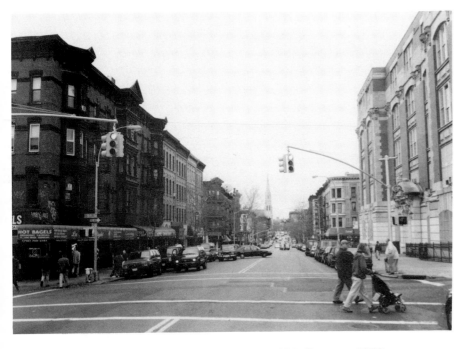

Seventh Avenue, northeast at Fifth Street - 1998

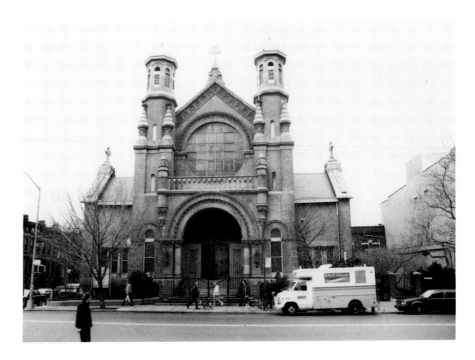

All Saints Episcopal Church, Seventh Avenue at Seventh Street

142

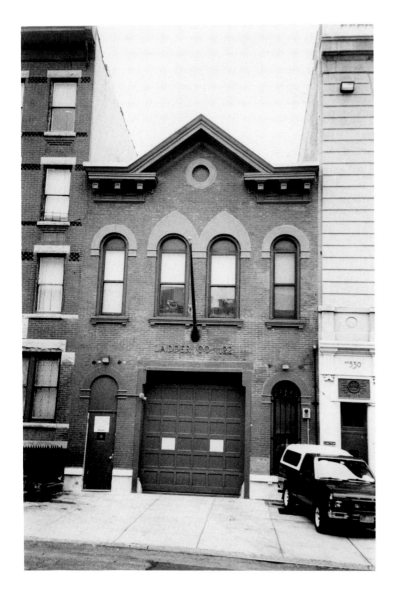

Ladder Company 122 - No. 532 Eleventh Street - 1998

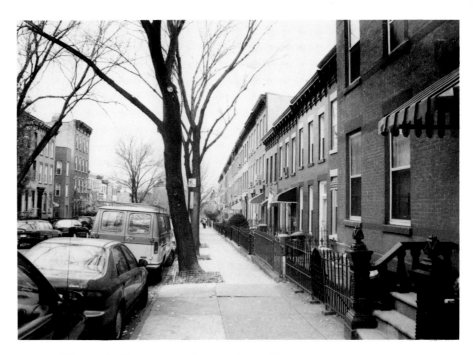

Eleventh Street, northwest from Seventh Avenue - 1998

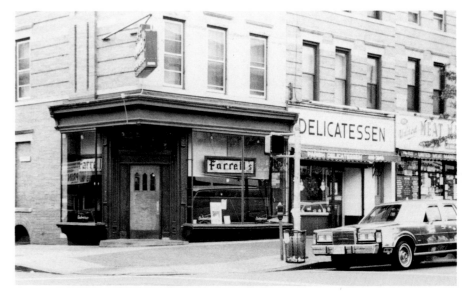

Farrell's Bar & Grill, Ninth Avenue at Sixteenth Street - 1998

This local landmark has been serving patrons since its opening in 1933.

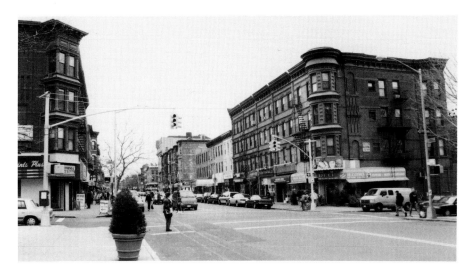

Seventh Avenue, southwest to Seventh Street - 1998

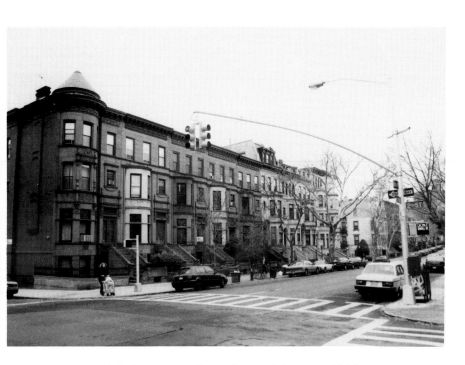

Eighth Avenue from Second Street - 1998

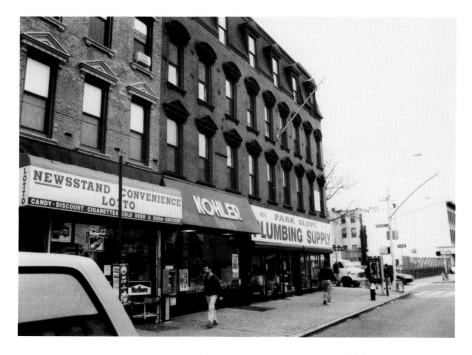

Fifth Avenue, near Prospect Avenue - 1998

144

Greenwood Baptist Church - Seventh Avenue at Sixth Street - 1998

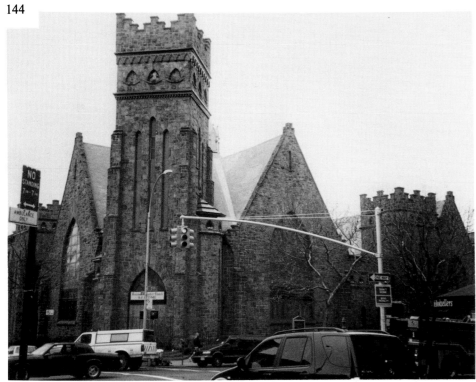

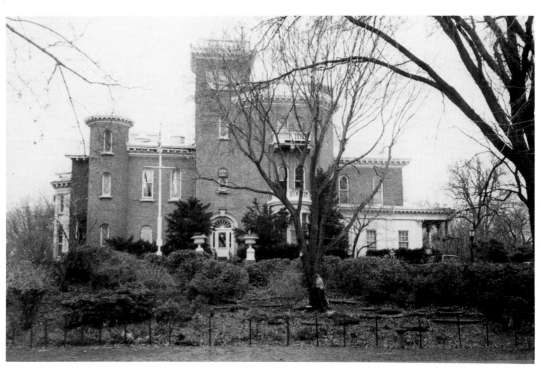

Litchfield Villa - Prospect Park at Fourth Street - 1998

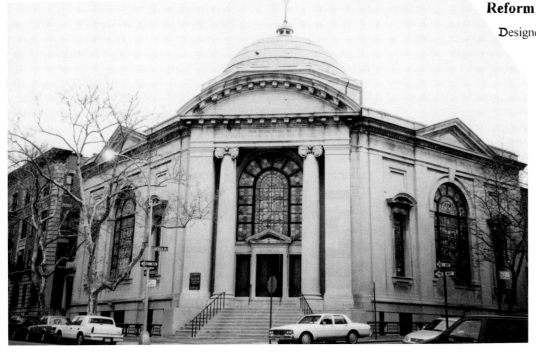

Reform Temple Beth Elohim - Eighth Avenue at Garfield Place - 1998

Designed by Simon Eisendrath with B. Horwitz, this synagogue was completed in 1910.

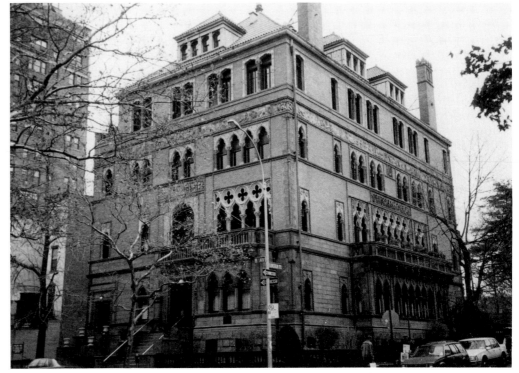

The Montauk Club - Eighth Avenue at Lincoln Place - 1998

Modeled after the *Ca d'Oro*, a Gothic palace on Venice's Grand Canal, this impressive structure was designed by Francis H. Kimball in 1889. Construction was completed in 1891. The total cost for the project, including the land, was $230,000. Membership was limited to five hundred at this prestigious club.

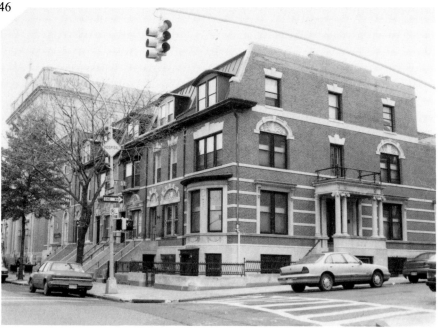

Eighth Avenue at Seventh Street - 1998

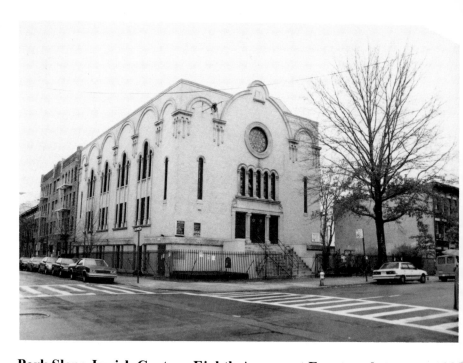

Park Slope Jewish Center - Eighth Avenue at Fourteenth Street - 1998

Founded in 1900, this structure was built in 1925. Scenes from the feature film *A Stranger Among Us* were shot in the sanctuary.

Seventh Avenue between Eleventh and Twelfth Streets - 1998

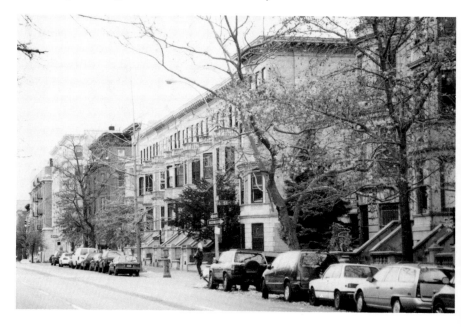

Prospect Park West, near Sixth Street - 1998

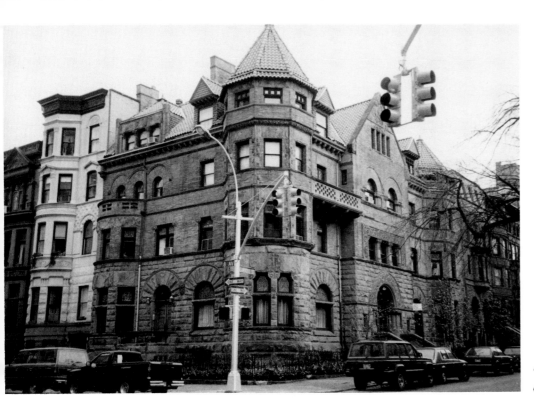

Nos. 115-119 Eighth Avenue, corner of Carroll Street - 1998

This masterpiece of Romanesque Revival-style residential architecture was designed in 1886 by C.P.H. Gilbert for chewing gum magnate Thomas Adams Jr.

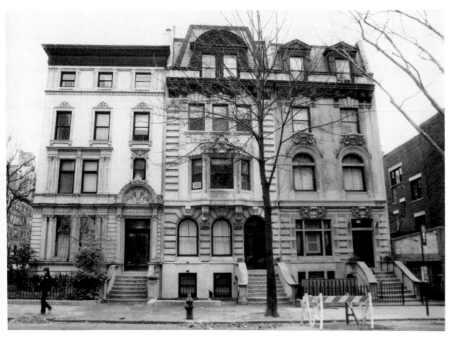

Nos. 121-125 Eighth Avenue, corner of Carroll Street - 1998

The house at the far left was probably designed by Montrose W. Morris

Real Estate Maps - 1929

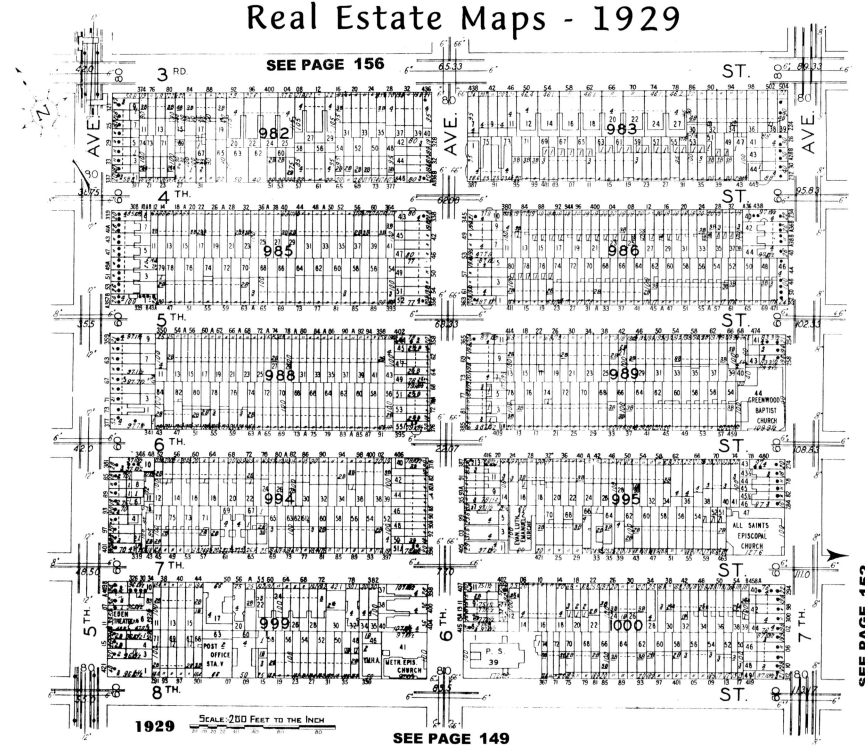

SEE PAGE 156

SEE PAGE 153

SEE PAGE 152

1929 SCALE: 200 FEET TO THE INCH

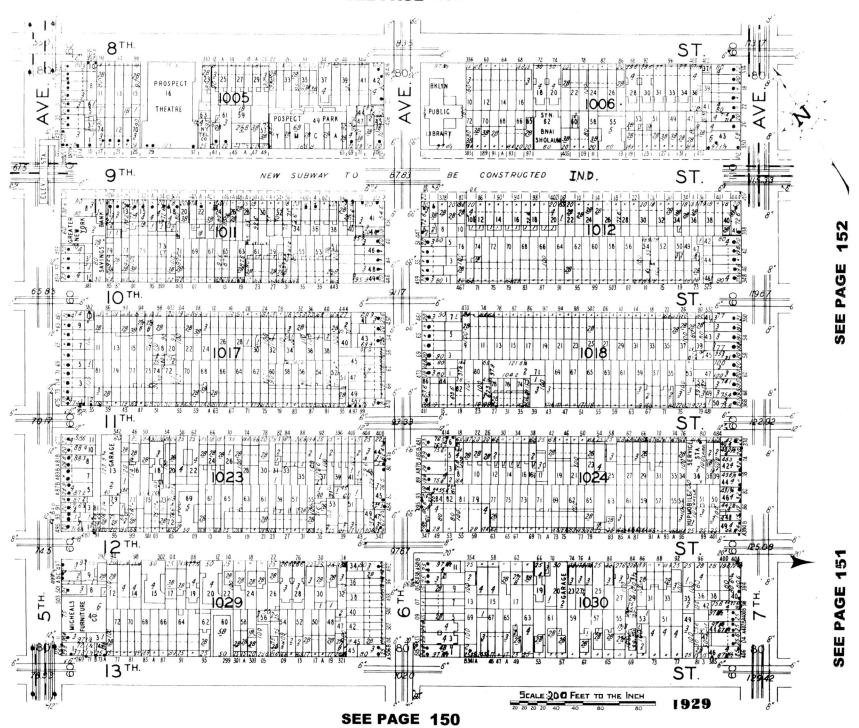

SEE PAGE 152

SEE PAGE 151

Scale 200 Feet to the Inch

1929

SEE PAGE 151

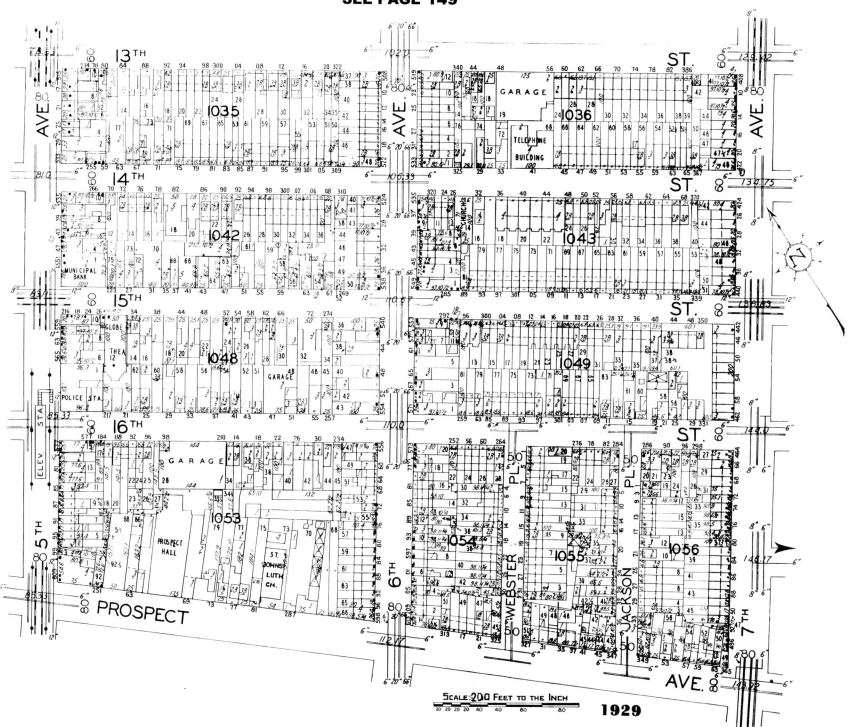

SCALE: 200 FEET TO THE INCH

1929

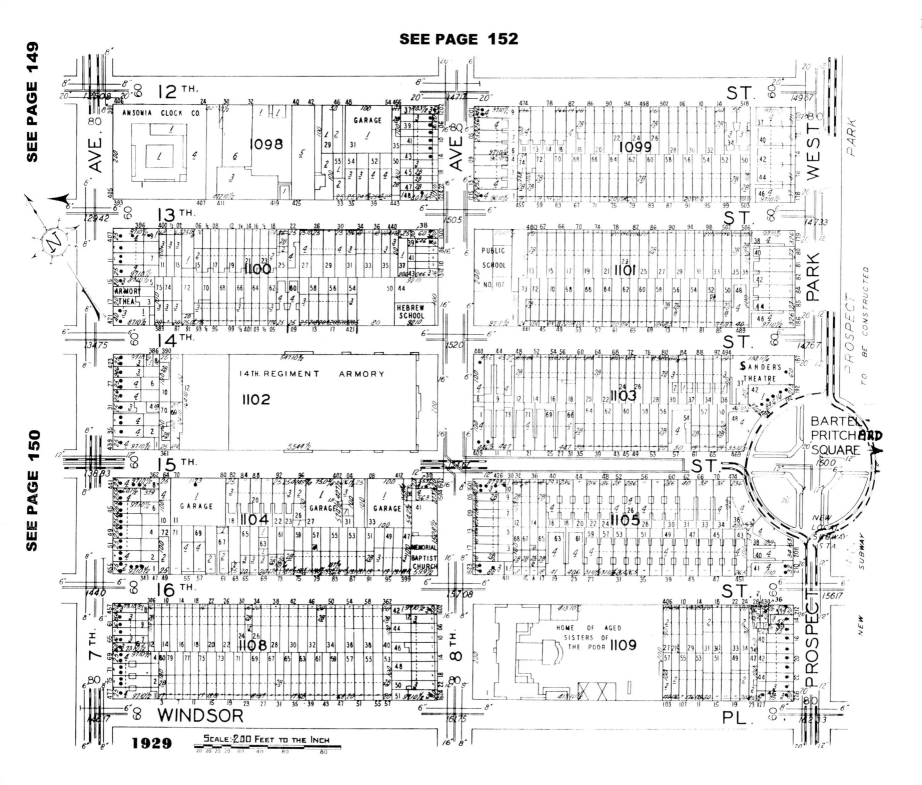

SEE PAGE 149

SEE PAGE 150

SEE PAGE 153

SEE PAGE 148

SEE PAGE 149

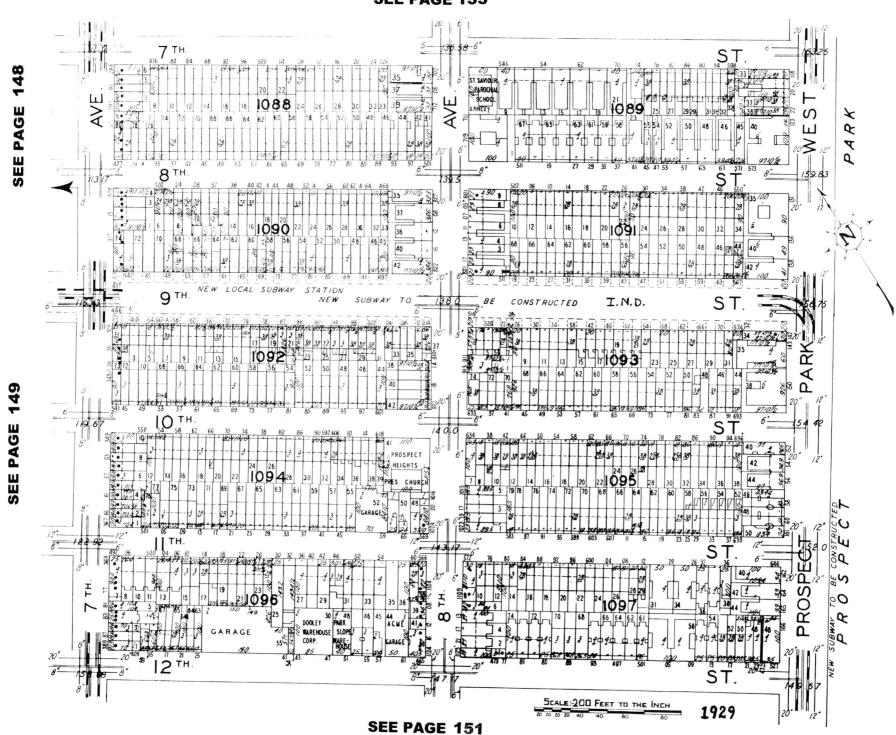

SEE PAGE 151

1929

SCALE: 200 FEET TO THE INCH

SEE PAGE 156

SEE PAGE 148

SEE PAGE 152

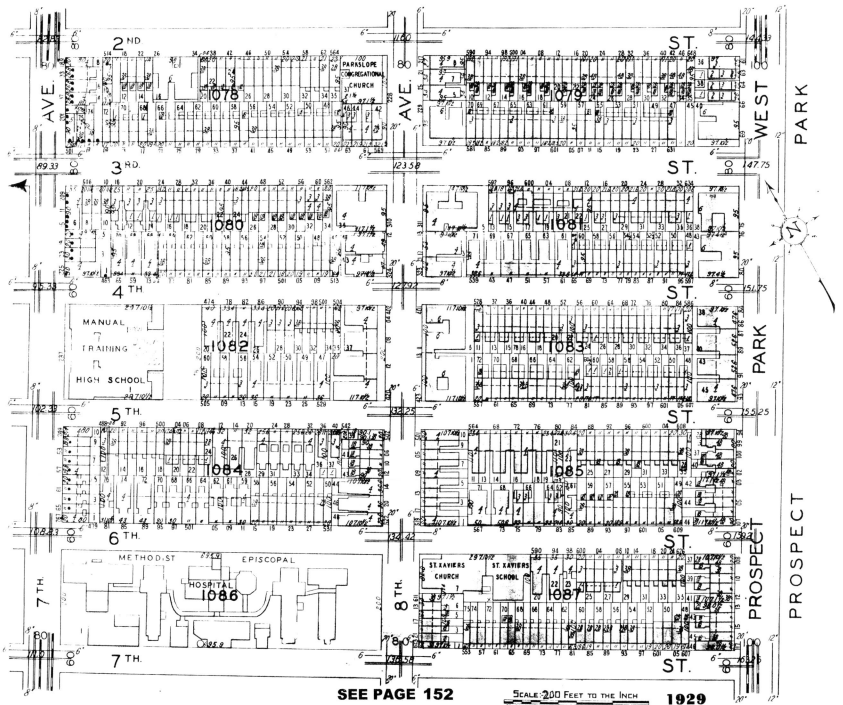

2ND AVE.

3RD

4TH

5TH

6TH

7TH

ST.

WEST PARK

PARK

PROSPECT

PROSPECT

PARK SLOPE CONGREGATIONAL CHURCH

1078

1079

1080

1081

MANUAL TRAINING HIGH SCHOOL

1082

1083

1084

1085

METHODIST EPISCOPAL HOSPITAL

1086

ST. XAVIERS CHURCH

ST. XAVIERS SCHOOL

1087

SCALE: 200 FEET TO THE INCH

1929

Scale: 200 Feet to the Inch

1929

SEE PAGE 158

SEE SUB PLAN B

SUB PLAN B

STERLING PL.

PARK PL.

7TH AVE.

FLATBUSH AVE.

SITE OF 1960 plane crash

PILLAR OF FIRE CHURCH

CHARLTONE THEATRE

CHURCH

GARAGE

GARAGE

GARAGE

76TH AVE.

70TH ST.

ATLANTIC AVE.

PACIFIC SUB PLAN A

119

75TH AVE.

70

N

SUBWAY

FLATBUSH AVE.

936

939

942

6TH

PL.

PL.

PL.

70 ST.

DEAN ST.

A. G. SPALDING

HA METZ

LABORATORY

WAREHOUSE

1127

1135

PACIFIC

FLATBUSH

ATLANTIC THEATRE

BERGEN ST.

SUBWAY

931

933

935

938

941

ST. MARKS AVE.

PROSPECT

PARK

STERLING

PROSPECT PL. M.E. CHURCH

ST. AUGUSTINE'S SCHOOL

ST. AUGUSTINE'S BROTHERS' HOME

CHURCH

RECTORY

5TH AVE.

ELLER STA.

5TH

6TH

SEE PAGE 155

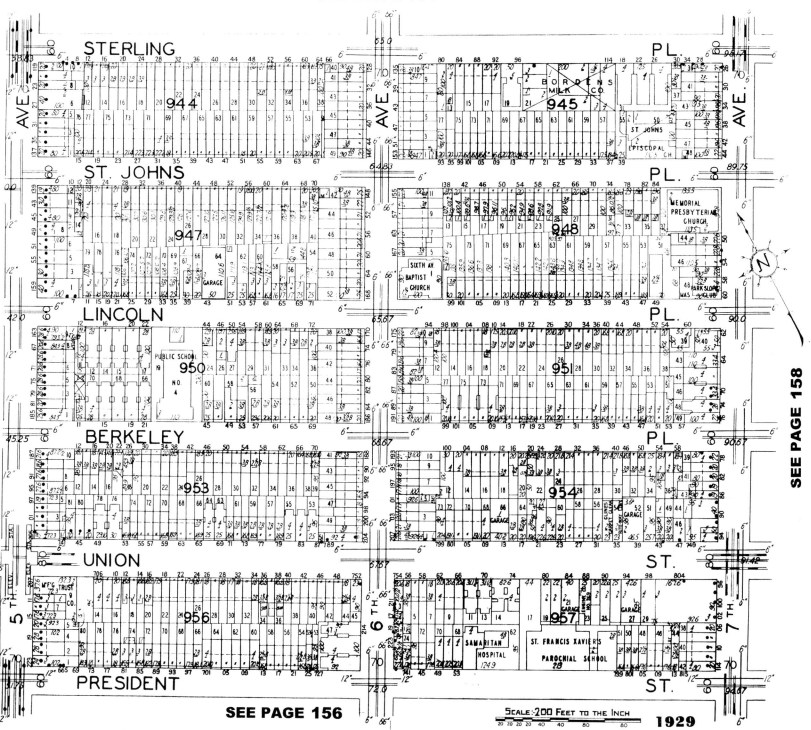

SEE PAGE 158

SCALE: 200 FEET TO THE INCH

1929

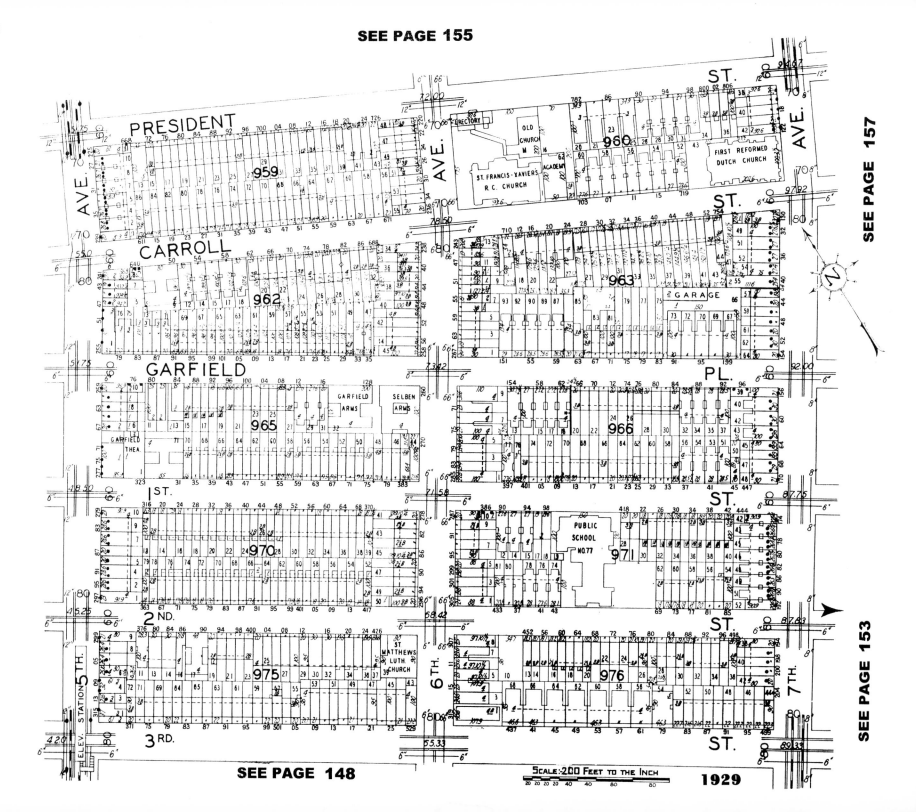

SCALE: 200 FEET TO THE INCH

1929

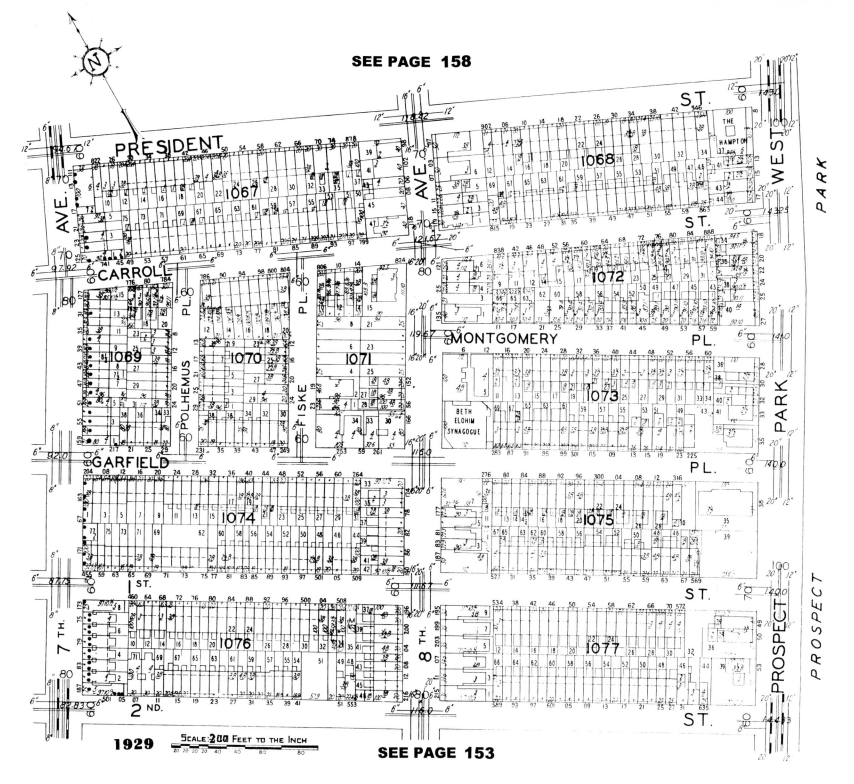

SEE PAGE 156

PRESIDENT

AVE.

1067

1068

ST.

WEST

PARK

CARROLL

1069

1070

1071

1072

MONTGOMERY PL.

POLHEMUS PL.

FISKE PL.

1073

BETH ELOHIM SYNAGOGUE

PARK

GARFIELD

1074

1075

PL.

7TH ST.

1076

1077

ST.

8TH

PROSPECT

PROSPECT

ST.

2ND

1929

SCALE: 200 FEET TO THE INCH
20 20 20 20 40 60 80

THE HAMPTON

SEE PAGE 155

STERLING PL.

STERLING PL.

STERLING

RIDING - DRIVING CLUB
OF BROOKLYN

169

SEE SUB - PLAN

SUB PLAN

N

STERLING

170

PROSPECT LANE

PLAZA LANE

BUTLER PL.

AVE.

STERLING

1058

GRACE
M. E.
CHURCH

FLATBUSH

SUBWAY

OVERLAND
WILLYS KNIGHT
SALES

BUICK
SALES

GARAGE

ST. JOHNS PL.

PL.

1059

BERKELEY INST.

AVE.

PARK TOWER

1060

MONTAUK
CLUB

ST.

P R O S P E C T P A R K

P L A Z A

VANDERBILT AVE.

PLAZA

LINCOLN PL.

1061

1062

BERKELEY PL.

1063

1064

SCALE 200 FEET TO THE INCH

1929

UNION

1065

7TH

8TH

1066

GARAGE

GARAGE

KNIGHTS
OF
COLUMBUS

PROSPECT PARK WEST

THE PRESIDENT

PRESIDENT.

ST.

SEE PAGE 157

Melkite Greek Catholic Church (Originally the Park Slope Congregational Church) - Eighth Avenue at Second Street - 1998

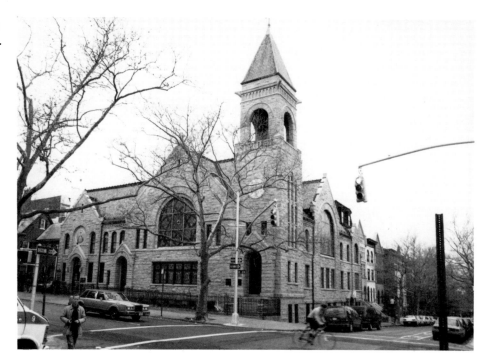

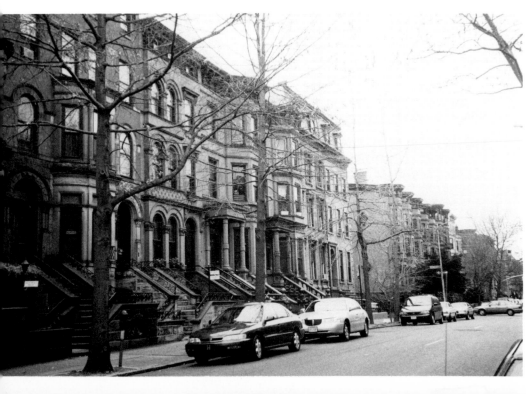

Eighth Avenue, toward Berkeley Place - 1998

CATALOG

WELCOME BACK TO BROOKLYN
by Brian Merlis & Oscar Israelowitz 172 pages
ISBN 1-878741-14-4 **$19.95** Paper (plus $2.50 shipping)

BROOKLYN - THE WAY IT WAS
by Brian Merlis 250 pages (Landscape Format)
ISBN 1-878741-20-9 **$24.95** Paper (plus $2.50 shipping)
ISBN 1-878741-21-7 **$39.95** Hard Cover (plus $3.50 shipping)

BROOKLYN - THE CENTENNIAL EDITION
by Brian Merlis 132 pages
ISBN 1-878741-33-0 **$19.95** Paper (plus $2.50 shipping)

BROOKLYN'S GOLD COAST - The Sheepshead Bay Communities
by Brian Merlis & Lee Rosenzweig 160 pages
ISBN 1-878741-49-7 **$19.95** Paper (plus $2.50 shipping)
ISBN 1-878741-48-9 **$24.95** Hard Cover (plus $3.00 shipping)

BOROUGH PARK CENTENNIAL EDITION
by Oscar Israelowitz 96 pages
ISBN 1-878741-36-5 **$19.95** Paper (plus $2.50 shipping)

BROOKLYN'S PARK SLOPE - A Photo Retrospective
by Brian Merlis & Lee Rosenzweig 165 pages (Landscape Format)
ISBN 1-878741-47-0 **$29.95** Hard Cover (plus $3.00 shipping)

BROOKLYN'S BAY RIDGE & FORT HAMILTON
A Photographic Journey 1870 -1970
by Brian Merlis & Lee Rosenzweig 165 pages (Landscape Format)
ISBN 1-878741-43-8 **$24.95** Hard Cover (plus $3.00 shipping)

POST CARDS - Brooklyn Views
30 images taken from the collection of Brian Merlis
$1.00 each (minimum order - 10) (plus $1.00 shipping)

UNITED STATES JEWISH TRAVEL GUIDE (5th Edition)
by Oscar Israelowitz 680 pages
ISBN 1-878741-40-3 **$24.95** Paper (plus $3.00 shipping)

EAT YOUR WAY THROUGH AMERICA
- A Kosher Dining Guide (5th Edition)
by Oscar Israelowitz 125 pages
ISBN 1-878741-41-1 **$9.95** (plus $2.00 shipping)

GUIDE TO JEWISH EUROPE - Western Europe (10th Edition)
by Oscar Israelowitz 384 pages
ISBN 1-878741-19-5 **$19.95** Paper (plus $2.50 shipping)

ITALY JEWISH TRAVEL GUIDE
by Annie Sacerdoti 242 pages
ISBN 1-878741-42-X **$19.95** Paper (plus $2.50 shipping)

ISRAEL TRAVEL GUIDE
by Oscar Israelowitz 350 pages
ISBN 1-878741-26-8 **$19.95** Paper (plus $2.50 shipping)

CANADA JEWISH TRAVEL GUIDE
by Oscar Israelowitz 196 pages
ISBN 1-878741-10-1 **$9.95** Paper (plus $2.00 shipping)

THE JEWISH HERITAGE TRAIL OF NEW YORK
by Oscar Israelowitz 156 pages
ISBN 1-878741-37-3 **$14.95** Paper (plus $2.00 shipping)

ELLIS ISLAND GUIDE with Lower Manhattan (1998 Edition)
by Oscar Israelowitz 128 pages
ISBN 1-878741-01-2 **$7.95** Paper (plus $2.00 shipping)

LOWER EAST SIDE TOURBOOK (6th Edition)
by Oscar Israelowitz 150 pages
ISBN 1-878741-38-1 **$9.95** Paper (plus $2.00 shipping)

NEW YORK CITY SUBWAY GUIDE
by Oscar Israelowitz 260 pages
ISBN 0-961103607-1 **$6.95** Paper (plus $2.50 shipping)

SYNAGOGUES OF THE UNITED STATES
An Architectural & Photographic Survey
by Oscar Israelowitz 200 pages
ISBN 1-878741-09-8 **$24.95** Paper (plus $2.50 shipping)
ISBN 1-878741-11-X **$29.95** Hard Cover (plus $3.00 shipping)

SYNAGOGUES OF NEW YORK CITY
History of A Jewish Community by Oscar Israelowitz
ISBN 1-878741-44-6 **$29.95** Paper (plus $3.00 shipping)

ISRAELOWITZ PUBLISHING
P.O.Box 228 Brooklyn, NY 11229
Tel. (718) 951-7072
E-Mail oscari 477 @aol.com

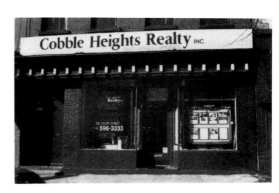

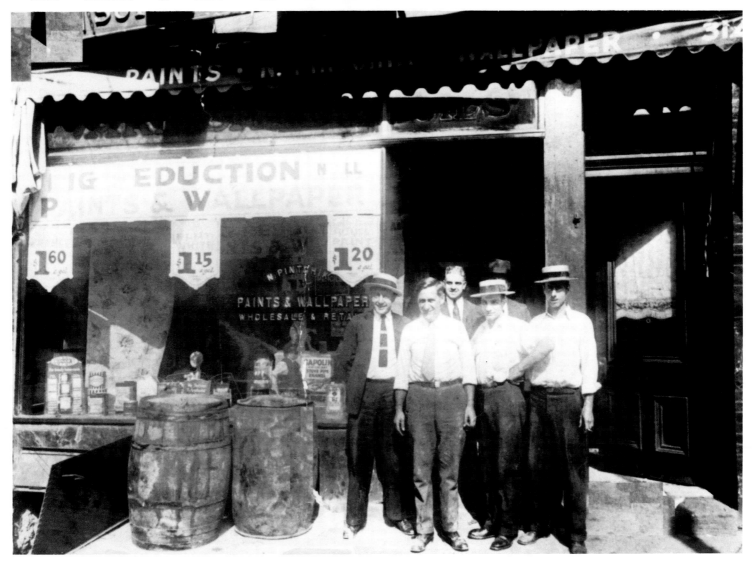

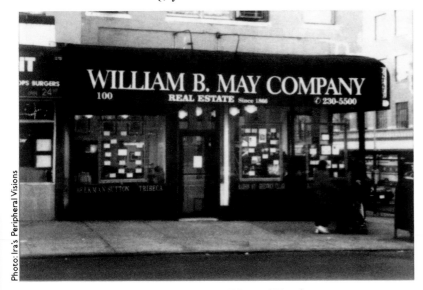

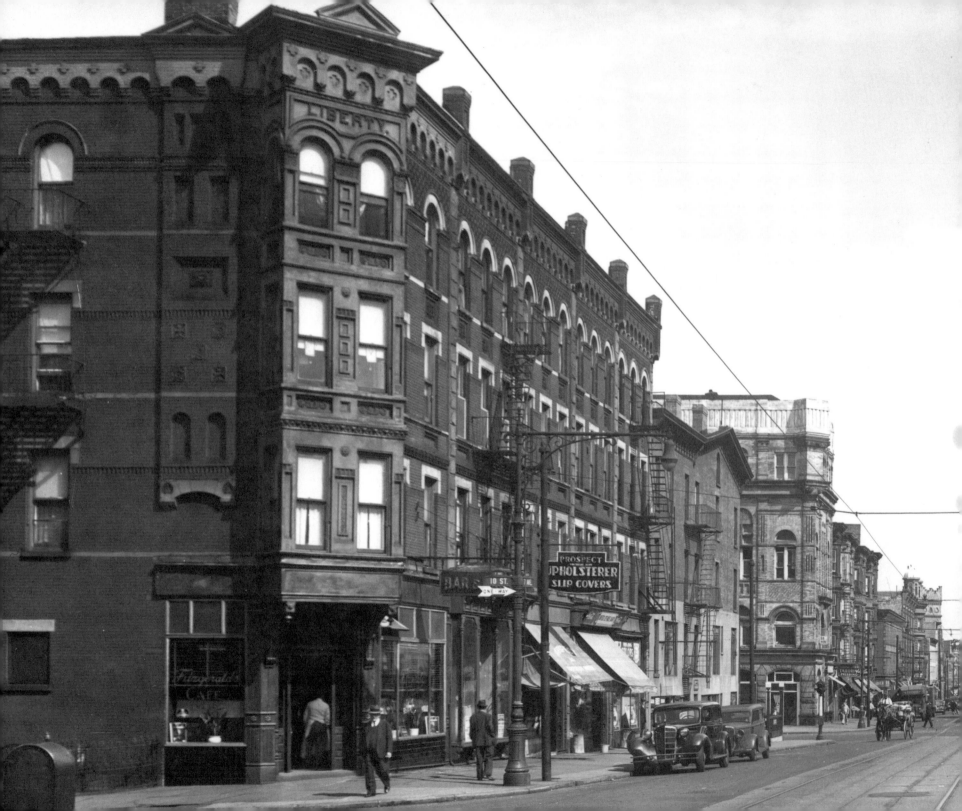